TIEPOLO

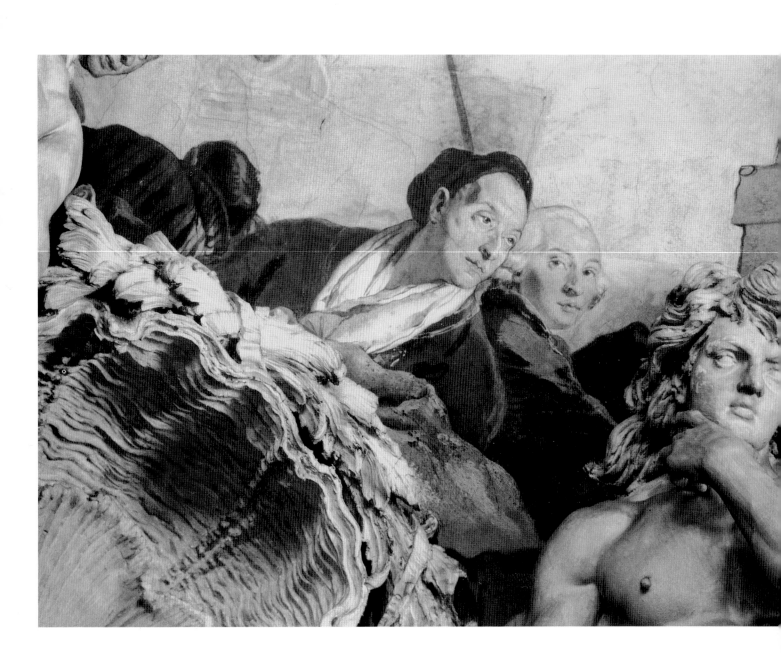

GIAMBATTISTA
TIEPOLO

BY
WILLIAM L. BARCHAM

THAMES AND HUDSON

For Raphael and Arianna

Frontispiece: *The Allegory of the Four Continents,* detail
showing the artist and his son Giandomenico (right).
1752–53. Ceiling fresco, 62′4″ × 100′ (19 × 30.5 m).
Stairwell, Archbishop's Palace, Würzburg

CONTENTS

Gio Batta Tiepolo

Giambattista Tiepolo was the last great painter of Renaissance and Baroque Italy. Connoisseurs have long valued his art, and collectors and museums today vie to buy his paintings and drawings at auctions, but the general public has yet to appreciate him. Several factors can explain this. The Venetian State, in which Tiepolo was born and worked, collapsed in 1797, and at its demise the patrician class and many of the ecclesiastical organizations that had commissioned him were disbanded or suppressed. Thus the historical and societal elements telling on Tiepolo died or disappeared shortly after his own death in 1770. Moreover, the subjects that figure prominently in his painting dropped from the repertory of Western European art after 1800: religious subjects all but ceased to exist, and allegory and ancient history slowly vanished. The modern world's general inability to believe in those narratives and to interpret allegory has closed his art to us. The twentieth century looks to eighteenth-century art for its nascent secularity rather than for its traditional piety and emblematic themes.

Tiepolo's art is primarily concerned with allegory, Greek and Roman history and mythology, and Counter Reformation subject matter emphasizing the Virgin Mary and Christ's saints. His elegant protagonists, adorning the walls and ceilings of eighteenth-century European palaces and churches, and his visionary figures, in paintings over altars, embody the values of an old order. For the modern viewer, they hold aloft the pretensions of a lost aristocracy and the beliefs of a much-ignored theology. Because twentieth-century political ideals and spiritual values coincide little with those of Tiepolo's era, his art has sometimes been accused of both cynicism and superficiality. But if we accept, for instance, the sincerity of Raphael's *Sistine Madonna* (Gemäldegalerie, Dresden), then the honest belief in divine revelation that Tiepolo gave image to in his *St. Clement Adoring the Trinity* (plate 12) should not be questioned; it expresses the same faith in God's guidance of mankind that was held by believing Christians during the Renaissance. If we are willing to trust, for example, the authenticity of sentiment in Nicolas Poussin's *The Death of Germanicus* (Institute of Arts, Minneapolis), then the genuineness of the high-minded virtue Tiepolo pictured in *The Generosity of Scipio* (plate 23) should not be at issue, for it presents the same concepts of goodness and excellence that were subscribed to by patrician families of the seventeenth century.

Tiepolo's art has been misunderstood because his Baroque style has been simplistically interpreted as ostentatious and grandiloquent. Based on the highly questionable axiom that the severe Neoclassical manner that followed his honestly expresses noble principles, historians have concluded that Tiepolo's colorful and flamboyant style can only give voice to a corrupt society. Is it really the case, as the traditional art-historical reading of the eighteenth century would hold, that a sparer idiom denotes greater sincerity? Is the color- and light-filled Gothic church less genuine in its expression of devotion to God than the dark Romanesque one? Employing style to measure integrity of purpose must lead to empty pontification.

Finally, Tiepolo's manner engendered no artistic legacy except the work of his son. Its worst sin, there-

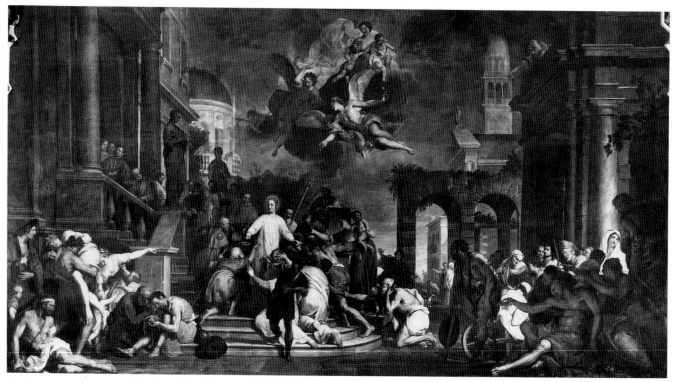

1. Gregorio Lazzarini. *The Almsgiving of S. Lorenzo Giustinian*. 1691. Oil on canvas. S. Pietro di Castello, Venice

fore, was that it was historically barren. In sum, Tiepolo's art exists for many modern viewers beyond a broad and deep cultural chasm. It is like a closed book, undecipherable. But if the book is opened and examined with unprejudiced eyes, viewers will discover a wealth of ideas, a richness of imagery, and a depth of sentiment rare in the history of Italian art.

Giovanni Battista Tiepolo was born in Venice in the district of Castello on March 5, 1696, and he was baptized in Venice's cathedral, S. Pietro di Castello, on April 16. Domenico Tiepolo, his father, was a merchant with ship holdings who died when the baby was only one year old, and the young Giambattista was raised by his mother, Ursula. While a boy, he was apprenticed with the artist Gregorio Lazzarini, who was immensely successful in Venice during his own time but is generally forgotten today except as Tiepolo's teacher.[1] Judging from his *The Almsgiving of S. Lorenzo Giustinian* of 1691 (fig. 1), considered Lazzarini's masterpiece, the teacher would have had his pupils study the artistic heritage of Renaissance Venice, particularly the paintings of Jacopo Tintoretto, Paolo Veronese, and Palma Giovane, Titian's last important follower. The *Almsgiving* reveals figural twistings culled from Tintoretto, an architectural setting *alla* Veronese, and compositional groupings and disjunctive lighting taken from Palma.

Although the paintings of the young Tiepolo are quite different from those of his master, Giambattista learned his lessons well, and his art more than that of any contemporary rests on the pictorial traditions of sixteenth-century Venice.

Tiepolo's name appears on the lists of the Venetian painters' guild in 1717. Although his artistic independence can certainly be dated from that year, he must have been important in local artistic circles somewhat earlier, because at age twenty, in 1716, he had become advisor and painter to Giovanni Cornaro, who reigned as *doge*, or duke, of Venice from 1709 to 1722. Tiepolo counseled the political leader on artistic matters relating to the family palace and produced portraits of earlier Cornaro doges to decorate it.[2] In 1716, too, Tiepolo painted single figures of apostles for spandrels over the lateral altars in S. Maria dei Derelitti (the church of the Ospedaletto); and in the same year, his *The Crossing of the Red Sea* (present whereabouts unknown) was publicly applauded at the annual open-air exhibition held on the feast day of St. Roch, August 16.[3] Also datable to around 1716 are his first ceiling frescoes, *The Assumption of the Virgin* in S. Maria Assunta in Biadene, near Montebelluna (fig. 2), and *The Glory of St. Lucy* in a church in Vascon, near Treviso.[4] Tiepolo's earliest-known commissions were therefore totally traditional in subject matter, depicting the Virgin Mary,

8

2. Giambattista Tiepolo. *The Assumption of the Virgin*. c. 1716–17. Ceiling fresco. S. Maria Assunta, Biadene (Montebelluna)

saints, biblical narrative, and Venetian patricians.

Tiepolo's achievements in fresco blind the modern observer to the fact that it was hardly to be expected that a Venetian-trained painter would become expert in the medium. Because of the city's humidity and the intermittent flooding of ground-floor rooms, with moisture consequently rising through a building's walls, frescoes simply cannot enjoy a long life in Venice. By Tiepolo's day, patrons realized how unlikely it was for any painting on plaster to survive for very long. To give only the most notable examples of such decay in the city: the fourteenth-century narratives on three walls of

the Hall of the Great Council in the Ducal Palace, which illustrate the Peace of 1177, had begun to deteriorate so badly by 1474 that the government ordered a complete repainting of the hall, except for one scene in the cycle, Guariento's much-hallowed *Paradise*, which less than a hundred years later had itself become practically illegible. (After a devastating fire in 1577, the hall was entirely redecorated.)

Even more susceptible to the elements than indoor frescoes were those on palace facades. Giorgione's well-known figures on the former Fondaco dei Tedeschi, the warehouse of German merchants trading in Venice and

3. Louis Dorigny.
Female Figures.
c. 1685. Ceiling fresco.
Salon, Palazzo Zenobio,
Venice

today's main post office, were only shadows of their former selves by Tiepolo's lifetime. Wanting to record them for posterity, Anton Maria Zanetti engraved what little remained of them, and of other famous local frescoes, in 1760. Fresco was practical only on the Venetian mainland, and during the later Renaissance, Veronese and others used the medium to decorate the interiors of patrician villas. But because local patrons and painters continued to eschew fresco painting in the capital, large canvases painted in oil were the preferred means of covering walls and decorating ceilings in private and public, secular and ecclesiastical buildings throughout the late sixteenth and early seventeenth centuries. As a result, native artists had little practice in fresco painting by the middle of the seventeenth century.

After 1650, several foreign painters living in Venice were working in the medium, and it subsequently enjoyed a renewed popularity. Domenico Bruni from Brescia turned the ceiling in the sacristy of S. Martino di Castello, near where Tiepolo grew up, into a dizzying complex of twisting columns and curving balusters. But the two most expert practitioners of fresco were the Roman Girolamo Pellegrini and the Frenchman Louis Dorigny. In S. Francesco della Vigna, Ss. Cosma e Damiano (now deconsecrated), S. Zaccaria, S. Pietro di Castello, and the Scuola Grande di S. Rocco, Pellegrini executed weak versions of Roman illusionistic domes of

the mid-seventeenth century. And Dorigny, like Bruni before him in S. Martino, decorated the ceiling of the salon in Palazzo Zenobio with an illusionistic architectural complex (fig. 3). Bruni's, Pellegrini's, and Dorigny's frescoes showed the young Tiepolo that, although humidity militated against it, the medium was a viable choice for interior pictorial decoration in Venice.

Tiepolo's earliest frescoes, *The Assumption of the Virgin* in Biadene and *The Glory of St. Lucy* in Vascon, were not threatened by unfavorable climatic conditions because they were painted on the mainland. Although they survived the centuries, they were long overlooked, and both paintings have only recently been identified.[5] They reveal that the young artist was capable of remarkable foreshortening of figures, which are elegantly attenuated, with spidery limbs and small heads. Despite this, the frescoes are disappointing. The figures are limp, space is tensionless, and in each case the drama of a visionary apotheosis is lacking.

In early 1719, Tiepolo asked the patriarchal office in Venice for permission to marry Cecilia Guardi (1702–1779) without publishing the usual bans. (Suspecting that his family would disapprove of his bride, perhaps because her parents were neither Venetian nor well-to-do, Giambattista sought to circumvent any public embarrassment for the young woman should such opposition be expressed.) He obtained the office's consent and married Cecilia in November 1719, becoming the

brother-in-law of the painter Giannantonio Guardi and of Francesco Guardi, who was only seven years old at the time but would become Venice's great view-painter during the second half of the century. The newlywed Tiepolos settled into a house near S. Francesco della Vigna, a church whose interior and facade were designed, respectively, by Jacopo Sansovino and Andrea Palladio. Eight of their nine children would be born in that house. In 1734, they moved to a larger home in the parish of S. Silvestro, near the Rialto, and in 1749, they moved across the Grand Canal, to "enviable domestic comfort" in a house near S. Fosca.[6] Across the centuries it appears that the long marriage was a happy one; decades later when the elderly Giambattista worked in Madrid, far from Cecilia who had remained in Venice, he sent her pearls and lingerie embroidered with lace.

Around 1719, Giambattista collaborated with Giuseppe Camerata and Silvestro Manaigo, both former Lazzarini students like himself, in producing drawings for engravings by Andrea Zucchi that would appear in Domenico Lovisa's publication *Il gran teatro di Venezia*

ovvero raccolta delle principali vedute e pitture che in essi si contengono (The Great Theater of Venice, or A Compendium of the Principal Views and Paintings that Are Included in It). The three artists copied sixteenth-century Venetian paintings, with Tiepolo reproducing a historical canvas by Francesco Bassano in the Hall of the Great Council of the Ducal Palace, an Old Testament narrative by Francesco Salviati on the choir ceiling of S. Maria della Salute, and two altarpieces by Tintoretto, *The Beheading of St. Christopher* in S. Maria dell'Orto and the *Assumption* in S. Maria Assunta, the Jesuit church in Venice.

Tiepolo's particular taste for Tintoretto's highly dramatic scenes and his budding ability to re-create the sixteenth-century master's monumentality can be easily seen in the ambitious *Crucifixion* he painted for the church of S. Martino, on the island of Burano, about 1719–20 (fig. 4). Tiepolo appears to have been inspired by two of Tintoretto's representations of the same subject, one now in the Gallerie dell'Accademia and the other in the Scuola Grande di S. Rocco, both in Venice.

4. Giambattista Tiepolo. *The Crucifixion*. c. 1719–20. Oil on canvas, 8′2″ × 13′2″ (2.5 × 4 m). S. Martino, Burano (Venice)

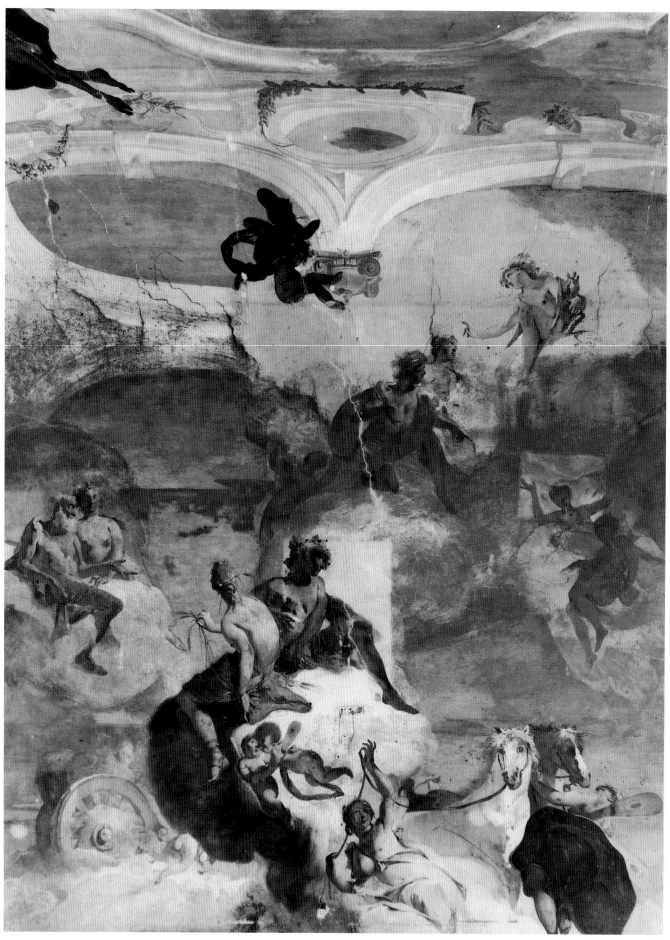

5. Giambattista Tiepolo. *Phaëthon Asking Apollo for the Chariot of the Sun*. c. 1719. Wall fresco.
Palazzo Baglioni, Massanzago (province of Padua)

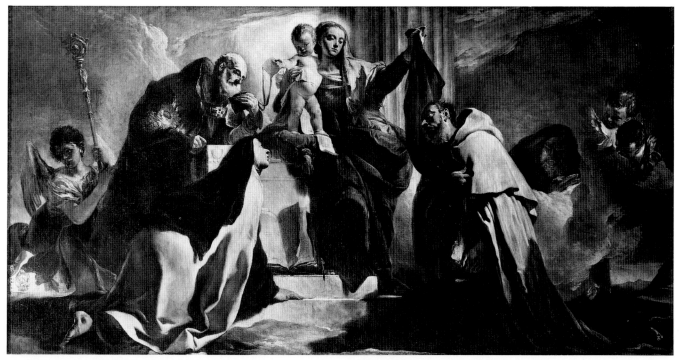

6. Giambattista Tiepolo. *The Virgin of Carmel*. 1722–27. Oil on canvas, 7′10⅝″ × 24′11⅛″ (2.1 × 7.6 m). Pinacoteca di Brera, Milan

He repeated their intense drama but simplified their compositions, clarifying space and reducing the number of figures; he also altered the figures' proportions to create more supple and elegant forms. A grand image, this youthful *Crucifixion* is, however, a flawed work: each figure or group seems to function independently, like a mini-drama, rather than uniting into a powerful narrative. The composition reveals the hand of an artist not yet in charge of his resources.

Contemporary with the Burano *Crucifixion* are the frescoes the twenty-three-year-old Giambattista painted on the ceiling and walls of the main hall in Palazzo Baglioni, in Massanzago just north of Padua (fig. 5).[7] In this scene, beyond an illusionistic framework, Phaëthon asks Apollo for his chariot to cross the heavens. Various divinities sitting on cloudbanks attend the Sun God's audience, while the horses who will later crash Phaëthon and his chariot to earth look out innocently toward the viewer. Like the *Crucifixion*, *Phaëthon Asking Apollo for the Chariot of the Sun* is compositionally fragmented and contains several enervated figures. Moreover, the young artist was unable to transform his artistic sources into a personal idiom. Here, the work of Dorigny is apparent, in the softly rounded contours of the female figures, the moon-struck faces, and flapping draperies (fig. 3). But however imperfect these frescoes and the *Crucifixion* may be, they already exhibit the strengths that would characterize Tiepolo's art during

his more than fifty-year career: intense drama expressed through staccato rhythms, and fluid line coupled with delicate form.

Tiepolo's rapid maturation as an artist took place soon after 1720, and we can begin to trace it in *The Virgin of Carmel* (fig. 6). The work was commissioned in late 1721 for a chapel in S. Aponal dedicated to prayers for the dead recited under the protection of the Virgin of Carmel. It is a broad canvas celebrating the Roman Catholic cult of the scapular and the popular belief in its capacity to save the soul from the eternal fires of purgatory.[8] On the left, two souls yearning for salvation reach toward the right where the infant Christ, Mary, the beatified Patriarch Albert of Jerusalem and Simon Stock, and St. Theresa of Avila are gathered in a *sacra conversazione*, or holy conversation. On the extreme right, the Old Testament prophet Elijah appears as a hooded figure in prayer hovering mystically before a landscape in whose far distance one can discern Mt. Carmel. Elijah's presence reinforces the painting's message of salvation through traditional Christian interpretations of Old Testament scripture, that is, his power to resurrect the dead as narrated in 1 Kings 17:21–24 and his ascension into heaven in 2 Kings 2:11–12. Christian belief in heavenly redemption through the Savior's sacrifice is further underscored by the Infant's swaddling cloth, which recalls the shroud and the descent from the cross. The brilliant light emanating from

13

7. Giambattista Tiepolo. *Diana and Callisto*. c. 1722. Oil on canvas, 39 × 52¾″ (99 × 134 cm). Gallerie dell'Accademia, Venice

behind Christ contrasts with the gloom surrounding the dead on the left; set before deep blues, they are painted muddy brown, deep beige, and dark ocher. Members of a Carmelite confraternity in the center of the canvas wear dull gray and black. *The Virgin of Carmel* is a sophisticated painting that gives voice to the confraternity's hopes for everlasting life, and it demonstrates the young Tiepolo's ability to present traditional Counter Reformation themes in dramatic terms.

About 1722, when he began work on *The Virgin of Carmel*, Tiepolo painted four canvases of identical size narrating episodes from Ovid's *Metamorphoses*. They are *The Rape of Europa*, *Diana and Actaeon*, *Diana and Callisto* (fig. 7), and one that has been mistakenly identified as *Apollo and Marsyas*.[9] The four demonstrate Tiepolo's skill in juxtaposing male muscularity against female grace; they also reveal his ability to create compositions whose staccato rhythms contrast with smooth, flowing ones—compare the craggy landscape setting with the long, slender limbs of the heroine and nymphs in *Diana and Callisto*. (It is notable that these figures foreshadow

François Boucher's mincing shepherdesses and elegant goddesses of two decades later.) But the paintings' most impressive aspects are the orchestration of figural groups echoing each other from canvas to canvas and of a foreground stage constructed along diagonal lines (the lines of recession) that corresponds from one painting to another.

The years 1722–24 were important for Tiepolo's public career. While working on *The Virgin of Carmel*, he entered an open competition to paint the ceiling of the new chapel dedicated to St. Dominic in Ss. Giovanni e Paolo. At the same time, he participated with eleven other painters in creating a cycle of twelve canvases—one artist assigned to each painting—depicting Christ's apostles for the church of S. Stae (Venetian dialect for Eustace) (plate 1), and he completed his first secular and ecclesiastical frescoes in Venice, in Palazzo Sandi (plate 2) and in S. Maria di Nazareth, the church of the Scalzi, or Discalced Carmelites (plate 3). Tiepolo did not win the St. Dominic competition of 1722–23, although his loss was an honorable one, for the prize went to his only

significant competitor in the city, Giovanni Battista Piazzetta, older by thirteen years. In *The Martyrdom of St. Bartholomew* for S. Stae, Tiepolo produced the century's greatest image of religious commitment. And in *The Allegory of the Power of Eloquence* in Palazzo Sandi and *St. Theresa in Glory* in S. Maria di Nazareth, he created a new kind of Venetian ceiling painting, the pair of them different in medium and in pictorial conception from Piazzetta's contemporary canvas in Ss. Giovanni e Paolo.

Tiepolo completed his first, large-scale masterpieces not at home but outside Venice. In the mid-1720s, he traveled to Udine to paint for Dionisio Dolfin, a member of an old patrician family, who had been named patriarch of Aquileia in 1699. In the Archbishop's Palace, on the stairwell vault and on the walls and ceilings of the Patriarchal Gallery and the Ecclesiastical Gallery, Tiepolo painted over two dozen Old Testament figures and narratives, depicting an iconographic program that responded to the grave political threat thrust at the thousand-year-old patriarchy by Emperor Charles VI of Austria (plates 4, 5).[10] The frescoes demonstrate Tiepolo's ability to portray sharp confrontations between antagonists, to depict lyrical apparitions of the divine materializing before humble humanity, and to dazzle with impressive displays of foreshortening and brilliant juxtapositions of color.

After passing through the palace courtyard, visitors climb a grand staircase which brings them to the public rooms on the *piano nobile*. On the stairwell ceiling, Tiepolo frescoed the Archangel Michael banishing the rebel angels from heaven in an illusionistic *tour de force*. One can imagine Patriarch Dolfin's immense pleasure in watching his guests react with surprise first to the muscular figures that seem to plunge downward toward them and, then, to the realization that this convincing scene was a brilliant re-creation of Veronese's famous *Jupiter Expelling the Vices* (Musée du Louvre, Paris), which still decorated the ceiling of the Council of Ten in the Ducal Palace, Venice, during Tiepolo's lifetime. The patriarch would have then led his guests through the Throne Room into the Patriarchal Gallery (plate 4). To view the gallery today is as pleasurable an experience as it must have been for Dolfin and his visitors. Its walls and ceiling are adorned with a gorgeous complex of differently shaped paintings enframed by varying levels of fictive moldings, and a breathtakingly rich gamut of color. Tiepolo's forms and hues appear as if in a kaleidoscope; they seem to change each time we shift our vision. The culmination of Dolfin's decorative ensemble was the Ecclesiastical Tribunal, on whose ceiling Tiepolo frescoed *The Judgment of Solomon* (plate 5). Like *The Fall of the Rebel Angels*, it bears the unmistakable

8. Sebastiano Ricci. *The Virgin and Child with Saints*. 1708. Oil on canvas, 13′4″ × 6′10″ (4.06 × 2.08 m). S. Giorgio Maggiore, Venice

imprint of Veronese. Following the latter's *Venice with Justice and Peace*, on the ceiling of the Council of the Collegio in the Ducal Palace, Tiepolo depicted an enthroned figure backed by great draperies and sitting on a sharply foreshortened platform reached by several steps.

Tiepolo's brilliant remaking of Veronese's art in Udine was neither casual nor insignificant. At the beginning of the century, Sebastiano Ricci had already created a modern manner *alla* Veronese, producing an altarpiece for the church of S. Giorgio Maggiore (fig. 8)

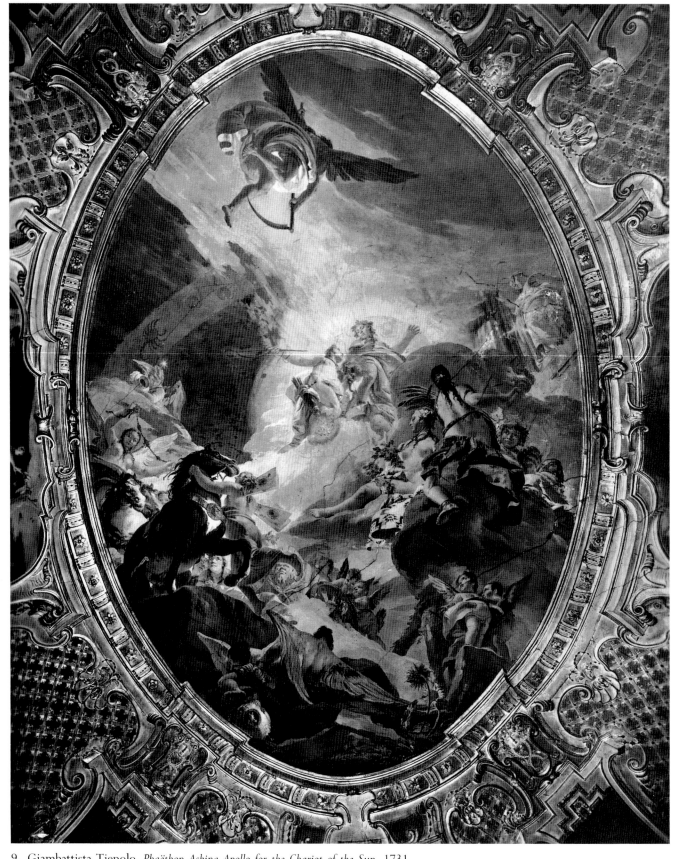

9. Giambattista Tiepolo. *Phaëthon Asking Apollo for the Chariot of the Sun.* 1731.
Ceiling fresco, 29′6″ × 23′ (9 × 7 m); destroyed. Formerly in Palazzo Archinto, Milan

that was based on the master's *The Mystic Marriage of St. Catherine* (Gallerie dell'Accademia, Venice). Tiepolo's Veronesianism strikes a far deeper note than Ricci's did, although it was certainly based on his older colleague's earlier revival. Tiepolo's neo-Veronesianism invokes Venice's great artistic tradition just as his iconography in the Udine frescoes stresses local ecclesiastical and political history. Like the contemporary revival of Palladianism in Venetian architecture, which impressed through its antique-looking dignity and sobriety, Tiepolo's neo-Veronesianism revived the magnificent opulence and bold illusionism of Venetian Renaissance art.

Tiepolo's outstanding achievements in Udine catapulted him into a career as a decorator of monumental pictorial ensembles in both fresco and oil. In the early 1730s, he began to work outside the confines of the Venetian Republic, painting frescoes in the *palazzi* Archinto (fig. 9) and Casati (now Dugnani) in Milan. Returning to Venice, he executed an enormous canvas depicting *The Brazen Serpent* (plate 6, fig. 10) for the front of the choir stall in Ss. Cosma e Damiano on the Giudecca island. In 1732–33, he frescoed three lunettes in the Colleoni Chapel in Bergamo with stories of John the Baptist (plate 8) and two more with the figures of Sts. Bartholomew and Mark; four Virtues cover the pendentives. In 1734, he frescoed the stairway and salon of Villa Loschi outside Vicenza, his first of approximately a dozen extensive decorative projects in villas in the Veneto. His subject matter in these paintings ranges across ancient history, allegory, mythology, and biblical narrative. In *The Brazen Serpent* and the Colleoni frescoes, he depicted dramatic figures heralding, seeking, and offering divine salvation. In Palazzo Casati-Dugnani, he illusionistically transformed walls into stages for reenactments of noble deeds, and in Palazzo Archinto and Villa Loschi, he opened ceilings into air-filled spaces where apotheoses show gods and allegorical personifications representing high moral values.

Little appreciated, the 1734 Loschi frescoes are a milestone in Tiepolo's development. He painted them using neither his early dark, or "tenebrist," manner nor his elegant Veronesian mode; instead their style is a tempered classicism, quite apt for such noble themes as Time Discovering Truth, Innocence Banishing Deceit, and Honor Crowned by Virtue (fig. 11). The figures are robed *all'antica* and stand fixed like classical statuary. However, they seem inert and thus lack drama; their restrained gestures are mostly confined to the holding aloft of attributes the painter gleaned from emblem books like Cesare Ripa's famous early-seventeenth-century *Iconologia*. Tiepolo reduced architecture and landscape in the frescoes to a minimum and subdued his colors. Air itself seems missing from the paintings. The Loschi frescoes communicate less the solemnity that their elevated morality would seem to require than a kind of scrupulous ceremonialism.

One might argue that Tiepolo's natural artistic sensibility represented more convincingly scenes of conflict, elegant pageants, visionary experiences, and even humorous events than it did isolated figures in airless spaces. His violent depiction of the Baptist's death in the Colleoni fresco (plate 8), which is nearly contemporary with the Loschi paintings, would sustain such an argument. But the essential difference between the two lies more in the circumstances behind the commissions rather than in the different subject matter. In Villa Loschi as in all of his private decorative projects, Tiepolo felt the demands of a wealthy individual whose cultural milieu and artistic taste had to be expressed in appropriate pictorial terms.[11] Settling on static compositions and on figural frontality and isolation, which would correspond to the didactic themes Loschi gave him, Tiepolo painted in a Neoclassical style—and it must be seen as such—that parallels trends current in the arts and literature in the Veneto during the early eighteenth century.

The passion for neo-Palladianism in Venice, which had given birth to Domenico Rossi's facade for S. Stae in 1709 and to Giorgio Massari's S. Maria del Rosario, the church the Gesuati, in 1726, went hand in hand with a taste for the neo-antique. Around 1706, Andrea Tirali designed a classical temple front raised on stairs for the facade of Vincenzo Scamozzi's Theatine church of S. Nicolò dei Tolentini and so introduced the Pantheon's portico into the city. Less than a decade later, Giovanni Scalfarotto brought an entire mini-Pantheon to Venice, the church of S. Simeon Piccolo. The subject matter of much contemporary painting in the city also relied heavily on inspiration from the ancient world. Beginning in the late seventeenth century and continuing into the mid-eighteenth, many patrician families decorated the great halls of their palaces with canvases depicting events from Roman history: the *palazzi* Barbaro-Curtis, Pisani-Moretta, Vendramin-Calergi, Corner at S. Polo, Zenobio, Dolfin, Barbaro, and Correr all boasted such work.[12] They happily disturbed the public spaces of their tranquil homes with scenes of battles, military triumphs, and noble sacrifices to elevate their own position in society or to declare ancient familial traditions.

Members of the literary, scientific, and medical communities in the Veneto likewise turned back to ancient Greece and Rome, although for different purposes. The

writers and scholars Apostolo Zeno and his brother Pier Caterino in Venice, Niccolò Madrisio in Udine, Scipione Maffei in Verona, and the scientists Giovanni Poleni and Giambattista Morgagni in Padua revived ancient sources and materials in their respective disciplines. The University of Padua witnessed a flowering in the study of ancient texts and the redacting of new critical editions, first under Domenico Lazzarini and then Giovanni Antonio Volpi. A glance at the Veronese Scipione Maffei, in particular, sheds light on contemporary intellectual attitudes. In 1713, he published his play *Merope*, whose theme is linked to that of a lost tragedy by Euripides and whose sources lie in Pausanias, Apollodorus, and Hyginus. With *Merope*, which enjoyed

On this and facing page:
10. Giambattista Tiepolo. *The Brazen Serpent*. c. 1731–32. Oil on canvas, 5′4½″ × 44′5⅞″ (1.64 × 13.56 m). Gallerie dell'Accademia, Venice

a great success, Maffei attempted to refashion the contemporary spoken theater on the example of ancient drama. Maffei later engaged himself even more deeply in the study of ancient literature by translating sections of the *Iliad* and the *Odyssey*. But his personal commitment to the antique world is found, above all, in his several volumes entitled *Verona illustrata* (1732), in which he presented a history of his native city, of its antique monuments and artifacts.[13]

Tiepolo himself contributed to this publication by producing a dozen drawings of emperors and antique busts for prints. Thus only a few years before his work for Count Loschi, Tiepolo was directly involved with one of the Veneto's most important intellectuals.[14] In the *Verona illustrata*, Maffei praised Tiepolo's ability to respond to ancient art, noting that he had searched far and wide before finding a painter whose work so satisfied through its correctness of facial expression and its affinity for the antique.[15] He further commended Tiepolo's directness of manner. It is this very pictorial straightforwardness, or simplicity, that Tiepolo employed in the Loschi frescoes, in a work such as *Honor Crowned by Virtue* (fig. 11). Maffei's *Merope* little interests

the modern audience, and today Venetian neo-antique architecture can appear all too dry and serious. It is not surprising, therefore, that Tiepolo's hieratic figures and airless spaces in Villa Loschi can seem fustian. But the 1734 allegories and virtues were expressions of the same cultural phenomenon as Maffei's *Merope* and Scalfarotto's S. Simeon Piccolo. In his Loschi frescoes, Tiepolo played a role in the Veneto's classicizing trends, which would find a greater voice in the Neoclassicism of Rome, London, and Paris half a century later.

By the mid-1730s, Tiepolo was internationally famous. The writer Vincenzo da Canal had noted only a few years earlier that "engravers and copiers try to engrave his works, to capture their invention and the

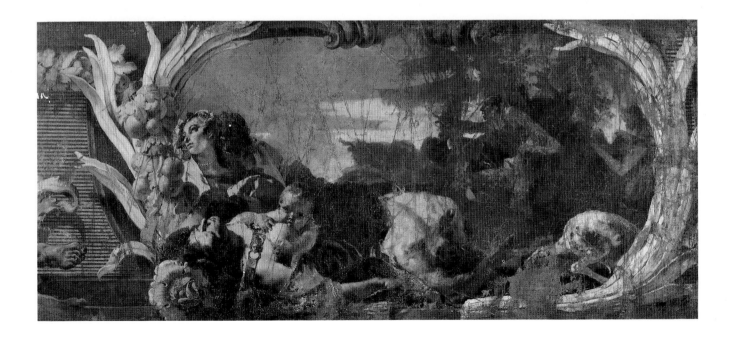

11. Giambattista Tiepolo. *Honor Crowned by Virtue*. 1734. Wall fresco, 7′6½″ × 5′10⅞″ (2.3 × 1.8 m). Salon, Villa Loschi-Zileri Dal Verme, Biron (province of Vicenza)

cleverness of their thought; and his drawings are already so esteemed that books of them are sent to far away countries."[16] In 1736, the king of Sweden invited him to Stockholm to paint in the Royal Palace. Now able to demand enormous fees for his work, Tiepolo turned down the king's unsatisfactory offer, which was presented to him by Count Carl Gustav Tessin, the royal emissary. Even without such a prestigious commission, Tiepolo's financial success was large enough so that, in 1734, he and Cecilia moved to a new house where, in circumstances more comfortable than before, they awaited the birth of their ninth and last child.[17]

The continued triumph of Tiepolo's career is also mirrored in the brightened tonality of his palette during this period. He had begun his career as a tenebrist, following painters like Antonio Zanchi, Federico Bencovich, Piazzetta, and Giambattista Pittoni, who had developed and practiced this manner from about 1675 to 1725. The young Tiepolo embraced their intense palette and dramatic chiaroscuro, ignoring, or refusing, the innovations of Ricci and Pellegrini, who had produced brightly colored images since 1710 or earlier. Tiepolo shunned, too, the more polished surfaces of paintings by Niccolò Bambini, Antonio Balestra, Jacopo Amigoni, and even his own teacher, Lazzarini, whose six canvases of 1694 in the Sala dello Scrutinio of the Ducal Palace stand out for their high-keyed tonalities. Tiepolo had aligned himself with a tradition whose roots lay in the late Venetian Renaissance, in the art of Tintoretto and Palma Giovane, and whose flowering in the seventeenth century was based on Caravaggism and the subsequent example of the Neapolitan Luca Giordano. In the early eighteenth century, Tiepolo's youthful tenebrist style was but the most modern expression of more than a century and a half of the Venetian pictorial tradition.

Tiepolo lightened his fresco palette during the mid-1720s and early thirties, after Ricci and Pellegrini returned to Venice from several years' stay in northern Europe. He produced several chromatically and luministically splendid works in this medium. In the salon of Palazzo Sandi, Minerva and Mercury swirl through a sky of streaking lights (plate 2), and in the Archbishop's Palace in Udine, Solomon sits in brilliant majesty (plate 5). Both ceilings date to about 1725. During the early 1730s, Tiepolo depicted Phaëthon approaching a blindingly bright Apollo in Palazzo Archinto, Milan (fig. 9), and in the Loschi murals he placed his allegorical figures against pale blue skies. But his oil paintings remained dark. Their shadows are murky, as in The Brazen Serpent (plate 6, fig. 10), and he modeled his forms by applying increasingly dark tones rather than by

brightening the highlights, as he usually did in fresco. Even when he used bright hues and strong lights in an oil painting, for example, The Education of the Virgin (plate 7), the fields of color are restricted, their visual power strongly reduced by gloomy darkness. Rays of light illuminate only isolated areas.

Beginning about 1733–34, Tiepolo began to alter radically the relationship in his oil paintings between light and shadow, and between bright color and darkness. Here he was affected by Veronese's art, by the popularity of Ricci's and Pellegrini's paintings, and by his own experience in fresco. He may also have looked at Antonio Canaletto's bright views of Venice dating from about 1730. It may well have been, however, the creamy ivories and bright beiges of Piazzetta's new "blond" style of the mid-1730s — in his The Assumption of the Virgin (Musée du Louvre, Paris), Sts. Vincent Ferrer, Hyacinth, and Ludovico Bertrando (S. Maria del Rosario, Venice), and Rebecca at the Well (Pinacoteca di Brera, Milan) — that finally persuaded Tiepolo to alter his palette. Through much of his long career, he felt challenged by Piazzetta's art, which was the only contemporary work visible in the city that could rival his for its grand breadth of composition and its dramatic fervor. In his early oil painting The Martyrdom of St. Bartholomew of about 1723 (plate 1) and several other paintings, Tiepolo took compositional ideas, motifs, and even tonality from his older colleague. Clearly, Piazzetta's art played a crucial role in the younger Giambattista's decision to change his style.

By 1736, Tiepolo had developed a bright colorism in his art that expressed a totally different kind of intensity from the turbulence of his first style. In 1734, exactly contemporary with the Loschi commission, he produced a great altarpiece for the church of the Ognissanti in Rovetta, a small town in the hills above Bergamo (plate 9). In it, color is vibrant and overpowers all shadows, producing chromatic richness and pictorial vibrancy. The silvery figure of the Virgin Mary soars into a gold empyrean high above figures robed in bright reds, yellows, pinks, and blues. His other sacred images of the later 1730s likewise communicate a sense of effulgent victory rather than offering parishioners the quiet meditation of earlier altar paintings like The Education of the Virgin (plate 7). Tiepolo expands his pictorial space in these later works, too. In St. Clement Adoring the Trinity (plate 12), his brilliant draftsmanship and powerful composition express Clement's deep yearning for the Deity; in the ceiling frescoes in S. Maria del Rosario (plates 13, 14), they portray Mary's eternal majesty; and in the S. Alvise triptych (plate 15, fig. 12), they convey Christ's overwhelming suffering on earth.

12. Giambattista Tiepolo. *The Crowning with Thorns*; *The Way to Calvary*; *The Flagellation*. c. 1739. Oil on canvas, 14′9″ × 4′5⅛″ (4.5 × 1.35 m); 14′9″ × 17′ (4.5 × 5.17 m); 14′9″ × 6′4⅜″ (4.50 × 1.94 cm). S. Alvise, Venice

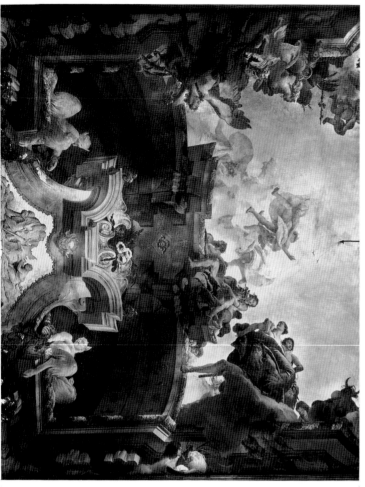
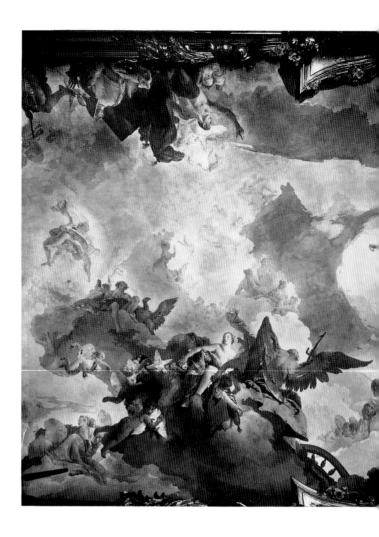
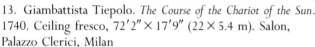

13. Giambattista Tiepolo. *The Course of the Chariot of the Sun*. 1740. Ceiling fresco, 72′2″ × 17′9″ (22 × 5.4 m). Salon, Palazzo Clerici, Milan

The success of Tiepolo's religious art in no way eclipsed that of his secular imagery. As he completed the solemn *Immaculate Conception* for a Franciscan church in Vicenza (plate 10), he sold a sensual and comical *Jupiter and Danaë* (plate 11) to Count Tessin, the Swedish nobleman who had brought the king of Sweden's invitation to paint in the Royal Palace. Tiepolo's Jupiter, undressed and undecorously perched on a cloud while secretly entering Danaë's closed tower, leers at the youthful sleeping princess. In the altarpiece for the archbishop-elector of Cologne (plate 12), he used the same male with an identically hooked nose for the all-forgiving God the Father, who peers down on the beseeching St. Clement. Not one contemporary painter in all of Europe could communicate as successfully as Tiepolo both the carnality of the ancient gods, and the overpowering miracle of the Christian Deity appearing before mankind.

Count Tessin's decision not to fulfill Tiepolo's demands in 1736 was Sweden's loss, but a number of north Italian aristocrats and wealthy professionals did come to terms with the painter when they sought to embellish their homes during the next decade. Throughout the forties, he executed more than a half-dozen grand decorative cycles in urban palaces and country villas in addition to producing religious works. He painted the ceiling of the salon in Palazzo Clerici in Milan in 1740 (plate 16, fig. 13); decorated the hall of Villa Cordellina, in Montecchio Maggiore outside Vicenza, in 1743–44 (plate 23, fig. 14); also in those years, he painted a ceiling in Palazzo Giusti del Giardino in Venice; and in about 1745, he decorated two rooms in Palazzo Barbaro and frescoed the salon in Palazzo Labia (plates 24, 25, fig. 15), both Venetian projects. In the second half of the decade, he decorated a hall in Villa Contarini in Mira, between Padua and Venice, and painted a ceiling for Palazzo Vecchia in Vicenza. While engaged on these secular projects, Tiepolo frescoed the ceiling in S. Maria di Nazareth, the church of the Scalzi (plates 21, 22, fig. 16), and completed nine canvases for the ceiling

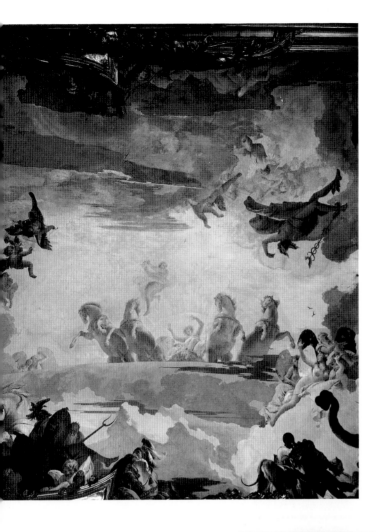

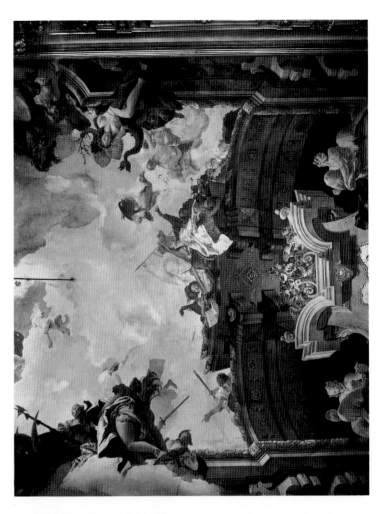

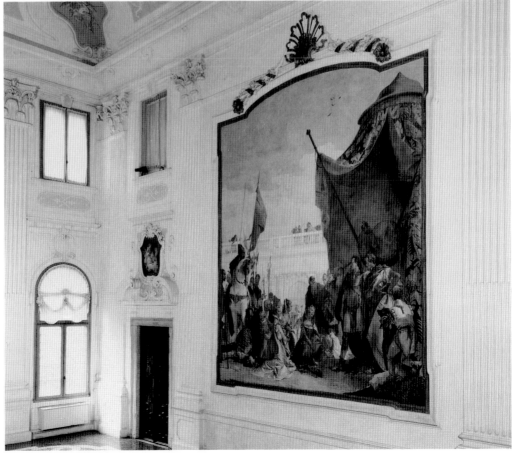

14. Giambattista Tiepolo.
*The Family of Darius Before
Alexander*. 1743–44.
Wall fresco,
16 × 18′ (4.9 × 5.5 m).
Salon, Villa Cordellina,
Montecchio Maggiore
(province of Vicenza)

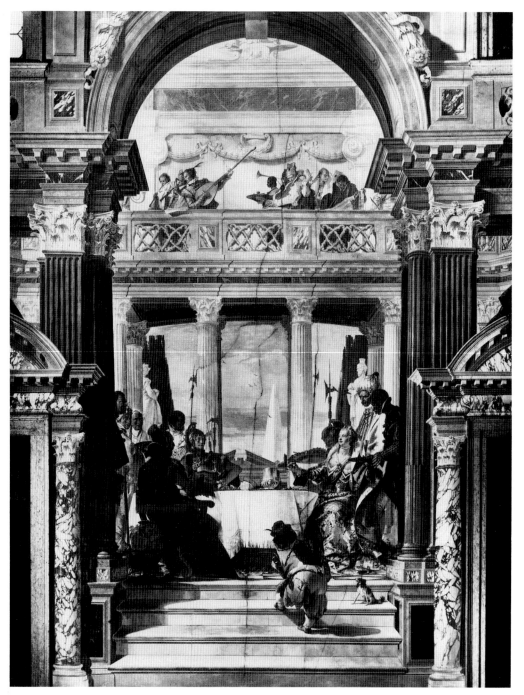

15. Giambattista Tiepolo. *The Banquet of Anthony and Cleopatra*. c. 1744–47. Wall fresco, 21′4″ × 9′10″ (6.5 × 3 m). Salon, Palazzo Labia, Venice

of the chapter room in the Scuola Grande dei Carmini, a Carmelite lay confraternity (plate 29).

How did Tiepolo complete all of these immense decorative projects within one decade? Now over forty years of age, he certainly needed good health to sustain the daily climb up scaffolding and the long, uncomfortable hours spent in cramped quarters under a ceiling. He had to have, too, a studio or at least several assistants to help in the preparation and execution of the frescoes. Part of Tiepolo's preparation consisted of making drawings, and he and his studio produced thousands of them. Today more than three thousand "Tiepolo" drawings exist in museums and private collections throughout the world. Although the number is enormous, the categories comprising these sheets are really only two: pen or wash on light paper over an underdrawing in chalk or pencil (figs. 17–19), and chalk on blue paper heightened with white.[18] In producing the drawings, he made compositional or figural studies, copying from life or from well-known works of art, or calling on his own fertile imagination. He also made many sheets as finished works of art to be sold.

The life drawings in particular came to constitute a repertory of pictorial ideas. One study that helped Tiepolo in the creation of an early masterpiece shows nude youths in various positions overlapping each other

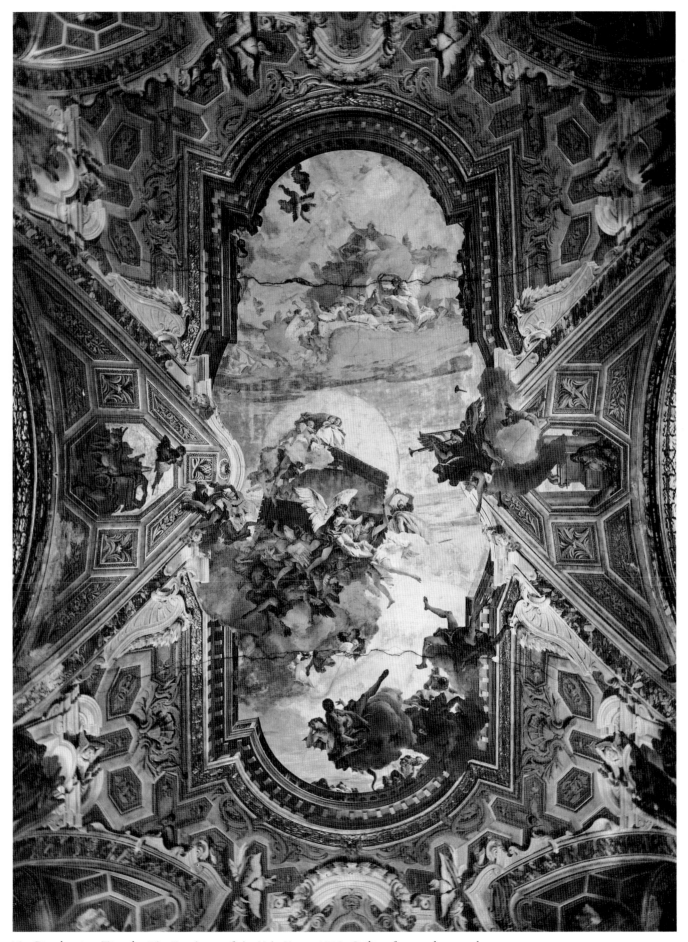

16. Giambattista Tiepolo. *The Translation of the Holy House.* 1745. Ceiling fresco; destroyed.
Formerly in S. Maria di Nazareth, Church of the Scalzi, Venice

on the sheet, their shadows boldly created by broad hatching of the pen (fig. 18). The most complete figure in the mass tilts dizzyingly in space, his outstretched limbs dislocated in the air and his torso placed at a forty-five-degree angle to the sheet's borders. Based on figures in Tintoretto's *The Brazen Serpent* in the Scuola Grande di S. Rocco, the form metamorphosed into the martyred St. Bartholomew in Tiepolo's canvas of about 1722–23 for the church of S. Stae (plate 1). A contemporary sheet with female nudes was done in wash over pencil heightened with white on buff paper (fig. 19). These soft, passive figures are very different from the tense forms in the other drawing; the shadows are rendered differently, too, covering the figures in curvilinear patterns rather than in sharp, angular disjunctions. Tiepolo set washes of varying intensities against the lightness of the paper, producing shadows that

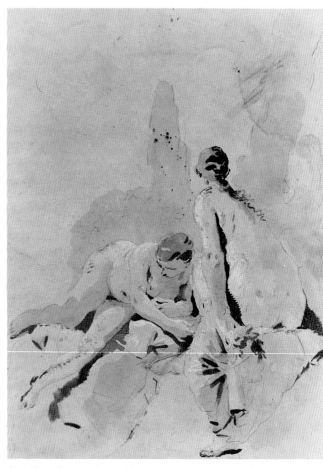

19. Giambattista Tiepolo. *Two Nude Women*. n.d. Bistre wash over pencil, heightened with white, on light paper, 12⅜ × 8⅝″ (31.4 × 22 cm). Victoria and Albert Museum, London

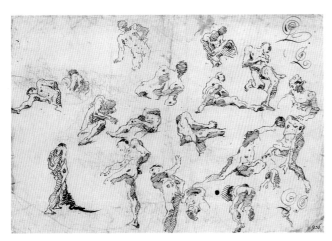

17. Giambattista Tiepolo. *Figure Studies*. n.d. Pen and black ink on light paper, 8¾ × 13⅛″ (22.2 × 33.5 cm). Wallraf-Richartz Museum, Cologne

18. Giambattista Tiepolo. *Figure Studies*. n.d. Pen on light paper, 5⅝ × 7¼″ (14.4 × 18.5 cm). Victoria and Albert Museum, London

range from dark to transparent to gossamer and thereby creating atmosphere that magically envelops the nudes.

The two drawings, one a tangle of ideas and the other an organized grouping, differ from the preparatory composition in which Tiepolo mixed different media and styles. For the early Burano *Crucifixion* (fig. 4), for example, Tiepolo produced a sheet in whose center he very lightly sketched in pencil the essential element, the crucified Christ (fig. 20). On the right-hand side, using pen and deep-toned washes, he represented one of the thieves punished with Christ, Christ's mourning family and friends, and a mounted soldier. He provided no balancing equivalent on the left, however. The result is a lopsided composition of unbalanced values. Tiepolo astutely corrected this on the canvas, adding a mounted centurion on the left and surrounding Christ with figures who are depicted with either strong color or gesture. Seeking contrast, he placed grieving and passive witnesses on the right while representing faceless but strenuously active executioners on the left.

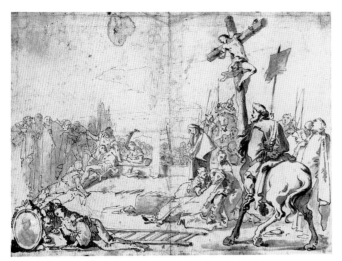

20. Giambattista Tiepolo. *Study for "The Crucifixion."* n.d. Pen and brown wash with pencil on light paper, 15⅛ × 21⅛″ (38.5 × 53.7 cm). Tiroler Landesmuseum Ferdinandeum, Innsbruck

Tiepolo's creation of the six wall and three ceiling frescoes and the two illusionistic wall-statues in Villa Loschi in 1734 was completely different from his groping development toward the Burano *Crucifixion* fifteen years earlier. Now a mature artist, Tiepolo found his way more quickly to satisfactory solutions. The Loschi frescoes follow very closely the many preparatory drawings that survive today, indicating that the artist simply copied the ideas he had first visualized in pen and wash. He thus greatly expedited his work for Count Loschi, an important consideration given that he had to work "day and night without a break."[19] *Honor Crowned by Virtue* (fig. 11), for instance, follows its drawing (fig. 21) almost exactly, even down to the brief notation of a distant mountain range in the bottom left corner. The positions of the figures, their drapery folds, and several of their attributes are already so fully delineated in the drawing that the artist could easily transfer the scene from one medium to the other. Although the frescoes lack the spontaneity of the drawings, their clarity is unquestionable; Tiepolo had merely refined his image.

In addition to preparatory drawings, Tiepolo relied on small oil sketches, too, sometimes two or three of them for one project. Many of these very beautiful pictorial "thoughts" have fortunately come down to us. One impressive project from his mature years for which many drawings and an oil sketch are extant is the ceiling in the salon of Palazzo Clerici in Milan (plate 16, figs. 13, 22–24). The fresco was commissioned by Antonio Clerici, who had inherited the family palace in 1736 and who, after an eight-year engagement, married a member of the powerful Visconti family in 1741.[20] It was painted in 1740, probably to celebrate Antonio's

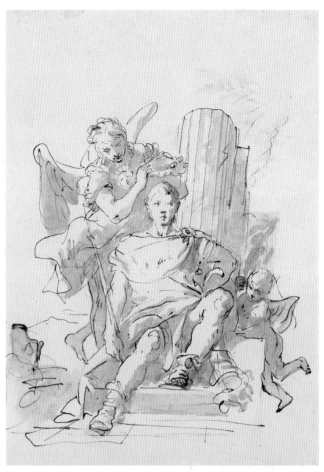

21. Giambattista Tiepolo. *Study for "Honor Crowned by Virtue."* c. 1734. Pen and wash over pencil on light paper, 12⅜ × 8½″ (31.5 × 21.6 cm). Victoria and Albert Museum, London

imminent wedding with Fulvia. The ceiling depicts a refulgent Venus in an airy, brightly lit sky. The Clerici fresco would thus appear to be an epithalamic celebration, and Tiepolo would create this type of work again later in his career.

He had also produced such an image before, in Palazzo Archinto in Milan in 1731.[21] The Archinto *Phaëthon Asking Apollo for the Chariot of the Sun* (fig. 9) is related to the Clerici fresco in several ways, most obviously by the presence of the same protagonist, Apollo. In Palazzo Archinto, Tiepolo depicted the Sun God with his left arm raised at the crest of a mass of figures who turn their bodies or gazes toward him. A similar pattern reappears in an oil sketch that has traditionally been associated with the Clerici fresco (fig. 22).[22] In the center of the sketch, Apollo appears in white hovering in a golden empyrean; his right arm reaches outward toward mythological and allegorical figures who rest on cloud banks and toward others who spill over an illusionistic cornice. In both works, Apollo is the center and the apex of the compositional groupings.

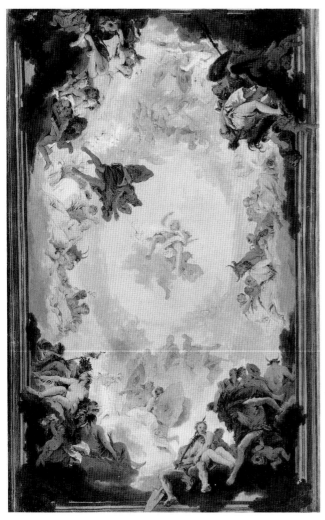

22. Giambattista Tiepolo. *Oil Sketch for "The Course of the Chariot of the Sun."* c. 1737–40. Oil on canvas, 39 × 25″ (99.1 × 63.5 cm) unframed. Kimbell Art Museum, Fort Worth, Texas

Another link between the Archinto ceiling and the oil sketch is that, in both instances, Tiepolo cleverly took into account the fact that the Sun God would be seen upside down when visitors entered the hall. That is, in the Archinto fresco, the painter placed the shadowed figure of Father Time, his wings and scythe boldly extending his form, so that he seems to swoop down toward the brilliantly lit Apollo. Tiepolo focuses our gaze on him and forces us to turn in space to see the Sun God correctly. In the oil sketch, the darkened figures of Flora and Zephyr likewise fly toward the radiant god, directing the viewer's attention to him and tightening the airy composition. Given these similarities, one might even suspect that the sketch was preparatory to the Archinto fresco; but the bold illusionism of the cornice in the sketch and Tiepolo's great exploration of heavenly space beyond the cornice demonstrate that the sketch originated in a later, more mature period of the artist's development.

That Tiepolo moved from the Archinto fresco to the oil sketch is suggested by circumstantial as well as pictorial evidence. Antonio Clerici must have seen Tiepolo's frescoes in Palazzo Archinto often during the 1730s; his mother, Maria Archinto, was the daughter of Carlo Archinto, for whom Tiepolo had worked in 1730–31. When Tiepolo returned in 1737 to paint frescoes in Milan again, in the church of Sant'Ambrogio, he more than likely heard that Carlo's grandson, Antonio, had inherited his paternal family palace in 1736 and that he was engaged to Fulvia Visconti. Antonio, finding that the Venetian painter was once more in the city, no doubt seized the opportunity to commit him to the decoration of a public room in the Clerici palace exactly as his grandfather, Carlo Archinto, had done seven years earlier. Although Clerici may not have decided which room in his new home should have its ceiling frescoed, patron and painter perhaps agreed that Apollo would once again reign in the heavens. Tiepolo promised an oil sketch for the proposed ceiling.

The sketch fits convincingly into such a chain of events. It was a *primo pensiero*, or first thought, for a yet undetermined location. When the date of the Clerici-Visconti nuptials was set, Antonio must have insisted that Tiepolo return to Milan and execute his fresco for the imminent wedding celebrations. A specific room in the palace would have been chosen, and Tiepolo would have had to adapt his first idea to the room's specific proportions. He responded to the length of the salon by creating a more dynamic compositional surge than he had originally envisioned in the sketch. Groups now dart in zigzagging courses and move on diagonal axes across the space rather than merely sitting in formations that follow the painting's rectangular format. Furthermore, he found it necessary, given the room's shallow height, to alter the viewer's perception of both the breadth and depth of the illusionistic sky. Thus, at the two short ends of the room, above the real cornice, he projected fictive architectural moldings that fill in the area of the springing of the vault, thereby restricting the span of the heavens and illusionistically pushing the sky further upward. The onlooker's gaze is shifted toward the center of the ceiling. Notwithstanding these modifications, which were clever responses to the dimensions of the salon, Tiepolo changed the groupings at the four corners of the oil sketch very little, merely redirecting many of the figures so that, like the viewer below, they focus on the heavens.

Tiepolo must have also decided to modify the sketch's program to suit the upcoming Clerici-Visconti marriage. Apollo, who was the controlling force in the oil sketch, lost his role as sole protagonist and was

23. Giambattista Tiepolo. *Study for the Figure of Time.* c. 1740. Pen and brown ink, pale and dark brown wash over black chalk, 10 × 12¾″ (25.6 × 32.2 cm). The Metropolitan Museum of Art, New York. Rogers Fund, 1937 (37.165.7)

24. Giambattista Tiepolo. *Study for the Figure of Time.* c. 1740. Pen and brown ink, brown wash, over black chalk, 10½ × 12⅜″ (26.8 × 31.5 cm). The Pierpont Morgan Library, New York, IV, 125

moved to one side; from this point he comes charging toward the viewer in a quadriga. In the center of the fresco, three putti—one with a bow, one with a torch, and one with a rose—tumble and cavort. The references to love and marriage culminate in the inclusion of Venus herself, who is indeed now the other protagonist of the scene. She reigns in an airy world glowing with the morning sun, which seemingly emanates from behind Apollo but in reality enters the room through a set of windows. Venus is the first of a new kind of Tiepolo heroine, one who poses motionless within a whirlwind of compositional activity. She extends one of her hands

into space and daintily holds a white rose; one of her legs anchors her solidly on a cloud; a cloak of gold brocade enfolds her; and a rose-colored drapery flutters up and around her head. Although she is immobile, the positioning of her limbs and the treatment of her clothing give the impression that she is moving. All the while, she looks fixedly upon us, the ceiling's sole figure to do so. Standing below the Clerici fresco today, the visitor is overwhelmed by the artist's varied inventions. But Tiepolo's vast undertakings only began with this ceiling and with the Gesuati frescoes that he had finished just before, in October 1739 (plates 13, 14).

In December of that year, only two months after completing the Gesuati ceiling and just before working in Palazzo Clerici, the Scuola Grande dei Carmini in Venice, a lay confraternity whose members were dedicated to the Virgin and the cult of her scapular, asked Tiepolo to decorate the ceiling of their chapter room. Already boasting *The Assumption of the Virgin* by Padovanino in its center, the ceiling needed only lateral canvases to be completed. In offering the commission to Tiepolo, the confraternity must have been thinking of earlier Venetian ceilings such as that by Palma Giovane and Leonardo Corona in the church of S. Zulian, in which a central canvas depicting the saint's apotheosis was surrounded at its sides and corners by others showing Virtues, as in figure 25. Tiepolo refused the Scuola's offer, however, explaining to its members that a painter drew his ideas for laterals from the ceiling's central work and that in Padovanino's painting there was no allusion to the confraternity's titular saint, the Virgin of Carmel.[23] One month later the confraternity returned to Tiepolo, asking him to paint a new central canvas as well as the eight laterals already requested. Tiepolo accepted. The laterals were unveiled in 1743, but the central canvas, which depicted the Virgin and Child with Simon Stock, was not completed until 1749 (plate 29). The incident reveals not only the respect Tiepolo's opinion commanded in the lay community but also his own sensitivity to religious imagery and the way in which it should reflect Post-Tridentine devotions. The Scuola's response to Tiepolo's ceiling was to elect him one of its members.

Tiepolo's grandest religious image of the decade, and indeed of his long career, was *The Translation of the Holy House* (fig. 16), frescoed on the ceiling of S. Maria di Nazareth, the church of the Scalzi, or Discalced Carmelites. Tiepolo produced two oil sketches (plates 21, 22) before starting work in April 1745. He finished that November. The ceiling and much of the church were destroyed on October 28, 1915, by Austrian bombs meant for the adjacent railway station.

25. Palma Giovane. *S. Giuliano in Glory*. 1588–89. Oil on canvas, central canvas 19′8¼″ × 19′8¼″ (6 × 6 m). S. Zulian, Venice

Begun in the 1650s, the Scalzi was designed by Baldassare Longhena, Venice's greatest architect of the seventeenth century. Its facade was designed by Giuseppe Sardi in the 1670s. The church was finally consecrated in 1705.[24] Several elegant tabernacles ornament the interior, but the largest and most elaborate stands behind the main altar, dominating the entire hall. Designed by Giuseppe Pozzo, the tabernacle is a great scenographic confection. It boasts eight twisting columns, four on either side of a central opening, all made from deep purple marble and sitting on bases extending across the width of the presbytery. The columns support a structure whose remarkable elevation consists of two arching pediments, a higher concave attic story, and a still higher rising trapezoid. Two elegant scrolls

rest at the very top. The tabernacle's lavish color and ornate shapes are present throughout the Scalzi's interior, "which for sheer variety and range of coloristic effect is unsurpassed in Venice, except by the decorative complexities of San Marco itself."[25]

The richness of the Scalzi's interior is important to remember, because Tiepolo had to conceive his fresco in terms of that splendor and grandeur. The painting simply cannot be understood without taking its elaborate architectural surroundings into consideration. Tiepolo responded to these conditions by calling in as collaborator Girolamo Mengozzi-Colonna, the Bolognese specialist in illusionistic architectural painting who had worked with him in the Archbishop's Palace in Udine and who was then assisting in the frescoes in

32

Palazzo Labia. As in the Gesuati and many other Venetian churches, the Scalzi's foundations and supports could not hold a stone or brick vaulting system, so that a wooden armature feigning such a structure was built and covered with plaster.[26] Mengozzi-Colonna painted a bold, fictive framework that belies the church's false vault. Along the two long flanks of the hall, he gave the flat surface plasticity by painting interlocking polygonal coffers. He fashioned four great tabernacles—two on either of the ceiling's long sides—to add to the impression of depth and massiveness. At the center, he illusionistically opened this immense architectural crown, surrounding the opening with a fictive molding whose own weight is emphasized by a series of corbels, balusters, and railings. In the midst of Mengozzi-Colonna's impressive architecture, Tiepolo represented the flight of the Virgin's Holy House toward the West after the Saracen invasion of the Holy Land.

The years between 1740 and 1745, the period encompassing the Clerici and Scalzi projects, must have been among the busiest of Tiepolo's entire career. During that time he completed or was working on an imposing number of large canvases and frescoes: the eight lateral canvases for the Scuola dei Carmini; two enormous canvases for the church of S. Lorenzo in Verolanuova, near Brescia (plate 17, figs. 26, 27); a series of eight canvases illustrating episodes from Torquato Tasso's *Gerusalemme liberata* for a room in an unidentified Venetian palace (plate 18); a ceiling painting showing Mars and Venus in Palazzo Pisani-Moretta; the frescoes in the salon of Villa Cordellina at Montecchio Maggiore, outside Vicenza (plate 23, fig. 14); several paintings for the court of Augustus III in Dresden; and a pair of paintings for Empress Elizabeth's Summer Palace outside St. Petersburg.[27] More than likely he painted the salon of Palazzo Labia (plates 24, 25, fig. 15) during this period; in 1745, he completed the immense *Martyrdom of St. John, Bishop of Bergamo* for the cathedral in Bergamo (plate 26), and he painted monochrome frescoes in the Sagredo Chapel in S. Francesco della Vigna, Venice.[28] He found time for several smaller projects as well. In spite of this furious pace, his art did not diminish in quality but reached new heights. In March 1746 he celebrated his fiftieth birthday.

Three years earlier, Tiepolo had met Francesco Algarotti, one of the century's most beguiling luminaries. Algarotti was born into the family of a well-to-do merchant in Venice in 1712 and had a classical education in Venice, Rome, and Bologna. He was also well versed in the modern sciences, having become a dilettante of Isaac Newton's optics. After living in Paris, London, and Berlin and traveling in Russia, Algarotti settled in Dresden where he became friends with Count Heinrich Brühl, minister to Augustus III, king of Poland and elector of Saxony. After currying Brühl's favor, Algarotti was named Augustus's minister of war and sent to Italy in 1743, not to plan military strategy but to purchase paintings for the royal collections of art. Algarotti and Tiepolo met in Venice that year.

Already grand in the Clerici ceiling of 1740, Tiepolo's art became even more so both in scope and scale after he befriended Algarotti. Tiepolo's massive architectural settings in the Cordellina and Labia frescoes, and the small but relevant archaeological details in those works reflect Algarotti's appreciation for both Raphael and Poussin and his erudite, if at times suspiciously modish, taste for the antique.[29] It is to Tiepolo's credit, however, that he never sacrificed drama and sentiment, nor his exquisite color—the perfume of his art—to Algarotti's antiquarianism. The subject matter of the paintings Tiepolo executed under Algarotti's aegis (plate 19) may smack of artful contrivance, but that is the fault of the learned patron, not the failure of the artist.

In the midst of the intense activity of 1740–45, Tiepolo found time to publish the *Capricci*, a series of ten etchings.[30] They were not his first venture into the world of prints; he had contributed drawings for four prints in Lovisa's publication of *Il gran teatro di Venezia . . .* just before 1720, and he had done the same for Maffei's *Verona illustrata*, which was published in 1732 but prepared a few years earlier. Throughout the 1730s, he continued to make drawings for frontispieces for such varied publications as Francesco Mediobarbo's *Imperatorum Romanorum Numismata a Pompejo Magno . . .*, published in 1730, Gian Alberto Tumermani's 1737 edition of Battista Guarini's *Il Pastor Fido*, and Giovanni Poleni's *Ultriusque Thesauri Antiquitatum Romanarum Graecarumque . . .* of the same year.[31]

Although an independent foray into the print medium (that is, made for himself and not for another publication), the *Capricci* may not have been his first. Scholars have debated the question whether the *Capricci* were preceded by Tiepolo's only other series of etchings, the *Scherzi di fantasia* (fig. 28).[32] The themes in both series are very similar, emphasizing death, decay, and deformity versus the life-giving forces of youth, beauty, and nature. In both sets, magic and knowledge appear to offer answers to the imponderable. Mystery prevails, however, and the riddles posed both to those within the prints and to the audience remain unsolved. However, the use of line in the two sets is quite different, the *Capricci* being the more loosely conceived of the two, that is, more "wind-swept" in appearance. If one relies on

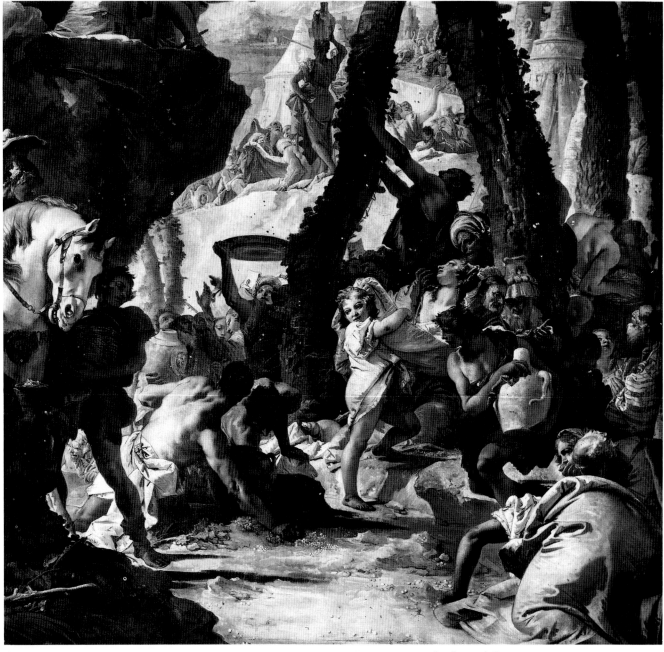

26. Giambattista Tiepolo. *The Fall of Manna* (detail). c. 1740–43. Oil on canvas, 32′10″ × 17′3″ (10 × 5.25 m). S. Lorenzo, Verolanuova (province of Brescia)

the development of Tiepolo's brushwork as a basis for arguing the etchings' dating, then the more painterly *Capricci* must have been produced after the *Scherzi*. But manipulating the burin and controlling the biting of a copper plate are not the same maneuvers as applying oil to canvas. Until further evidence arguing decisively one way or another is found, it can be assumed that the two series are approximately contemporary.

Situating Tiepolo's etchings in the early to mid-1740s makes perfect sense when one considers the medium's general popularity in Venice at the time and the contemporary etchings by other Venetian painters, such as Michele Marieschi, Canaletto, and Giambattista

Piranesi. The dating of Tiepolo's prints should be viewed, too, in terms of his paintings of the period. The etchings' repertory of ruined architectural monuments, ancient soldiers, orientalizing patriarchs, seminude females, satyrs, antique altars and urns, human and animal skulls, writhing serpents, owls, trumpets, and torches appears as well in his painted oeuvre of about 1740–43. For example, although used to very different effect, helmets, armor, swords, and tambourines fill the S. Alvise triptych (plate 15, fig. 12) and the two canvases in Verolanuova (plate 17, fig. 26). In addition, the same confrontation between Roman soldiers and orientalizing elders in some of the prints occurs in the three parts

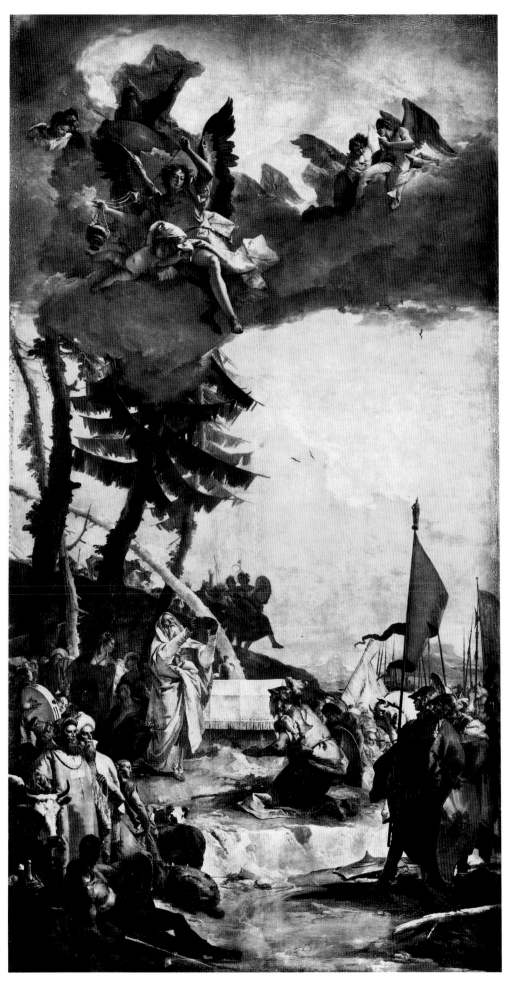

27. Giambattista Tiepolo.
The Sacrifice of Melchizedek.
c. 1740–43. Oil on canvas,
32'10" × 17'3" (10 × 5.25 m).
S. Lorenzo, Verolanuova
(province of Brescia)

28. Giambattista Tiepolo. *Two Philosophers and a Youth*. Vesme edition, 1906, 34 i/ii. Etching reworked in pen and brown ink, 5½ × 7⅜″ (14 × 18.8 cm). The National Gallery of Art, Washington, D.C. Rosenwald Collection

of the triptych and in the Verolanuova *Sacrifice of Melchisedek*, where the Romans and elders observe quietly from the sides and rear as if aware of the deeper significance of the events taking place. In both the prints and the paintings, faces are arranged in tightly knit rows, old versus young, bearded against clean-shaven, male with female. Many of the physiognomies in the prints are identical to those in the Verolanuova canvases, and urns abound in the *Fall of Manna* as they do in the etchings.[33] Finally, one element undeniably linking the etchings to the Verolanuova canvases is the thematic concentration on sacrifice before an altar.

Tiepolo's treatment of space and landscape further unites the prints with the Verolanuova paintings. Still closer to the etchings' settings are those in the Tasso canvases (plate 18), which can be dated to about 1742. It has been noted "that the world of sorcery and magic [the prints] illustrate may derive, in some degree, from a close reading of Tasso's epic poem [the *Gerusalemme liberata*] . . . , the course of [whose] events is constantly influenced by good and bad magicians, by malevolent or benevolent sorceresses."[34] Scholars' suggestions regarding the presence of specific philosophers in several of the prints are convincing, as is the argument that the prints themselves refer to Gnosticism.[35] But apart from their fascinating imagery, the etchings are significant because they show that rather than simply rest on his laurels as he neared age fifty, Tiepolo kept current with contemporary artistic practice. Just as he renewed his painting through the learned Algarotti's antiquar-

ianism, so he also tried his hand independently at the print medium, achieving in it images of singular beauty.

Tiepolo's involvement with secular themes in the 1740s was complemented by the number of great altarpieces he completed during the same decade. He had begun his career thirty years earlier as a painter of religious works — the *Crossing of the Red Sea*, the *Assumption* fresco (fig. 2), the *Glory of St. Lucy* fresco, and others (see page 8) — but none of these decorated an altar. Nor had Tiepolo painted a grand altarpiece before 1730. But very few commissions for them arose in Venice during the 1720s, and those that did went to painters all older than Tiepolo — Ricci, Piazzetta, and Pittoni. Why Europe's greatest religious artist of the century had to wait until nearly age thirty-five before being asked to adorn an altar in his native city is a difficult question to answer.[36]

By 1736, however, Tiepolo had completed a number of such commissions: *The Education of the Virgin* for the new church of the Fava (plate 7); *The Adoration of the Christ Child*, first exhibited during the Christmas season of 1732–33 in the church of S. Zulian but now in the Sacristy of the Canons in S. Marco; and the delicate *Vision of S. Gaetano* for the family chapel in Palazzo Labia. Outside Venice, he produced *The Christ Child with Sts. Joseph, Anne, and Francis of Paola* for the Benedictine convent of S. Prosdocimo in Padua, *The Virgin in Glory with Saints* in Rovetta (plate 9), and *The Immaculate Conception* for the Franciscan convent-church of the Aracoeli in Vicenza (plate 10). These paintings not only

reveal the wide spectrum of his patronage and the emotional range of his art, but they also demonstrate the variety of his solutions for portraying saints. In all the earthly scenes, Tiepolo created shallow three-dimensional space by employing monumental, architectural backgrounds. Events take place in these spatially tangible settings, and the occurrence of a strong vertical element—either a column or pilaster—determines the placement of a male protagonist. After about 1735, Tiepolo deepened his space; the shallow platforms give way to more open areas, as in *St. Clement Adoring the Trinity* (plate 12). At this time he also brightened his palette.

In his altarpieces of the 1740s, Tiepolo maintained the bright palette and monumentalizing architecture of his works of the late thirties. Light pours over high-keyed color, and great architectural members carefully plot out space, both in enormous paintings like the dramatic *Martyrdom of St. John, Bishop of Bergamo* (plate 26) and in the diminutive and contemplative *Last Communion of St. Lucy* (plate 28). What differentiates the altarpieces of the forties from those of the thirties is Tiepolo's new concentration on a protagonist who is brought up close to the foreground of the picture. The device creates great personal drama and focuses our attention on gesture: St. John, open-armed, conveys his willingness to accept the martyrdom about to befall him, and St. Lucy, arms folded humbly across her chest, awaits last communion and imminent death, which Tiepolo indicated by the dagger lying directly before her.

Tiepolo's ability to portray profound Christian dedication with elegant forms and rich brushwork is apparent in his altarpiece of *Sts. Maximus and Oswald* (fig. 29). Datable to about 1745, this large canvas was executed for the high altar of the tiny church of S. Massimo in Padua; as part of the commission, Tiepolo painted the smaller *St. John the Baptist* for the church's left altar and *The Rest on the Flight into Egypt* for the right. Maximus, second bishop of Padua, and Oswald, king of Northumbria, are depicted in a hallway defined by several structures, one of which is ornamented with a niche figure of Faith. The saints' palpable presence is achieved in part by their position in the foreground. It is further conveyed by the tangibility of Oswald's crown, scepter, and medallion, by the lusciously painted censer sitting in the foreground to the right of an acolyte's leg, by the realism of St. Maximus's luxurious cope covering a delicately embroidered chasuble, and by the remarkable crozier behind, an example of the extravagant gold and silver work of the Italian Baroque.

Each of the two saints experiences Christian revelation differently. Maximus appears to be meditating,

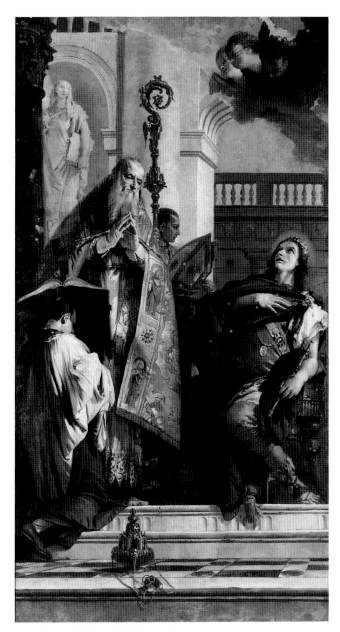

29. Giambattista Tiepolo. *Sts. Maximus and Oswald.* c. 1742–45. Oil on canvas, 12′2″ × 6′7″ (3.7 × 2 m). S. Massimo, Padua

while Oswald responds externally—his face is overwhelmed by a vision and his body shifts. The two contrast in every way—the elderly, bearded man of the Church stands while the youthful, clean-shaven, king sits on his throne. Their faces and differing attitudes create a more deeply moving image in the small church than any photograph can convey.

By the end of the 1740s, Tiepolo had worked for his city's oldest aristocracy, received commissions from many new patricians, painted altarpieces for recently built churches and for ones whose structures were centuries old. He had worked outside Venice, both in urban Milan and in provincial centers, and sent paintings abroad, as far away as Cologne, Dresden, and

London. His private life must have been equally fulfilling. He and Cecilia had had nine children, and in 1747 they moved their large family from near S. Silvestro, close to one end of the Rialto Bridge, to the other side of the Grand Canal, to a larger house in the district of Cannaregio near the church of S. Fosca. His eldest son, Giovanni Domenico, turned twenty in 1747. As if in celebration of that milestone birthday, Giandomenico produced what seem to be his first completely independent works, the fourteen canvases depicting the Stations of the Cross for the Oratory of the Crucifix at the church of S. Polo.[37] Very different from his father's heroic images, these works portray Christ's sufferings in a realistic world. The paintings must have enjoyed a notable success because they were published as a set of etchings two years later. By 1750, the elder Tiepolo could boast not only of his own eminence as an artist but also of his first-born son's successful launching in the same career.

The image of Venice's first painter happily working in his studio, or walking or boating across town to fresco a ceiling, or at home comfortably surrounded by a brood of growing children, did not endure for long. Nor could it have in eighteenth-century Venice. The attractions of foreign courts, the vagaries of local patronage and the shortage of available monies in the city had forced a number of Tiepolo's fellow Venetian painters to seek employment abroad. Only a few years earlier, Canaletto and his nephew, Bernardo Bellotto, had seen the market for urban views dry up because of the War of the Austrian Succession (1740–48), which kept foreigners, who might have wanted their scenes of Venice, from traveling as freely as before. Seeking new clients, Canaletto went to London in 1746 and Bellotto to Dresden in 1747. Even earlier, before 1720, Sebastiano and Marco Ricci had worked in London, as had Pellegrini, who had also operated in Germany, Holland, and Paris. Rosalba Carriera, too, had painted in Paris. The Venetian Piranesi left for Rome in 1740; he returned briefly in 1744 but left the city definitively the next year. Pittoni spent his life mainly in Venice but was forced to send most of his works to the provinces. Piazzetta, on the other hand, was fortunate; his altarpieces decorated Venetian altars, and several private collectors bought from him, but even he had spent a brief time "abroad," in nearby Bologna. Only Tiepolo among them all had been able to build and enjoy his career without once relocating.

In 1750, however, Giambattista received an offer for a monumental commission from faraway Germany. He was invited by the prince-bishop of Würzburg, Karl Philip von Greiffenklau, to fresco the Kaisersaal, or Imperial Hall, in the newly built Archbishop's Palace, which had been principally designed by Balthasar Neumann. The commission's particular circumstances and challenges, different from anything Tiepolo had previously experienced, were so special that they must have eased the fifty-six-year-old painter's apprehensions concerning separation from family and home. The invitation offered him the opportunity to paint three frescoes of imposing size, two on the Kaisersaal walls and one on its ceiling. The Kaisersaal itself was larger than any secular space Tiepolo had worked in before, and its decoration was more lavish than he could possibly have imagined while still in Venice. To help offset the long journey to Franconia and the loneliness of the new world into which he would move, as well as the difficulties of the large commission, Tiepolo took along two assistants, his sons Giandomenico, twenty-three years old, and Lorenzo, age fourteen. Accompanied by a servant, the three left Venice in late 1750 and arrived in Würzburg on December 12. Less than eighteen months later, they had completed the two scenes over the room's cornice — *The Investiture of Bishop Herold* and *The Marriage of the Emperor Frederick and Beatrice of Burgundy* (fig. 30), and the ceiling image, *Apollo Bringing Beatrice of Burgundy to the Seat of the German Empire* (plate 30). This commission, and the ensuing work over the stairwell of the palace (plates 31, 32, figs. 31, 32), came from a man of little personal achievement who had unexpectedly inherited his position through a coincidence of family lineage. Tiepolo produced his greatest frescoes for the prince-bishop of Würzburg; in their scope and beauty they not only overwhelm the viewer but are to be measured among the greatest pictorial ensembles in Western art.

The visitor enters the octagonally shaped Kaisersaal after passing through the stunning Weisser Saal, or White Hall, whose walls and grayish vault were decorated with white stucco designs of exuberant vitality by Antonio Bossi. In contrast to the monochromatic tones there, the Kaisersaal, which overlooks the palace's extensive gardens, is filled with lustrous color; Bossi repeated his restrained scheme of whites and grays and intensified it with golds and roses, which are made brilliant by the light from outside shining through the crystals of six enormous chandeliers and by the many tiny mirrors set within some of the stucco work. For his frescoes Tiepolo chose golds and bright yellows, roses and warm browns, and whites and cerulean silver blues, which enhance and are themselves enhanced by the Kaisersaal's rich coloring.

From the doorways leading in from the Weisser Saal, the visitor sees *The Investiture of Bishop Herold* above the

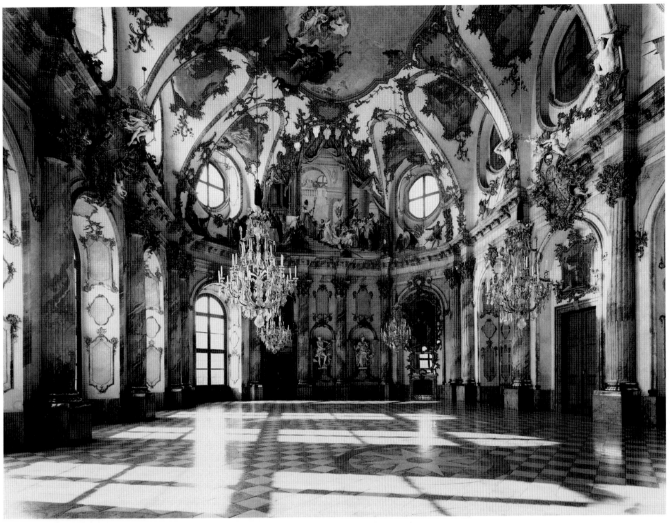

30. Balthasar Neumann. Kaisersaal, Archbishop's Palace, Würzburg, 1719–44, showing Tiepolo's *The Marriage of the Emperor Frederick and Beatrice of Burgundy*, 1751

left cornice, which sits slightly beneath the attic-story windows. The figures are set on a terrace before an architectural screen, and on the right is a hill on which grows a Mediterranean pine. The enthroned Emperor Frederick Barbarossa is conferring secular power onto Bishop Herold, who kneels before him in the exact center of the painting. Frederick's strength and wisdom are clearly indicated by the monumental statues of Hercules and Minerva that flank the brocaded cloth of majesty behind him. In the left foreground, on the lower level of the terrace, kneels a young, blond page, perfectly graceful and beautiful; this figure marks the beginning of a diagonal line that sweeps up to the right, past the bishop and the emperor, and ends at a group of courtiers on the far right.

Tiepolo's *The Marriage of the Emperor Frederick and Beatrice of Burgundy* is in the same position above the cornice as the *Investiture* but on the right side of the Kaisersaal. Together, the two scenes expound Barbarossa's acquisition of an empire through marriage and the secular rights given Bishop Herold by the emperor. Like the *Investiture*, the *Marriage* is also a theatrical re-enactment, taking place in a space beyond the real cornice and behind an illusionistic drapery of gilded stucco inset with mirrors, which is gathered and held up by hovering cherubs.[38] But unlike the *Investiture*'s outdoor setting, that of the *Marriage* is a church interior; further, the giant columns and archway in the *Marriage* create a vertical thrust that contrasts with the horizontal expanse of the terraced scene opposite.

The Bishop's crozier in the *Marriage* underscores the architecture's monumental verticality. The composition's sweep upward to the left, which provides a counterpoint to the *Investiture*'s movement up and to the right, begins in a minor key with a dwarf's walking stick at the bottom right hand corner; the dwarf's figure, straining inward toward the bride and groom, continues the movement, which then passes along Beatrice's extravagant train and up the altar steps, and finally reaches the bishop's arms and the two silver candle-

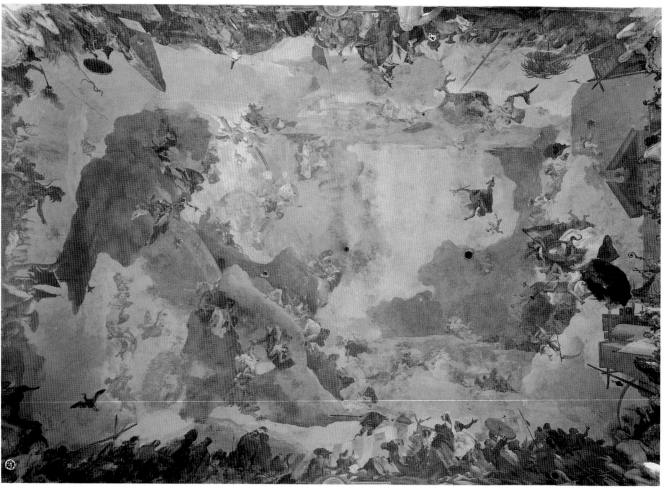

31. Giambattista Tiepolo. *The Allegory of the Four Continents*. 1752–53. Ceiling fresco, 62′4″ × 100′ (19 × 30.5 m). Stairwell, Archbishop's Palace, Würzburg

sticks. The culminating point of this diagonal displays Tiepolo's refined sensibility: showing from behind the stucco curtain are the legs of the crucified Christ — the Savior on the cross is fully revealed just to those in the holy (though fictive) church, not to the visitors in the secular Kaisersaal.

Tiepolo had completed the Kaisersaal ceiling in July 1751, before beginning the wall frescoes, which he finished a year later, on July 8, 1752. But even before the ensemble was concluded, its success was so evident that the bishop invited the painter to remain in Würzburg to fresco the immense ceiling, measuring approximately sixty by one hundred feet, that vaults over the imperial stairwell in the palace. On April 20, 1752, von Greiffenklau visited Tiepolo in his studio and saw a project for this new fresco. Tiepolo's solution for the stairwell rejected other painters' earlier ideas that the grand expanse had to be fragmented into several scenes. He preferred instead one prodigious image, in the center of which Apollo reigns among the gods (plate 32, fig. 31), bringing light and harmony to a world of fact and incident, which is represented by the Four Conti-

nents disposed around the four sides of the ceiling, above the cornice.

The bishop of Würzburg most likely asked Tiepolo to fresco the stairwell ceiling not because of his artistic innovations but rather because he saw that the painter was a supreme decorator able to exploit and overcome oddly shaped, large surfaces. But could he have imagined how brilliantly Tiepolo would fulfill the possibilities of the stairwell ceiling? The problem was not like that in the Kaisersaal, where three separate scenes would be viewed from two principal vantage points, either the doorways or the window wall. Here the challenge was how to paint one continuous surface that would be seen from viewpoints that changed as one moved up through the space as well as across it: partial views from the ground floor, changing sight lines during the walk up the stairway, a one-hundred-and-eighty-degree shift in axis when turning on the mezzanine level, and, finally, a panoramic view of the ceiling from the balcony encircling the stairway's upper level. These were perhaps more complications than the artist could be expected to solve.

Tiepolo responded perfectly to the space. Following his earlier solutions for the ceilings in Palazzo Sandi in Venice (plate 2) and Palazzo Clerici in Milan (fig. 13), he weighted down the stairwell's cornice with figures while opening up the vault with an airy, cloud-filled sky. In the only extant oil sketch for the ceiling, now in the Metropolitan Museum of Art, New York, and probably the very project von Greiffenklau saw in the painter's studio on April 20, 1752, Tiepolo showed Apollo in the center, with representations of Europe and America along the two short sides of the canvas and Africa and Asia on the long sides. The final fresco follows this idea closely, except that Europe and America exchange positions. Tiepolo must have decided on this modification after studying Neumann's architecture. Climbing the staircase, viewers do not see Europe first as the oil sketch suggests, but last, after turning on the landing. With this arrangement, visitors explore the three unknown continents of America, Africa, and Asia while still in the comparative darkness of the ground-floor portico and while ascending the first set of stairs. Arriving on the open landing of the mezzanine level, they see the skies unfold overhead. They then continue up either of two ramps, moving toward the culmination of the ensemble, the continent of Europe (plate 31).

32. Balthasar Neumann. Stairwell, Archbishop's Palace, Würzburg, 1719–44

Once on the upper balcony, guests see as well the group scenes and individual figures arrayed along the cornice. The relationship of these figures to the heavens and Apollo is now fully apparent.

Nothing quite like this image had been depicted before in Italian ceiling painting. The open and expansive composition differs from the Renaissance tradition of segmenting the surface into smaller fields, as in Michelangelo's Sistine Chapel ceiling and Annibale Carracci's Farnese Gallery ceiling, both in Rome, and Veronese's ceiling in S. Sebastiano and Tintoretto's in the Scuola Grande di S. Rocco, both in Venice and both of which were painted in oil on canvas and set into wooden frames. Only Correggio's frescoed dome in the Cathedral of Parma provided a Renaissance prototype of a single, unified image filling a vault, although it was not spatially expansive. Several Baroque artists followed Correggio's masterpiece by tightening space in their ceiling designs, narrowing it so that it appears to funnel toward infinity. Tiepolo did not use the standard device of arraying his forms in concentric circles to achieve this funneling effect. Instead, he employed zigzagging and angular cloud formations to push open the pictorial space, to expand the heavens rather than limit them.

Like the telescope and microscope, both invented in the seventeenth century, the imagery in a Baroque ceiling converges toward a central focus. But Tiepolo's stairwell ceiling in Würzburg expands our vision, dilating space outward. Although its cultural limits are entirely traditional and more narrowly drawn than those in Diderot's contemporary *Encyclopédie* (1751–65), the simultaneity of the two projects must not be overlooked. The painter's purpose, like that of the French philosopher, was all-inclusive, not exclusive.

The three Tiepolos left Würzburg in late 1753, arriving home almost three years to the day after they had departed from Venice. The city they returned to was not visibly different from the one they had left, although the time-honored values of Giambattista's society were slowly being gnawed away. Books from north of the Alps which seriously questioned traditional assumptions about God and State were finding their way into Venetian bookstores, and local theologians began responding to these foreign publications in the early 1750s. In 1751, the age-old patriarchy of Aquileia, whose foundation was credited to St. Mark and whose resident bishop had been chosen from the Venetian aristocracy for centuries, was disbanded. Then, on April 29, 1754, Piazzetta died. The thoughts of the fifty-eight-year-old Tiepolo regarding the events and changing values of his time and his reactions to the death of his eminent colleague are unknown. But what others

felt toward Giambattista himself while he was absent from Venice are known to us.

In the *Abecedario pittorico*, a biography of painters published in 1753 before Tiepolo's return home, the author wrote that "... as [Tiepolo's] ability and strength grow from day to day, so does the desire on the part of connoisseurs and amateurs to have his paintings; and so that he may satisfy that desire, it is to be hoped that the bestower of every good thing will allow him a long and prosperous life."[39] Furthermore, "work on the interior decoration of the Church of the Pietà, suspended between September 1751 and early 1754, may have been held up specifically in order to await Tiepolo's return [from Würzburg]."[40] After Christmas of 1753, Tiepolo took up not only the Pietà commission but many others as well.

Between April 1754 and Christmas of 1759, Tiepolo completed six important altarpieces, five for churches in the provinces and one for his native city. In the majority of these works, he increased the amount of space around each protagonist and reduced the importance of the setting, surely a result of his work in the Würzburg frescoes. Part of the emotional force of *The Virgin and Child Appearing to St. John Nepomuk* (plate 34) derives from the heavy, dense atmosphere that envelops the figures, and in *St. Thecla Liberating Este from the Plague* (plate 36), from unencumbered movement within a panoramic and deep landscape. In *The Glory of St. Gaetano of Thiene* (Parish Church, Rampazzo) and *The Vision of St. Anne* (Gemäldegalerie, Dresden), both datable to the second half of the fifties, figures are enfolded in clouds and bathed in golden light. Only in *The Martyrdom of St. Agatha* (Staatlichegemäldegalerie, Berlin) and *St. Sylvester Baptizing the Emperor Constantine* (Parish Church, Folzano), both also of the second half of the 1750s, does an architectural setting completely stabilize the figures, and in these two instances, quite different from the previous four altarpieces, the scenes recount events considered historical.

The most significant new aspect of the elderly Tiepolo's work is his emphasis on the emotions of the protagonists, whether they are undergoing a religious experience or enacting a secular drama. It is a vital element in all six altarpieces mentioned above and in the painter's splendid frescoes in Villa Valmarana, outside Vicenza, executed in 1757. The commission came from Count Giustino Valmarana, a distant relative of Nicolò Loschi, in whose villa Tiepolo had worked in 1734. At Villa Valmarana, he painted in the vestibule and four ground-floor rooms. Giandomenico Tiepolo, now age thirty, shared the project with his father, painting a suite of rooms in the adjacent guest house.

The commission was clearly intended to contrast the grand emotion of Giambattista's figures, which are culled from the great narratives of Greek, Latin, and Italian literature, and the anonymity of Giandomenico's peasants and merchants; to juxtapose the father's noble themes and the son's genre scenes; and to cause viewers to sympathize with the tragic plights of heroes and heroines in the villa and then delight in the fancy dress and bucolic pleasures in the guest house.

After climbing the few steps that lead up to the villa, visitors enter the vestibule and encounter, suddenly and unexpectedly, *The Sacrifice of Iphigenia* (fig. 33), which is painted on the right wall (with related scenes on the ceiling and left wall). A noble portico, which recalls the one that leads into the Valamarana grounds from the Via di S. Bastiano, illusionistically opens up the surface of the right wall. Although completely at odds with the little palace's unpretentious architecture, the portico provides a monumental stage for the ancient scene, which was drawn from Greek tragedy. On the far right of the fresco, quite near the entrance to the room, is King Agamemnon, covering his eyes. Forced to appease the gods' anger, he must sacrifice his daughter, who kneels before the high priest at the altar in the center of the painting. Agamemnon refuses to watch the awful spectacle, however. (The device of covering the eyes was most likely suggested to Tiepolo by descriptions of ancient paintings in which overwhelming grief was expressed with this gesture.) But visitors see that the murder will in fact not take place, that the goddess Diana, in the heavens on the ceiling, has stopped the execution by sending a replacement for the pathetic princess. Iphigenia, the priest, and several spectators look upward beseechingly to the dainty sacrificial hind standing on a cloud, which descends into our space at the far left. Now convinced that all will turn out well and that the Greek fleet will set sail for Troy, depicted in the painting on the left wall, visitors carry away the memory of Iphigenia's fear and Agamemnon's pain.

The themes of love fulfilled and love unrequited appear in the frescoes Tiepolo painted in the four other rooms, which are arranged symmetrically on either side of the vestibule, two of them to the right and two to the left. The narratives were drawn from four epics: Homer's *Iliad*, Ariosto's *Orlando furioso*, Virgil's *Aeneid*, and Tasso's *Gerusalemme liberata*; one poem is assigned to each room. To the vestibule's immediate right is the Homeric room. Here, as in the other three rooms, Tiepolo cleverly exploited our viewpoint to ensure narrative clarity, so that the first wall we see on entering the space shows the earliest scene depicted from the epic. Thus, in the Homeric room, *Briseis Led to Agamemnon* is the first

33. Giambattista Tiepolo. *The Sacrifice of Iphigenia*. 1757. Wall fresco, 11′6″ × 23′ (3.5 × 7 m). Villa Valmarana, Vicenza

painting we encounter. As in the *Iphigenia* fresco, we confront the suffering of a woman, the concubine Briseis, whom Achilles was forced to give up to Agamemnon. On the adjacent wall, in *Minerva Holding Achilles by His Hair*, the Greek hero is wisely restrained by the goddess from attacking King Agamemnon. Next to the *Minerva* is *Achilles on the Seashore* (fig. 34), the most singular of all Tiepolo's paintings in the villa but today sadly damaged. In the paintings already discussed, Tiepolo placed his protagonists in grand loggias or on stages to enhance the dramatic impact of the narrative. But here he does the opposite, bringing the grieving warrior onto our side of the fictive architecture. Our passage through the small room is halted abruptly by Achilles's presence, and we are compelled to brood with him on the loss of love. Further, in portraying the hero's solitary grief and his mother's for him (note the sea nymph Thetis in the waters beyond), Tiepolo re-emphasizes the theme of helplessness in the face of power, which we have already seen in the vestibule and the Homeric room.

The works in the other three rooms vary in tone, although the themes of love and duty continue as the moral framework. Following the scenes from the *Iliad* are four from Ariosto's *Orlando furioso*, where once again Tiepolo opens the sequence with the awful plight of a female character, Angelica tied to the rock and threatened by the monster. On an adjacent wall, Angelica cares for the wounded Medoro. Then the cycle turns to happier episodes. On the other two walls, Angelica and Medoro offer a ring to a peasant couple who have offered them hospitality, and Angelica carves Medoro's and her names into a tree to record their union. Unlike Achilles, Angelica finds fulfillment in love.

In the two rooms on the other side of the vestibule, passion submits to duty so that destiny may be fulfilled. In scenes from Virgil's *Aeneid*, Aeneas meets and falls in love with Dido but must abandon her in order to found Rome. And in the room illustrating Tasso's *Gerusalemme liberata* (plate 35), Rinaldo must part from Armida to serve the Christian forces fighting the infidels.

We can only guess at why Giustino Valmarana

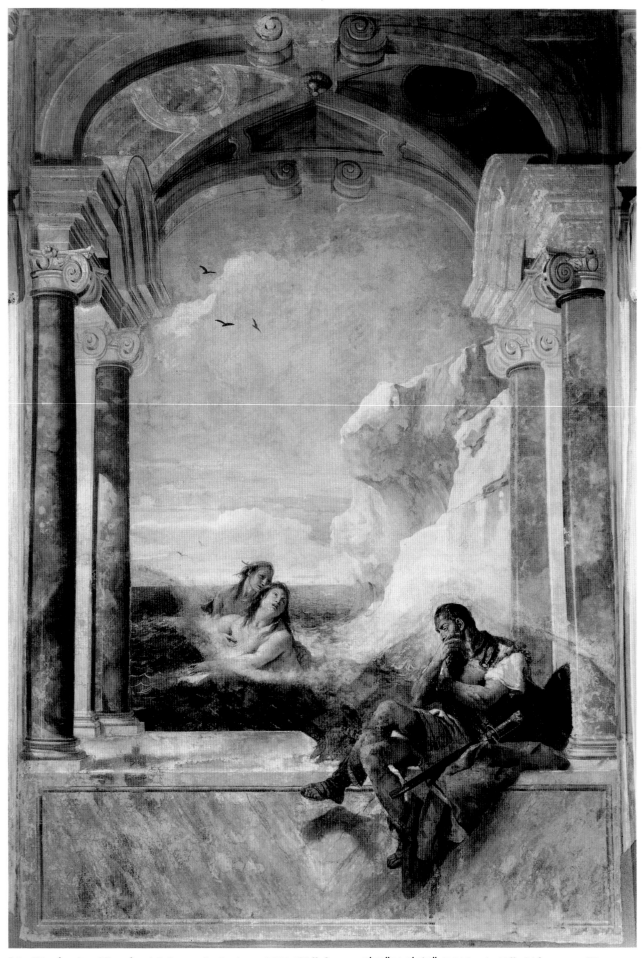

34. Giambattista Tiepolo. *Achilles on the Seashore*. 1757. Wall fresco, 9'10" × 6'6¾" (3 × 2 m). Villa Valmarana, Vicenza

wanted such themes; almost nothing of the commission's terms is known. Like the allegorical cycle of 1734 in the Villa Loschi stairwell and salon and the noble stories of 1743–44 in the Villa Cordellina salon, these frescoes of the 1750s hold up the merits of restraint and respect and the values of duty and heroism. But love, although shunned when it interferes with noble virtue, can hardly be avoided, nor — Valmarana and Tiepolo seem to believe — should it be! In Agamemnon's pain, in Achilles's mourning for Briseis, in Angelica and Medoro's joy, in Aeneas's fervor, and in Rinaldo and Armida's passion, Tiepolo has caught the dedication, sadness, and rapture of love.

Although he was sixty-one when he completed the Valmarana frescoes, Tiepolo did not hesitate to accept other large-scale commissions. Besides the ceiling in the Oratory of the Purità in Udine and *St. Thecla Liberating Este from the Plague* (plate 36), both of 1759, he executed two immense ceiling frescoes of secular subject matter, *The Apotheosis of Hercules* of 1761 in Palazzo Canossa in Verona (damaged in World War II) and *The Apotheosis of the Pisani Family* of 1762 in Villa Pisani at Strà, situated along the Brenta Canal between Venice and Padua. Both are impressive works, revealing his mastery at creating convincing depictions of the heavens, at integrating figures into his illusionistic space, and in designing bold pictorial compositions that dominate large interiors. These paintings confirmed what had already been clear a decade earlier, that Tiepolo was eighteenth-century Europe's only great painter on a monumental scale. These successes led him to his final grandiose challenges, the ceilings of the Royal Palace in Madrid.

In the autumn of 1761 Tiepolo had been commissioned by His Most Catholic Majesty to fresco the ceiling of the Throne Room of the newly completed Royal Palace, and a number of Spanish and Venetian aristocrats worked during the winter of 1761–62 to facilitate the artist's journey. As on the Würzburg mission in 1750, Domenico and Lorenzo accompanied their father, and the three set forth for the court of Charles III on March 31, 1762. After an arduous overland voyage, father and sons arrived in Madrid on June 4. Although Tiepolo tired more easily than before — he was sixty-six — he would eventually complete an impressive number of immense frescoes and large altarpieces in Madrid during the remaining eight years of his life.

Tiepolo had left Venice with a completed oil sketch (The National Gallery of Art, Washington, D.C.) for the Throne Room ceiling. Its subject, the Glory of Spain, fitted a nation whose political, geographical, and cultural achievements had transformed it through the sixteenth and seventeenth centuries into one of Europe's most potent forces. The new policies of the ruling Bourbon house, which during Charles III's regime (1759–88) considered itself among the most enlightened monarchies of its time, are integrated in the study with events from the country's past to create a Spanish *summa*. The fresco closely follows the composition of the oil sketch, but its meaning was altered so that the values of wisdom and peace are stressed instead of those of war and military might, which the sketch had emphasized.[41] Repeating a formula he had used in earlier royal imagery — in the Cordellina *Generosity of Scipio* (plate 23), in *Maecenas Presenting the Arts to Augustus*, painted for Augustus III of Poland (The Hermitage, Leningrad), and in *The Investiture of Bishop Herold* in the Würzburg Kaisersaal — Tiepolo chose as his principal motif an imperial figure enthroned between two monumental statues. In the sketch, Hercules and Apollo flank the throne. In Madrid, however, Tiepolo substituted Minerva for Hercules, thus replacing Strength with Wisdom and repeating the pair of gods he had taken from Raphael's *The School of Athens* for the Cordellina and Dresden paintings. Between the two statues sits Monarchy herself. Nearby, in the ceiling's center, Fame trumpets forth glory, while Christian Faith, directly below Monarchy, holds aloft a chalice. Traditional representations of ancient gods and goddesses, allegorical figures culled from Ripa's *Iconologia*, and personifications of the Spanish provinces enliven the heavens and areas around the cornice.

Perhaps richer in its pictorial complexity than any of his earlier ceilings, certainly more dense than most of them in meaning, *The Glory of Spain* is also the airiest of any of them. But even if exhilarating to view, the fresco is somewhat disappointing. With full knowledge of his previous work, one may conclude that Tiepolo merely repeated some of his earlier ideas, both in the fundamental concept and in many of the individual figures. It is, however, not the painting itself that finally disappoints but rather its relationship to its context. The fresco's broad scope is simply too overwhelming for the space. The compelling visual experience one enjoys in the physical surroundings of the Archbishop's Palace at Würzburg (fig. 30), Villa Cordellina (fig. 14), or Palazzo Labia (plate 24) does not occur in Madrid. Tiepolo's earlier frescoes do not merely decorate, but like great operatic voices they resonate through their spaces. The Madrid ceiling sits within its box like an imprisoned bird and does not sing.

Tiepolo's Spanish contemporaries, unfamiliar with his successes elsewhere, must have thought differently.

Upon completion of the Throne Room vault in 1764, Tiepolo was asked to stay on in Madrid to tackle two more ceilings, in the Saleta, or small hall, adjoining the Throne Room, in which he produced *The Apotheosis of the Spanish Monarchy*, and in the Guard Room, where he painted *The Apotheosis of Aeneas* (plate 38). He finished working in the Royal Palace in 1766.

In a letter written in early 1767 to Charles's secretary, Tiepolo said he hoped to serve His Majesty forever and that he was willing to paint in oils for him as he had done in other courts. Having displayed his unique talents as a "decorator," perhaps Tiepolo now wanted to show that he could follow in the impressive line of Italian artists, which included his fellow-Venetian Titian, who had executed great canvases for Spanish kings. His offer to Charles was opportune because the king was then engaged in building a new church in Aranjuez, outside Madrid, dedicated to St. Pascual Babylon, a follower of the Franciscan St. Peter of Alcantara. To obtain the grand commission for the church's seven altarpieces (figs. 35, 36), Tiepolo had to deal with the king through his dour confessor, Padre Joaquín de Eleta. The difficult task was Tiepolo's final courtly accomplishment, and the large canvases were his last great works in Spain, indeed his very last altogether.

Completed during the summer of 1769, the Aranjuez altarpieces sat in the artist's studio during the subsequent winter while the church was finished.[42] On March 27, 1770, Tiepolo died suddenly. He did not suffer from any grave illness, nor—happily—would he learn that although his altarpieces were put in S. Pascual Babylon in May of that year they would be removed in 1775, eventually to be replaced by canvases by Anton Rafael Mengs, Francisco Bayeu, and Mariano Salvador de Maella. In spite of this affront to Tiepolo's art and memory, Charles's decision was fortunate. Bayeu's and Maella's several altarpieces were destroyed by bombing during the Civil War, whereas parts of Tiepolo's altarpieces survive today. Mengs's work, now a grimy and dark cipher, still sits over the church's high altar.

Tiepolo never again saw either the children he left behind or his wife of half a century. But during his years in Spain, Giambattista sent several presents back to Cecilia, and only months before dying, he had bought gifts of lace for her. That she and his home remained deeply impressed in his mind, even if he never went back to them, is proven in part by those purchases, but more movingly by the very late *Rest on the Flight into Egypt* (plate 40), which quietly laments the immense distances and insurmountable barriers that then halted people in their travels. Perhaps just too tired to face the journey home, Giambattista never carried the lace back

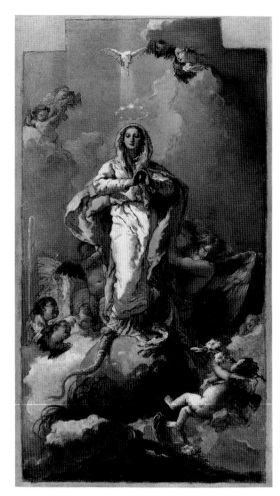

35. Giambattista Tiepolo. *Oil Sketch for "The Immaculate Conception."* 1767. Oil on canvas, 21 × 14" (53.5 × 35.5 cm). Courtauld Institute Galleries, London. Princes Gate Collection, Seilern Bequest, 1978

to his wife, but Giandomenico did, late in 1770, when he returned to Venice after his father's death. Giandomenico died in 1804. Lorenzo stayed in Spain, choosing like his father to remain in the service of Charles III. He died in 1776.

As the three-hundredth anniversary of Tiepolo's birth approaches, we can only be astonished that the greatness, splendor, and variety of his art were so little appreciated during the two centuries after his death. Except for intermittent praise from nineteenth-century Venetian historians and specialized art-historical studies of the first half of the twentieth century, most evaluations of his painting, even by well-informed individuals, saw it as merely a luxurious decoration, "pretty *boudoir* art, with delicate and slender, rose-colored legs."[43] He was, in other words, the Italian equivalent of Boucher.

Tiepolo suffered a loss of reputation because his paintings lost their audience. The *ancien régime* died soon after Tiepolo himself, and the Counter Reformation institutions for which so much of his art was

created carry little sway in today's world. His secular art glorifies historical figures and events of almost no import to a largely democratic society in which aristocratic privilege has lost its place. But if that is the case, then why do we admire Rubens's *The Apotheosis of King James I* on the Whitehall ceiling in London, and why do we meditate on Rembrandt's moving *Aristotle Contemplating the Bust of Homer* (The Metropolitan Museum of Art, New York)? Tiepolo's sacred art, too, glorifies cults and devotions that are now either little understood or are no longer adhered to. With the demise of religious art in the West after 1800 and the widespread secularity of modern civilization, Tiepolo's Post-Tridentine subject matter has come to be considered entirely tied to its own time and place. But if Gianlorenzo Bernini's *St. Theresa in Ecstasy* (S. Maria della Vittoria, Rome) can be thought a masterpiece of great emotional depth, then surely Tiepolo's saints and martyrs must be reevaluated.

The "Venetianness" that fills so many of his paintings—the color and exotic figures, the solemnity and high-minded allegories—looks to the uninformed today as if Tiepolo merely wanted either to charm us with pleasing forms or confound us with arcane pictorial references. But the beauty of his mature imagery was not just a restatement of Veronese's art; it was also an attempt to build an ideal world. The city he lived in convinced him that such beauty was physically attainable and that it could be a lasting and fulfilling condition.

The most profound value of Tiepolo's painting is its honest seriousness. His commitment to his subject matter was total. Our modern world-weariness and skepticism, legacies of the Enlightenment, have made Tiepolo's grandiloquent gestures and elaborate artistic machinery seem old fashioned. In reality, however, his interests are ones that will always concern us—human emotions, ambitions, and beliefs. To show true passion and devotion, Tiepolo tried to create palpable form. No other artist of his century so completely or successfully devoted himself or herself to this goal except Jacques-Louis David. It is one of the ironies of art history that because Tiepolo's style was supplanted by the totally different manner of David, the similarity of their goals is overlooked. The two artists' languages are diverse, but are the passions behind the forms contradictory? Do not the sons in David's *The Oath of the Horatii* (Musée du Louvre, Paris) die for the same reason as St. Bartholomew (plate 1) and St. John of Bergamo (plate 26)? Tiepolo's voice was as honest as any in the history of Western art, and his genuine emotion finds expression in the quiet willingness with which St. Lucy accepts her martyrdom (plate 28) and the turbulent distress Apollo

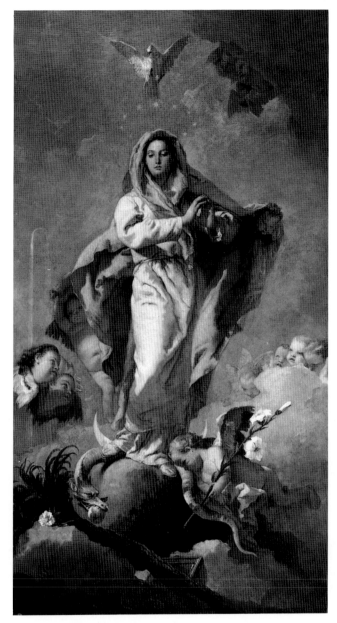

36. Giambattista Tiepolo. *The Immaculate Conception.* c. 1767–69. Oil on canvas, 119⅞ × 59⅞" (304.5 × 152.1 cm). Museo del Prado, Madrid

experiences at finding Hyacinth dead (plate 33). In both paintings, Tiepolo succeeds in moving his viewer. Such figures admit comparison with some by Tiepolo's greatest Italian predecessors—with Giotto's Anne and Joachim in *The Meeting at the Golden Gate* in the Arena Chapel, Padua, and Titian's saint in *The Martyrdom of St. Lawrence* in S. Maria Assunta, Venice.

Finally, the grandeur of Tiepolo's heroic imagination finds comparison in the history of Italian art only with the immense undertakings of Michelangelo and Bernini. The monumentality, variety, and inventiveness that characterize Tiepolo's fresco cycles justly place him in such illustrious company. He was the last great Italian artist in a tradition that had begun with Giotto.

1. THE MARTYRDOM OF ST. BARTHOLOMEW

c. 1722–23. Oil on canvas, 5'5¾" × 4'6¾" (167 × 139 cm)
S. Stae, Venice

Situated on the Grand Canal near its upper reaches and only a short walk from the Rialto, the church of S. Stae (Venetian dialect for Eustace) was rebuilt according to Palladian principles in the late seventeenth century: three chapels to the right and to the left flank a single nave. The facade was designed by Domenico Rossi in 1709, and five of the altarpieces in the six chapels were painted by Francesco Migliori, Jacopo Amigoni, Antonio Balestra, and Giuseppe Camerata between 1710 and 1720.

On April 10, 1722, one Andrea Stanzio left the church twelve hundred ducats for twelve canvases of Christ's apostles, and a different artist was to depict each apostle.[1] Two famous painters, not named in the codicil to Stanzio's will, were to direct the commission, choosing the ten painters who would join them in executing the project. The canvases originally decorated the pedestals of the twelve columns in the nave but were later transferred to the presbytery, where they still hang. The commission turned out to be a "who's who" of early eighteenth-century painting in Venice. The artists were, from eldest to youngest: Nicolò Bambini, Gregorio Lazzarini, Sebastiano Ricci, Antonio Balestra, Angelo Trevisan, Silvestro Manaigo, Pietro Uberti, Giannantonio Pellegrini, Giambattista Piazzetta, Giambattista Pittoni, Giambattista Mariotti, and Tiepolo.

The S. Stae series followed in a tradition of portraying complete sets of apostles. El Greco had painted such a series, and so had Rubens and van Dyck, all between 1600 and 1620.[2] Piazzetta produced a suite of drawings of apostles' heads, which was printed by Marco Pitteri, in about 1742.[3] The S. Stae group is different from all of these in that the apostles are not depicted in bust format or standing still but are dramatically represented, each during a key moment in his life—the writing of a gospel, imprisonment, torture, martyrdom, apotheosis, and so on.

Tiepolo's *St. Bartholomew* is the most forceful image of the entire commission, which is remarkable given the artist's young age of about twenty-six, his junior ranking in the group of painters, and his comparative lack of experience. He painted the work in his early tenebrist style, and took aspects of his composition from Piazzetta's entry in the project, including placing an onlooker in the bottom left corner to correspond to the real viewer of the painting, who is also watching the ghastly event. In both, the onlooker's face is brightly lit to draw our attention to him.

St. Bartholomew's muscular jailer, in the bottom right corner, is a restatement of two figures by two seventeenth-century Neapolitan artists who had left paintings in Venice: a servant in Francesco Solimena's *Rebecca at the Well* and a jailer in Luca Giordano's *The Crucifixion of St. Peter*. Tiepolo's angular rhythms and active narrative are entirely his own, however. The image's power derives mainly from the saint's ecstatic expression and bold gesture. Bound and restrained by stably positioned figures, Bartholomew falls perilously forward, offering himself to God while yielding before the knife just as he is about to be flayed alive. Tiepolo had first formulated this body, in which straining limbs pull vigorously away from each other in a zigzag configuration, on a sheet now in the Victoria and Albert Museum, London (fig. 18).

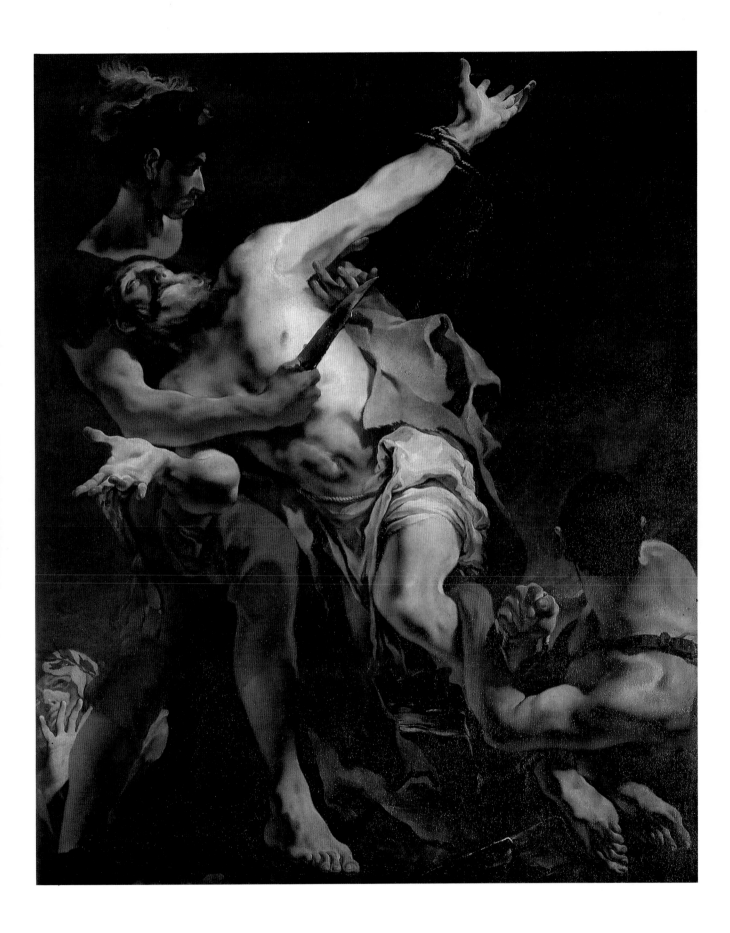

2. THE ALLEGORY OF THE POWER OF ELOQUENCE

c. 1724–25. Ceiling fresco, 34'9" × 21'10" (10.6 × 6.65 m)
Salon, Palazzo Sandi, Venice

Tiepolo painted the so-called *Allegory of the Power of Eloquence* on the ceiling of the salon in Tommaso Sandi's newly built palace, near the Grand Canal in the parish of S. Angelo. The Sandi fresco was Tiepolo's first secular fresco scene in a noble Venetian palace, and it was, arguably, his first fresco in Venice. Showing four tales from Greek mythology, the ceiling lauds the virtues of valor and eloquence. A painted canvas wrapping around the frieze level directly under the ceiling depicts animals and other wild beasts, centaurs, satyrs, and muscular men, all cavorting, perhaps meant to connote lasciviousness and unbridled power in contrast to the more noble events overhead.[4] On the walls below hung an impressive pictorial ensemble that used ancient narratives to communicate noble themes. It comprised Tiepolo's *Ulysses Discovering Achilles Among the Daughters of Licomedes*, *Marsyas and Apollo*, and *Hercules and Antheus*, and two paintings attributed to Nicolò Bambini, *Volumnia Pleading with Coriolanus* and *The Three Graces*.

Walking into the salon and looking up, viewers find a seated, lavender-clad Minerva and a brilliantly lit, flying Mercury peering down from the center of the ceiling. Along the cornice opposite the entrance, Amphion builds the walls of Thebes with the music of his lyre; over the wall on the right, Hercules clad in the skin of the Nemean lion pulls the thieving Cercopes with chains. Bellerophon astride the winged Pegasus fights the Chimaera over the wall to the left of the entrance, while directly above the entry wall, Orpheus looks back at the three-headed Cerberus, startling his wife Eurydice who will momentarily be forced to return to Hades.

The finished fresco differs substantially from its oil sketch (Courtauld Institute Galleries, London) in the disposition of the four narratives. Tiepolo had first depicted the stories of Hercules and Amphion opposite each other rather than over adjacent walls; Orpheus and Eurydice are on the left in the sketch and Bellerophon is on the right. In the fresco, Tiepolo shifted the elements so that the long sides of the rectangular ceiling are occupied by Orpheus with his violin and Amphion with his lyre, and the short sides by Bellerophon and Hercules. In making this change Tiepolo neatly clarified the ceiling's theme: while valor conquers evil, music has magical powers that move the gods and the earth itself.[5] In the center of the ceiling sit Minerva, an emblem of the strength of Bellerophon and Hercules, both of whom she had aided in their deeds, and her companion Mercury, messenger god and inventor of the lyre, who personifies oratory and the musical arts.

Tiepolo created a new kind of Venetian ceiling painting in Palazzo Sandi. In the city's earlier tradition of painted ceilings, figures either fly through space or stand on a rostrum that fills the center of the composition. But in order to meet his challenge, Tiepolo—who was charged with depicting four unrelated narratives—used the cornice like a stage, composing each scene like an ancient pedimental sculptural ensemble that rises to its greatest height at the center. While he linked the four episodes with the central figures Minerva and Mercury, Tiepolo also emphasized their independence by separating them with the heavens. He brilliantly lit and activated the heavens with bursts of sunlight and swirls of clouds. The golds, oranges, mauves, tawny yellows, and olive greens contrast with the gray white of Thebes, the painting's largest single motif, and the brightness that surrounds Minerva and Mercury.

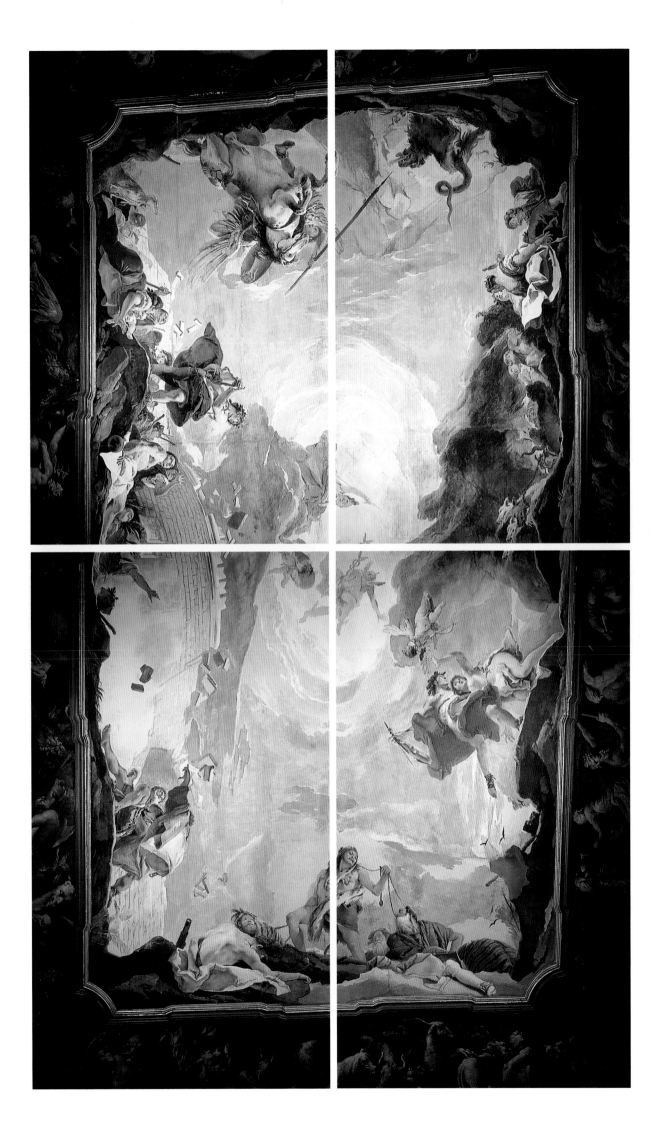

3. ST. THERESA IN GLORY

c. 1725–27. Ceiling fresco, 20' × 24'8" (6.1 × 7.5 m)
Chapel of St. Theresa, S. Maria di Nazareth, Church of the Scalzi, Venice

St. Theresa in Glory is Tiepolo's first religious ceiling fresco in Venice; its exact date, however, is unknown. The fresco ornaments the vault of the church's second chapel to the right, on whose lateral walls hang two large canvases by Nicolò Bambini narrating miraculous events from the saint's life. Tiepolo's painting depicts angels carrying St. Theresa from our earthly sphere through an illusionistic opening in the vault and into the heavens beyond; musicians seated on a severely foreshortenend balustrade offer the event the proper accompaniment. Swooping inward is an angel with a laurel wreath, a symbol of victory. Mediating on the right and left between God's realm and ours are three angels and the three Theological Virtues, who are portrayed as stone sculptures: Faith and Hope are on the left, and Charity is on the right.

St. Theresa in Glory must be seen in light of work submitted to a contest in 1723 and in relation to two earlier religious ceilings Tiepolo executed on the mainland. Certainly the *St. Theresa* ceiling is a great advance, compositionally, dramatically, and spatially, over both earlier ceilings, *The Assumption of the Virgin* in Biadene (fig. 2) and *The Glory of St. Lucy* in Vascon.[6] It is also an improvement over the oil sketch (Gallerie dell'Accademia, Venice) he submitted to the competition for the ceiling of the S. Domenico chapel in Ss. Giovanni e Paolo. The sketch, although executed at least five years after the Biadene and Vascon frescoes, is still an immature work, revealing uncertainties in spatial organization and, in its fragmented composition, recalling *The Virgin of Carmel* (fig. 6).

The *St. Theresa* is instead a decidedly mature painting. Nothing in it appears to come from the winning entry to the S. Dominic competition, Giambattista Piazzetta's *Glory of St. Dominic*. (That ceiling was inaugurated in January 1727.[7]) Theresa does not reveal the same ecstatic response to her heavenly ascent as does St. Dominic; she is passive, and in this recalls the personification of Venice in Veronese's *Apotheosis of Venice* (ceiling of the Hall of the Great Council, Ducal Palace, Venice). Tiepolo's wreath-bearing angel, rather than depending on Piazzetta's angel who also flies in from the opposite direction, rephrases Veronese's wreath-bearing angel. The space, composition, and bold foreshortening in *St. Theresa* bring to mind Tiepolo's *The Judgment of Solomon* in Udine (plate 5), datable to about 1727.[8] Like his figures there, and those of 1726 in the chapel of the Sacrament in the Cathedral of Udine, the *St. Theresa* angels feature beautifully delineated contours, their wings sweep boldly up- and downward, and the foreshortening of their limbs is impressive. The young painter's earlier tendency toward angularity has given way here to flowing curves and lyrical rhythms. Further linking the *St. Theresa* to the Udine commission in date are the similarly conceived decorative moldings and the inclusion of the figures portrayed as stone sculptures.

4. FRESCOES IN THE PATRIARCHAL GALLERY

c. 1725–27
Archbishop's Palace, Udine

In the Archbishop's Palace in Udine, on the long inner wall and ceiling of the Gallery, large, fictive, curvilinear moldings surround eight scenes from the Old Testament; and on both of the long walls, six prophetesses stand in *trompe l'oeil* niches. The two short walls, which are punctuated only by a door and a window, are decorated with illusionistic spiraling columns that recall the historical Solomonic columns in St. Peter's in Rome; they support broken pediments, within each of which is the Dolfin coat-of-arms. Tiepolo's patron at Udine was Dionisio Dolfin, patriarch of Aquileia from 1699 to 1734. Girolamo Mengozzi-Colonna painted the architectural elements and Tiepolo executed all figures and narratives (compare plate 24).

The Gallery's masterpiece is the series of frescoes on the long inner wall. Anchoring the sequence at its center is the monumental *Rachel Hiding the Idols from Laban* (Genesis 31), and its illusionistic frame locks it on either side to *Jacob and the Angel* (Genesis 32) and *Jacob and Esau* (Genesis 33). Tiepolo painted *Rachel Hiding the Idols from Laban* in rich autumnal colors, but in both Jacob paintings, he portrayed the figures as if they were made of white marble and cut into a golden ground, which is bordered in gilt and decorated with curvilinear floral patterns. To the right and left of the Jacob paintings are two of the six Old Testament prophetesses. Beyond them, at the entrance and the far end of the room, the young Tiepolo frescoed his sweetest and most lyrical images, *Abraham and the Three Angels* and *Sarah and the Angel* (both Genesis 18). The Jewish people's first father and mother humbly kneel before God's heavenly messengers who arrive, in the first scene, to receive Abraham's acknowledgment that he has fulfilled his covenant with the Lord and, in the second, to announce to the incredulous and toothless old woman that she will bear a child. Tiepolo's tender feelings for this aged pair, Abraham dressed in simple robes and set against a rocky landscape and his wife in Rubensian splendor in a fragile lean-to, is matched by his awe for the divine, which is manifest in the trio of angels before the patriarch who are draped in complementary colors centered around lustrous white, and in Sarah's annunciate angel who is brilliantly gowned *alla* Veronese, his ocher cloak repeating hers in a brighter key. On the ceiling, in *The Dream of Jacob*, *The Sacrifice of Isaac*, and *Hagar and Ishmael Lost in the Wilderness*, Tiepolo switched from the rich ochers, dark greens, blues, grays, and mauves of the wall frescoes to golden yellows, pale blues, lavenders, and pinks.

The significance of this lavish commission for a provincial palace can only be grasped if the narratives are read in terms of the dire political situation facing the patriarchy of Aquileia in the early eighteenth century.[9] The Austrian emperor Charles VI sought to control the region of Friuli, which included Udine, and forbade German-speaking subjects from obeying all Venetian officials, even Patriarch Dolfin. Fighting to maintain its age-old patriarchy, which was believed to have been established by St. Mark centuries before, the Venetian Republic mounted a political campaign against Austrian hegemony in the area. As part of this patriotic endeavor, Dolfin charged Tiepolo to paint narratives from the lives of the Old Testament's three patriarchs, who with their offspring claimed their rights of inheritance before God.

5. THE JUDGMENT OF SOLOMON

c. 1727. Ceiling fresco, 11'6" × 21'4" (3.5 × 6.5 m)
Ecclesiastical Tribunal (Sala Rossa), Archbishop's Palace, Udine

Tiepolo's greatest fresco in the Archbishop's Palace is on the ceiling of the Ecclesiastical Tribunal or Sala Rossa (Red Room). Composing *The Judgment of Solomon* so that Solomon is directed toward visitors, or plaintiffs, entering the room, he enthroned the youthful king against a cloth of majesty supported by monumental statuary. Solomon has just given the order to sever the contested baby in half, a cunning decision that immediately reveals the infant's true mother. Petitioners seeking justice at the hands of Patriarch Dolfin and viewing this famous example of wisdom were encouraged to hope for similarly judicious sentences. *The Judgment of Solomon* also fulfilled the commission's larger iconographic program relating to Venice's predicament with the court at Vienna (see plate 4), for it implies that violent division was as unjust a resolution for the patriarchy of Aquileia as it was for the Old Testament child.

At the corners of the ceiling, Tiepolo painted the prophets Isaiah, Jeremiah (or Jonah), Ezekiel, and Daniel.[10] Reading the four figures counterclockwise around the ceiling beginning over the entrance, one sees Isaiah receiving coal from one of God's seraphim (Isaiah 6:6–7), Jeremiah's lament over the destruction of Jerusalem (or Jonah outside Nineveh; Jonah 4:6–11), Ezekiel offered a scroll by a hand from heaven (Ezekiel 2:9–10), and Daniel's dream (Daniel 7:3). The prophets' four stories symbolize the feud then dividing Venice and Vienna but point to ultimate Venetian victory: Isaiah relates the story of a people deaf to understanding; Jeremiah (or Jonah) laments the momentary abandonment by God; Ezekiel exhorts mankind to follow God's laws; and Daniel and his lions, two at his feet and a winged version in the sky recalling St. Mark's apocalyptic emblem, refer to Venetian rule.

The Judgment of Solomon, which Tiepolo must have finished just after his thirtieth birthday, is far more sophisticated pictorially than his earlier paintings. The great sweep of the cloth of majesty is intersected by the king's head and pointing finger, and it curves down toward the jealous mother, who is identified by her green robe and the nearby points of two intersecting spears, one of which, tellingly, has been broken. Contrasting with her is the true mother, dressed in pure white and noble blue who with a heroic gesture intercedes to stop the executioner. The latter is said to be a portrait of the bishop of Vienna, who was a pivotal figure in the ecclesiastical controversy threatening Venetian power over the patriarchy of Aquileia. Tiepolo placed his drama on a platform that brightens in color from bottom to top, from the shadowed and then bright gray white steps to the golden carpet under Solomon which forms the cloth of majesty. In the sky above, Tiepolo painted a pink and white cloud that repeats the shape of Solomon's pose; it rises to cover the deep ocher cloud aligned with the threatening sword below.

The great white entablature topped with statues seen against the sky recalls Jacopo Sansovino's Library, which stands facing one wing of Venice's Ducal Palace; and the monumentalizing statuary flanking Solomon was, for any Venetian, a recollection of Sansovino's *Neptune* and *Mars*, which stand atop the Staircase of the Giants, the site at the Ducal Palace where the Venetian *doge*, or duke, traditionally took his oath of office. Thus Tiepolo's Solomon refers not only to Patriarch Dolfin, who was present in the Tribunal below, but also to the Venetian head of state in the Republic's capital.

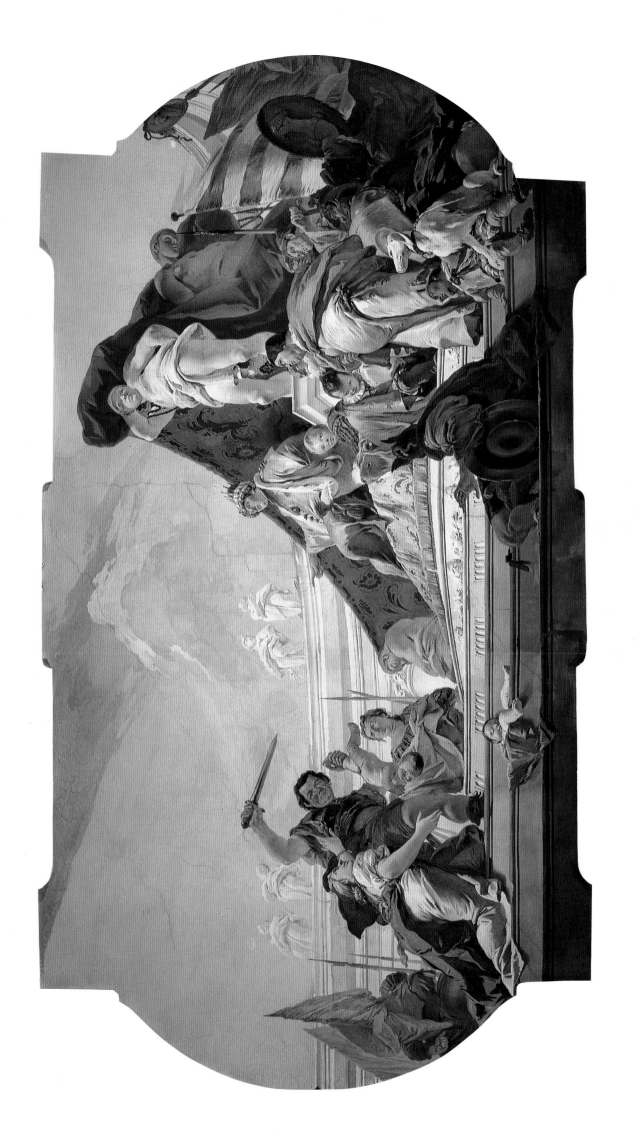

6. THE BRAZEN SERPENT (detail)

c. 1731–32. Oil on canvas, 5'4½" × 44'5⅞" (1.64 × 13.56 m)
Gallerie dell'Accademia, Venice

Numbers 21:6–9 tells the story of Moses's brazen serpent, which heals the afflicted Hebrews in the desert after their punishment by God. It was a popular subject in Christian art, because St. John (3:14–15) had recalled the bronze sculpture which Moses held up before the Jews as a metaphor for Christ's crucifixion and for the eternal salvation Christians could find through their Savior's sacrifice. In the sixteenth century, Michelangelo frescoed the narrative in one of the corners of the Sistine Chapel ceiling, Rome, and Bronzino portrayed it on a wall of the Eleonora Chapel in the Palazzo Vecchio, Florence. In Venice, Tintoretto painted the same subject in oil on canvas as one segment of the ceiling in the upper hall of the Scuola Grande di S. Rocco, and closer to Tiepolo's time, around 1660, Pietro Liberi depicted it, again in oil on canvas, for a chapel in Venice's cathedral, S. Pietro di Castello.

Tiepolo's canvas (fig. 10), terribly damaged after it was rolled up and placed in storage in the early nineteenth century, is like the above works in that it was meant to be viewed in relation to an altar, but it is different from them because of its remarkable shape. Its original position was within a large decorative program in the church of Ss. Cosma e Damiano on the Giudecca island, which served a community of Benedictine nuns. Once enclosed by an elegant wood frame, *The Brazen Serpent* must have covered the front of a choir loft, which in Venetian monastic churches often hung on the upper part of the entrance wall. The figures' foreshortening confirms that the canvas sat above eye level, and the decorative elements suggest its inclusion within a piece of furniture. The two illusionistic consoles separating the frieze into three compartments could have covered curved portions of the parapet. The positions, glances, and gestures of the muscular males and plaintive females create expressive rhythms that carry one's gaze back and forth across the great frieze.

Tiepolo's *Brazen Serpent* was one of thirteen paintings of biblical subject matter that decorated the interior of Ss. Cosma e Damiano.[11] Begun as an Old Testament cycle sometime before 1675, the earliest works in the group, by Antonio Zanchi and Antonio Molinari, emphasized the Chosen People and their search for nationhood, a metaphor for Venetian statehood during its convulsive wars against the Turks in the seventeenth century. The cycle then grew to incorporate New Testament narratives that parallel Jewish events, including stories of divine cures for human illness, which underlined the church's dedication to Sts. Cosmas and Damian, two doctors. These paintings were by Sebastiano Ricci, Giambattista Pittoni, Angelo Trevisani, Giambattista Crosato, Girolamo Brusaferro, and Tiepolo. The latter's impressive canvas depicting Moses healing the Jews while leading them to the Promised Land referred to both these themes. Moreover, it reminded the pious turning away from the high altar to leave the church that Christ had sacrificed himself for their salvation.

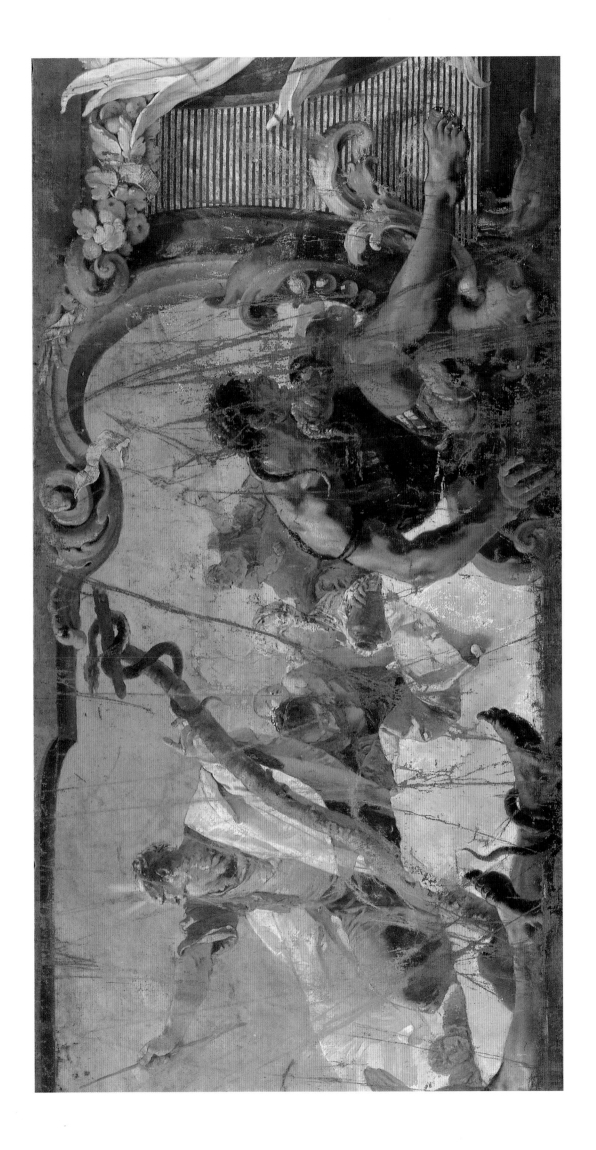

7. THE EDUCATION OF THE VIRGIN

c. 1732. Oil on canvas, 11'11" × 6'6¾" (3.62 × 2 m)
S. Maria della Consolazione, Church of the Fava, Venice

Painted when he was about thirty-six years old, this was Tiepolo's first altarpiece in his native city. It was commissioned for a new Oratorian church dedicated to the Virgin whose cornerstone had been laid in 1705. In its earliest mention in print in 1733, the painting was praised as an "illustrious work."[12] The large canvas stands above the altar of the first chapel to the right. In the second chapel to the left stands Giambattista Piazzetta's *The Virgin and Child Appearing to St. Philip Neri*; St. Philip was the founder of the Oratorian order.

Tiepolo painted the scene in the lustrous reds, greens, blues, and golds that are characteristic of this period in his career, and modeled the colorful forms in dark chiaroscuro. Bright light pierces the scene, falling on the Virgin and the Holy Book, the latter supported more by clouds than by Mary. Standing on an elegantly carved stool and dressed in brilliant white, she is held up before us as the Immaculate Virgin. The painting honors Mary's parents as well, and Anne was given special prominence because the church owned one of her relics.[13] Sitting on the left in the painting, her strong and aged profile silhouetted against her daughter's shoulder, Anne is looking at us as we enter the church. Joseph stands engulfed in deep shadow, and his vertical position is emphasized by an Ionic pilaster directly behind. Tiepolo employed this pictorial device for male figures in several contemporary altarpieces. Three angels in the upper left look at the family below, and they complete a bold zigzagging compositional line that copies Piazzetta's scheme in his earlier painting across the nave. Also demonstrating Giambattista's debt to his elder are St. Joseph's hands, clasped and held outward to our left, which duplicate those of St. Philip Neri in Piazzetta's altarpiece.

Tiepolo's painting can be related to three small oils and two drawings.[14] They suggest that the artist, when commissioned to do a large work for the church, reworked an earlier pictorial idea into a new oil sketch, then repeated that second image for a private collector, and finally generated the altarpiece itself. The oil sketch in the Musée des Beaux-Arts, Dijon (19 × 10½", 48 × 27 cm), is a very early work of perhaps 1722–24; it shows St. Joseph standing on the left, Anne sitting in a frontal position in the center, Mary sitting in profile before her, and a group of angels in the upper right corner. A second oil sketch (Cini Collection, Venice), is almost the same size as the Dijon sketch and dates stylistically to the early 1730s. It repeats Mary's and Anne's placement in the Dijon work. The third painting (Kaufmann-Schlageter donation to the Musée du Louvre, Paris) is oval in format and larger than the first two. It copies only the bottom half of the Cini composition, omitting the heavenly figures overhead. Its surface is too finished to be a study; it must have been a private, devotional work for someone who wanted a copy of the painting in Venice.

Tiepolo rethought his earlier placement of Mary and Anne for the altarpiece. For a temple dedicated to Mary and housing one of Anne's relics, he decided to focus on the daughter, placing her on a stool so she appears taller than her mother and turning her frontally so she faces the pious, while shifting Anne into a profile position.

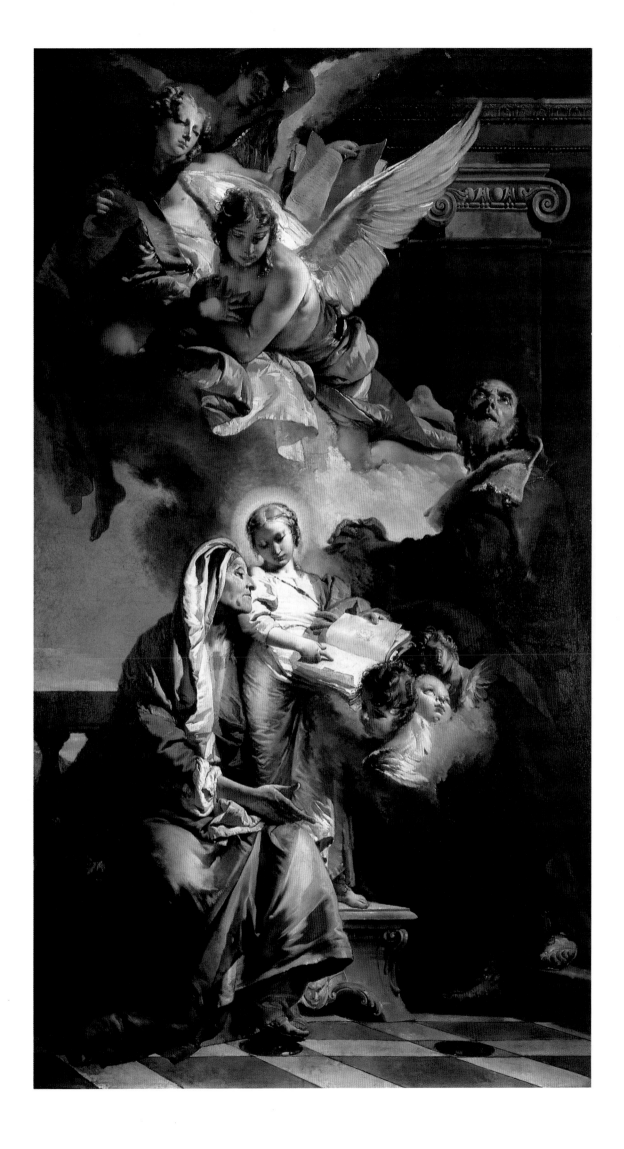

8. THE BEHEADING OF ST. JOHN THE BAPTIST

1733. Wall fresco, 11'6" × 16'5" (3.5 × 5 m)
Colleoni Chapel, Bergamo

In 1732 Tiepolo began work on a series of frescoes for the confraternity whose chapel was the Luogo Pio della Pietà Bartolomeo Colleoni in Bergamo's upper city.[15] In that year, he painted *Faith*, *Charity*, *Justice*, and *Fortitude*, two of the Theological and two of the Cardinal Virtues, on the pendentives of the chapel's dome. On the lunettes around the altar, he frescoed *St. Mark Writing His Gospel* and *The Martyrdom of St. Bartholomew*; the two were, respectively, the patron saints of Venice and of Bartolomeo Colleoni, the city's famous fifteenth-century mercenary general whose equestrian statue by Andrea Verrocchio graces the square outside the Dominican church of Ss. Giovanni e Paolo. The Bergamo project should be seen in the larger context of Tiepolo's first professional forays outside his native city to work for non-Venetians — in the Archinto and Casati palaces in Milan in 1730–31, at Villa Loschi outside Vicenza in 1734 (figs. 11, 21), and in Rovetta, in the countryside near Bergamo, also in 1734 (plate 9).

Having pleased the chapel's commissioning body in 1732, Tiepolo returned late the next year to fresco, on three of the building's walls, *The Preaching of the Baptist*, *The Baptism of Christ*, and the painting reproduced here. The first two show the Baptist (and Christ) in rocky landscapes with nearby figures who sit or stand, listen and watch. They are quiet scenes, recalling the pastoral tone of Tiepolo's slightly earlier *Rachel Hiding the Idols from Laban* (plate 4) in the Archbishop's Palace in Udine. The *Beheading*, on the entrance wall, contrasts violently with these. In what appears to be the corner of a darkened dungeon an executioner holds up the awful, severed head of the Baptist, blood dripping from it, while elegantly clad observers point to, comment on, or turn away from the gory sight. A small oil sketch for the *Beheading* (Nationalmuseum, Stockholm) differs from the fresco mostly in the positioning of the Baptist's body.

The beautiful Salome and the paunchy Herod stand prominently before two columns, and an old crone with a salver awaits reception of the ghastly trophy being held up near the center of the painting. A piece of John's banner reading "*Ecce Agnus Dei*" falls to the ground just below the salver. Counterbalancing the limp banner on the left is a sprightly terrier jumping at Salome's feet. This ghastly combination of images and powerful triangular composition illustrate Tiepolo's ability to unite great drama and elegance in a single painting.

Such imagery of Tiepolo's has been criticized as overdramatic and in bad taste. But his earlier Burano *Crucifixion* (fig. 4), *The Martyrdom of St. Bartholomew* (plate 1), *The Brazen Serpent* (plate 6, fig. 10), and *The Way to Calvary* (plate 15) all reveal his dependence on and relation to earlier Venetian painting — in particular works by Jacopo Tintoretto and Titian — whose continued vitality Tiepolo contributed to well into the mid-eighteenth century.

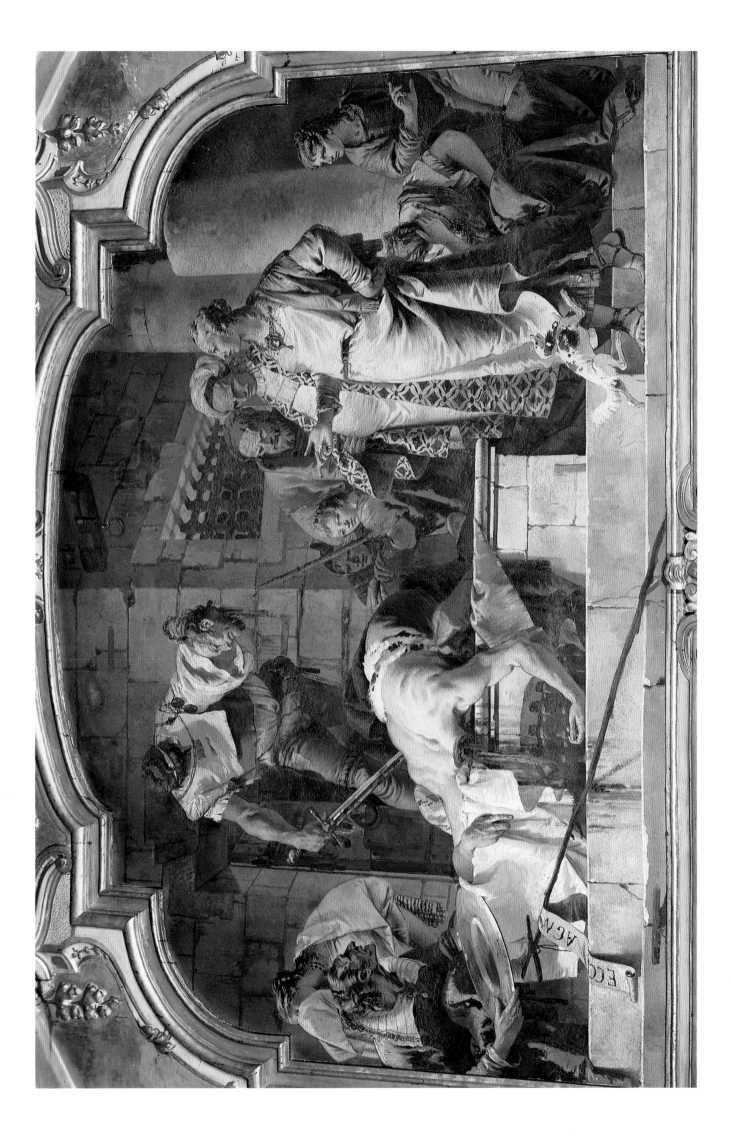

9. THE VIRGIN IN GLORY WITH SAINTS

1734. Oil on canvas, 12'5" × 4'5" (3.78 × 1.34 m)
Church of the Ognissanti, Rovetta (province of Bergamo)

Long recognized as a great painting of Tiepolo's early maturity but known to only a few because of its location in the mountains above Bergamo, the altarpiece in Rovetta is one example of the wide gamut of patrons that Tiepolo attracted within a very short span of time: Milanese aristocrats (the Archinto and Casati commissions of 1730–31), a Venetian religious order in 1731–32 (plate 7), a small, urban confraternity in 1732–33 (plate 8), a sophisticated, landed aristocrat in 1734 (fig. 11), and in the same year the townspeople of Rovetta, a tiny village twenty-three miles northeast of Bergamo. Showing the Virgin in glory over a crowd of male saints below, the canvas sits over the high altar of the town's parish church and within the chancel's artistic complex. Figures of Hope and Faith flank the painting, a stuccoed figure of Mary sits over the tabernacle, her feet resting on a banner carrying the phrase "*Venite Ad Me Omnes*," and frescoes on the quarter-dome of the apse show the Holy Spirit and, on the vault, the Sacrificial Lamb. Six reliefs narrating stories of King David decorate the chancel's two side walls.

Tiepolo's oil sketch (Museo Poldi Pezzoli, Milan) is exactly like the altarpiece in its composition. The only major difference between the two images, and a very significant one, is that the Virgin did not originally figure in the subject. The sketch shows that the commission began as an All Saints painting, understandable for a church dedicated to the Ognissanti. St. Peter is on the far left, St. Paul stands directly behind him, an unidentified bishop saint kneels in the center, the Baptist and St. Lawrence define the middleground, and a crowned figure (surely King David given the reliefs on the chancel walls) occupies a lower ground level in the distance. Three intersecting circles in the heavens—in the place Mary would later assume—imply that saintly dedication serves the heavenly Trinity.

The finished altarpiece exalts the Virgin, who wears a brilliant silver white gown and enters a golden empyrean. She rises over a white column, suggesting the Immaculate Conception. At the bottom of the painting and on a direct line with Mary is the bishop's robe, depicted in white satin and falling forward toward a book whose cover is painted a warm golden ocher. Between the white and ocher on the bottom steps and the silver gold in the heavens, Tiepolo dressed his figures in bright reds and roses, yellows, and blues. Bright sunlight covers much of the scene, far different from the somber lighting in paintings like *The Education of the Virgin* of just a few years earlier (plate 7). Radiating triumph and glory, the *Virgin in Glory* heralds Tiepolo's mature art.

St. Peter walks down the steps toward the faithful gathered in church, holding his key up and reminding them that the path to redemption lies in the examples set by his fellow saints. The sources for this heavenly gatekeeper are unusual for an eighteenth-century painter; they are found in the hieratically positioned saints in the paintings of the Venetian Vivarini family or of the Paduan Bartolomeo Montagna, all late fifteenth- and early sixteenth-century artists whose figures in turn recall the Byzantine tradition that lay behind much of Venetian painting. Tiepolo's use of such a pictorial formula produces the authoritarian pose necessary for this didactic lesson in salvation.

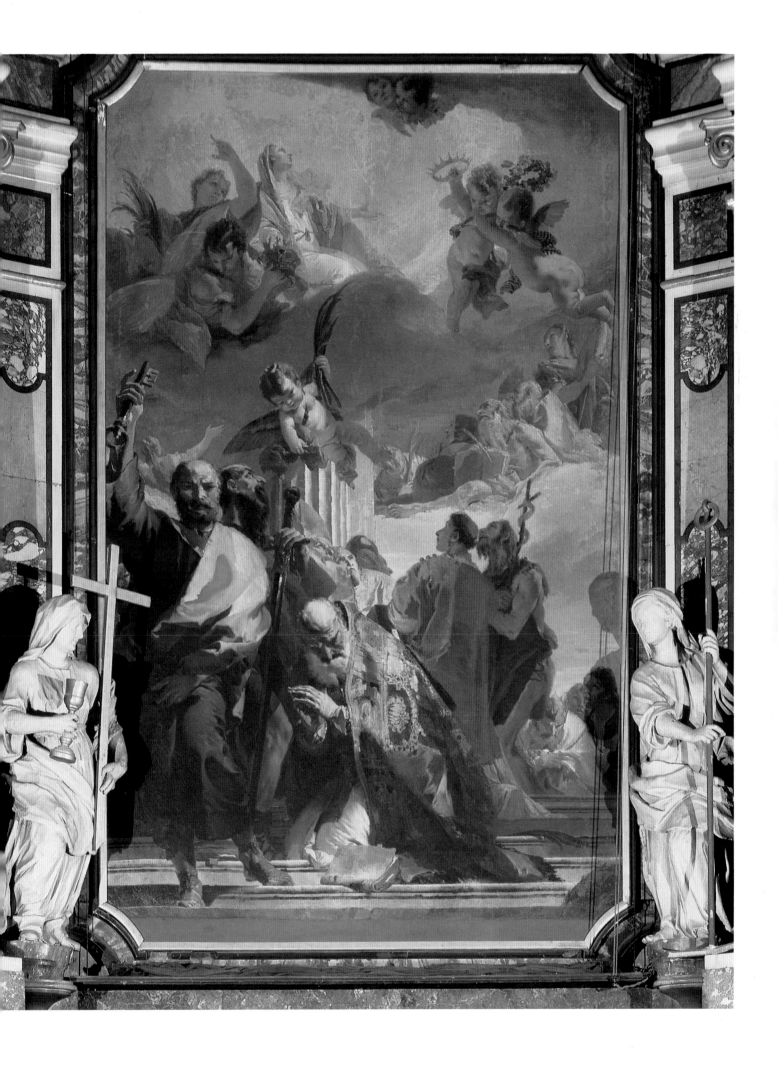

10. THE IMMACULATE CONCEPTION

c. 1733–34. Oil on canvas, 12'5" × 4'10" (3.78 × 1.87 m)
Museo Civico, Vicenza

The Immaculate Conception is one of several altarpieces Tiepolo painted during his lifetime that was to stand in direct relation with or near a painting by his distinguished older colleague Giambattista Piazzetta. *The Education of the Virgin* (plate 7) in S. Maria della Consolazione stands across the nave from, although not directly facing, the latter's *Virgin and Child Appearing to St. Philip Neri.* For the church of S. Maria d'Aracoeli in Vicenza, joined to a Franciscan convent of Poor Clares, Piazzetta painted *St. Francis in Ecstasy* (Museo Civico, Vicenza) in 1729;[16] within a few years, Tiepolo completed the painting reproduced here to stand across from it in the elliptically planned building, which held only the high altar and altars below this pair of paintings.[17] Piazzetta's work stood over the altar to the left; St. Francis's head, eyes closed, faced the entering parishioner. In Tiepolo's altarpiece on the right, Mary's head—eyes again closed—also turned in that direction. The two works were separated in the nineteenth century.

Belief in the Immaculate Conception holds that God created Mary before time and *sine macula*, without the stain of original sin committed by Adam and Eve; she is thus a pure and fitting vessel for God's only son. Declared dogma in 1854, the belief had undergone centuries of debate within the Church, particularly during the second quarter of the eighteenth century when Tiepolo painted his Vicentine altarpiece.[18] The Franciscans were the doctrine's most fervent supporters and the Clares were their sister order.

The Immaculate Mary became one of the most popular subjects in seventeenth-century Catholic art. She was often represented in a frontal position, standing on a quarter moon and adorned with a crown of twelve stars; the sun is nearby, and other attributes may flank her. The image is drawn from Revelation 12:1. In his altarpiece, Tiepolo followed the basic formula: the quarter moon cradles his figural composition at the bottom and the stars crown Mary's head. He eschewed other Marian references, such as the fountain, tower, and mirror, and placed the Virgin atop a globe. Wrapped around the globe is a serpent holding an apple in its mouth, an allusion to the belief that Marian power could help wipe sin from the earth. (Given the Church's original opposition to the tenet that the world was round, it is ironic that Catholic art used Columbus's discovery to depict this doctrine.) With a drapery fold that descends from just below the Virgin's clasped hands, Tiepolo emphasized her elongated body, thereby endowing the mother of Christ with an iconic strength. Clouds blow across the heavens—neither time nor place is hinted at—and animated cherubs fly around and above her, but Mary is still and voiceless.

The royal blue cloak covering Mary's head waves in the wind, and her silvery white robe shimmers under divine light. Her majesty is without question. Piazzetta's *St. Francis*, painted about five years earlier, features a range of warm ochers, deep russets, and mahoganies. Francis lies passively in an angel's arms on a diagonal, yielding to divine manifestation, while Mary stands erect, victorious over earthly sin. The altarpieces were impressive together; given their respective dates, one can assume it was Tiepolo who made them work so beautifully as a pair.

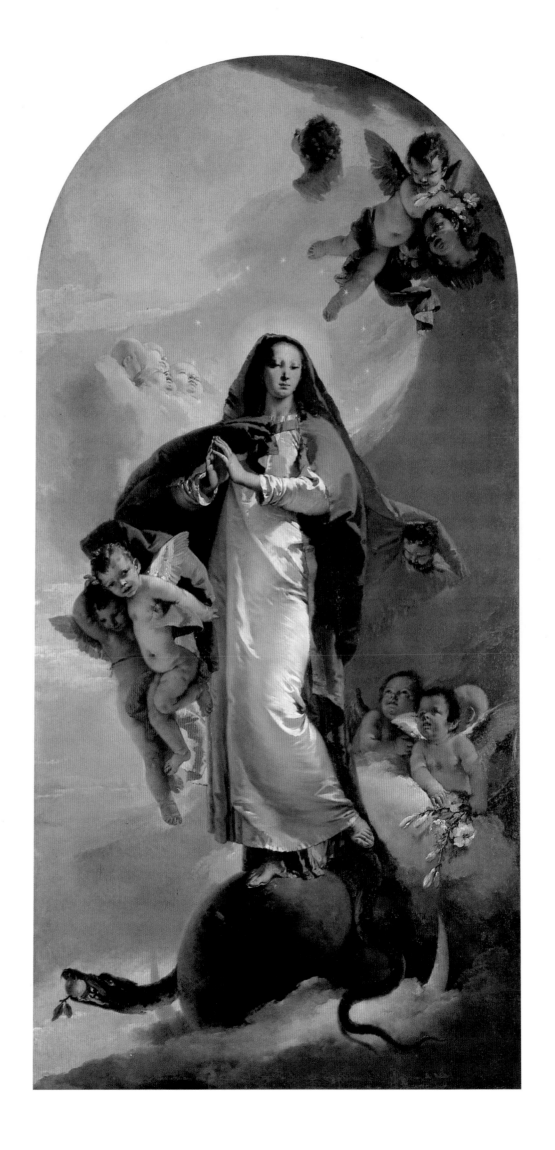

11. JUPITER AND DANAË

1733–35. Oil on canvas, 16⅛ × 20⅞" (41 × 53 cm)
Stockholm University Art Collection

Tiepolo was invited in 1736 to paint in the Royal Palace in Stockholm by the Swedish king's emissary, Count Carl Gustav Tessin.[19] Now very successful, the painter turned down what he considered the count's paltry sum of money but sold him two small oil paintings. Both were narratives, one religious and one mythological: the oil sketch for *The Beheading of St. John the Baptist* in Bergamo (plate 8) and this humorous depiction of one of Jupiter's conquests. The story comes from ancient sources, and Boccaccio repeated it in his *Genealogia Deorum*. The princess Danaë was imprisoned in a tower by her father, King Acrisius, who had sought to prevent access to her because of an oracle predicting that his grandson would kill him; Acrisius had no other children but Danaë. He closed her tower with heavy doors and placed savage dogs before them. Nevertheless, the king of the gods entered, taking the form of a shower of gold; from this union, Danaë bore Perseus who, during a discus-throwing contest years later, involuntarily killed his grandfather with a discus borne awry by the gods.

The subject offered painters the opportunity to depict a nude female responding amorously (or so male painters would always interpret her reaction) to a bright cloudburst. Titian's several versions of the 1540s and 1550s show the nude princess semirecumbent within a curtained bed, lovingly awaiting the shower of gold about to fall on her. A cupid stands watching or, as in the painting for Philip II of Spain, an old crone sits on Danaë's bed, holding her apron up for as much divine gold as will come her way. Rembrandt's *Danaë* of a century later reclines but lifts her head and one arm as if to embrace and welcome the king of the gods.

This *Jupiter and Danaë* is an altogether different work. Tiepolo enlarged the cast of characters, but he did not depict a tender or amorous woman, and the painting's mood is neither expectant nor hushed. An elderly, lecherous Jupiter—his mouth open as if incredulous before Danaë's voluptuousness or, more likely given his hoary beard and flaccid flesh, simply short of breath—sits vulgarly astride a cloud. She, in contrast, is resting languorously, hardly welcoming the divine visitor as she ought, and a young page is either informing the rude woman that someone has just come in or is actually helping her turn to receive Jupiter. An old female servant, similar in type to the woman with the salver on the far left of the Bergamo *Beheading*, holds a golden platter to gather the gold. Because of her position in the center of the painting, she transforms the story into one of pecuniary, not amorous, reward. Other humorous elements are the sixteenth-century Venetian architecture (an enclosed tower, indeed!), and the two noisy animals, Jupiter's screeching eagle and Danaë's tiny, leaping pup.

Tessin was too poor a patron to attract Tiepolo the frescoist, but he was an excellent judge of his art. He wrote home that it was full of spirit, fiery, brilliantly colored, and that it was executed with surprising speed. The description fits *Jupiter and Danaë* perfectly. In purchasing it along with the small *Beheading*, Tessin got hold of two diametrically opposed examples of Tiepolo's art, not just the religious versus the mythological, but also the deadly serious versus the humorous and sensual. No other eighteenth-century painter was capable of moving so brilliantly across this wide range. Although typical of many contemporary mythological paintings which are small cabinet works, the mock-heroics of *Jupiter and Danaë* recall such grand, seventeenth-century paintings as Caravaggio's *Amor Vincit Omnia* (Staatlichegemäldegalerie, Berlin) and Rembrandt's *The Rape of Ganymede* (Gemäldegalerie Alte Meister, Dresden), which innovatively altered Renaissance interpretations of ancient mythology.

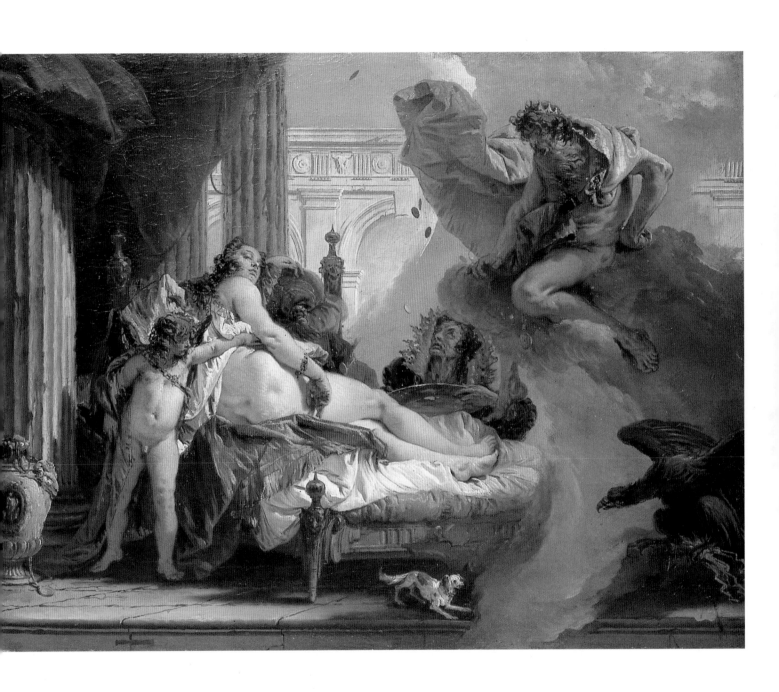

12. ST. CLEMENT ADORING THE TRINITY

c. 1735–36. Oil on canvas, 16′ ⅛″ × 8′ 8¾″ (4.88 × 2.56 m)
Alte Pinakothek, Munich

This altarpiece was commissioned by Clemens August, archbishop-elector of Cologne, for the Chapel of Nuns in the church of Nôtre-Dame at Nymphenburg Palace, Munich. The painting's style suggests that it was executed in the years immediately preceding 1739, when the chapel was consecrated.[20] The archbishop chose the subject, one assumes, to commemorate his patron saint, the Church's third pope, who was believed to have been martyred by drowning in the Black Sea. The Triune Divinity is one of the fundamental tenets of Catholicism, and the archbishop may have decided to have his papal namesake depicted in adoration of it to emphasize the central difference between his Catholicism and the northern Protestant world in which he lived.

Several sketches can be associated with the completed altarpiece. What appears to be the earliest of them both in style and compositional idea is the small oil in the Courtauld Institute Galleries, London (an identical image is in the Accademia Carrara, Bergamo).[21] It shows Pope Clement below the Trinity, but about to be martyred at the edge of the sea rather than praying in a church. A boat and anchor, associated with his death, appear in the middleground, and several executioners gather around him. The scene is one of both human tragedy and divine revelation. Another oil sketch (National Gallery, London) changes the first idea radically, presenting exactly what Tiepolo would finally depict for Clemens August in the altarpiece. Somewhere along the way the archbishop must have changed his mind about what he wanted from Tiepolo. He did not give up his wish for a painting of the pope's martyrdom, however, for he later commissioned this subject from Giambattista Pittoni for a church in Münster.

St. Clement was a giant step in Tiepolo's career, in part because of its monumentality. Never before had he painted such an immense altarpiece, and having to create a devotional composition in a grand vertical format of comparatively narrow width made new demands on his powers. His solution to the problem was to represent one principal theme along a diagonal line down the entire length of the canvas: a mystical conversation between two bearded old men, God the Father and Pope Clement, the first offering grace and the second searching for it. Christ's giant cross, which had played a minor role in the first oil sketch, parallels that oblique line, signifying that heavenly grace, represented by the Holy Dove, will come only through belief in the Son's self-sacrifice for mankind. The cross's position is reinforced by that of the papal crozier. Christ does not sit before the Father in space as he does in the Courtauld and Bergamo sketches but is here the Trinity's most passive member.

The painting's force is partially achieved by the incredible tangibility of the world in which the apparition is taking place. The impressive architectural space, the thick clouds, the magnificent censer on the altar steps, and the bejeweled tiara on the velvet cushion convince the pious of the miracle's believability. Presenting pictorial visions as palpably real was an approach that Tiepolo used in contrast to all contemporary Venetian painters, who emphasized the otherworldliness of the sacred realm.

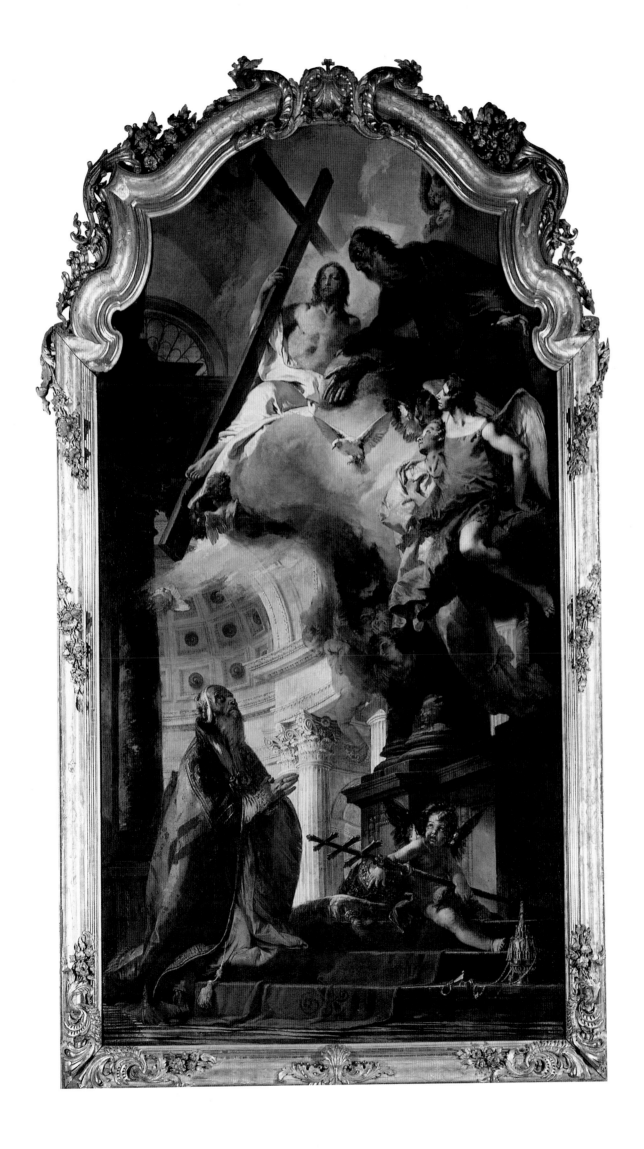

13. CEILING FRESCOES

1738–39

S. Maria del Rosario, Church of the Gesuati, Venice

These were Tiepolo's first great ceiling frescoes for an ecclesiastical interior in Venice. Here in this beautiful Dominican church, built on designs by Giorgio Massari in the 1720s and decorated in the 1730s and 1740s, Tiepolo painted forty frescoes of varying dimensions during a twelve-month period beginning in September 1738.[22] Covering the center of the nave vault (which is false and consists of stucco over a wood armature) are *The Glory of St. Dominic*, *The Institution of the Rosary* (plate 14), and *The Virgin Appearing to St. Dominic*. Medallions showing the fifteen mysteries of the Rosary and angels decorate the rest of the ceiling. On the upper wall over the principal doorway a roundel contains a portrait of Pope Pius V kneeling before an altar and an angel overhead pointing to a naval battle that rages in the distance. Tiepolo painted the symbols of the four Evangelists over the high altar; a roundel of David playing the harp surrounded by the prophets Isaiah, Jeremiah, Ezekiel, and Daniel over the choir's central bay; and a roundel of the Holy Trinity on the choir wall. All the frescoes but the three in the center of the ceiling are in grisaille, or gray monochrome.

The organization of the ceiling follows the usual Venetian tradition of painted ceilings in its compartmentalization into separate geometrical components; it is particularly close in design to Antonio da Ponte's framing of Veronese's oil paintings on the ceiling of the Sala del Collegio in the Ducal Palace. Unlike Veronese, however, Tiepolo painted in fresco, a technique that since the Renaissance was completely untraditional in Venetian interiors. Thus in its basic appearance, Tiepolo's ceiling is similar to yet different from earlier painted ceilings in his city.

Given the brightness of the light that enters through the church's six large windows looking toward Venice's widest canal, the Giudecca, and the awkward, oblong shape of the ceiling, Tiepolo was successful in fashioning a painted complex of refined elegance and great legibility. The sixteen monochromatic medallions of four different shapes stretch along the surface of the vault and appear fastened to it with delicate ribbons in floral designs. Simple moldings mark the springing of the vault, in whose center a heavier and more sculpturally conceived molding frames the three principal frescoes. The moldings increase in width and number toward the center of the ceiling and thus convey the impression of weight, a clever idea that adds to the illusionism of the vault and its pictorial scheme. Elegant floral scrollwork around the three central frescoes—roses symbolizing Mary and lilies referring to St. Dominic—contrasts with the thicker ribbing. The stucco work is painted a warm beige somewhat deeper in tone than the neutral color of the vault.

Never again would Tiepolo design a ceiling in which frescoes so exquisitely harmonize with their vault. The central narrative and its two flanking heavenly apparitions project clearly down to the viewer's world because of the contrast between their rich colors and the beiges and grays that dominate elsewhere on the ceiling. The neutral spaces around the medallions create an impression of openness and lightness that contrasts with the bursts of color and the fully modeled figures in the central fields, and with the heavy architectural rostrum in *The Institution of the Rosary*.

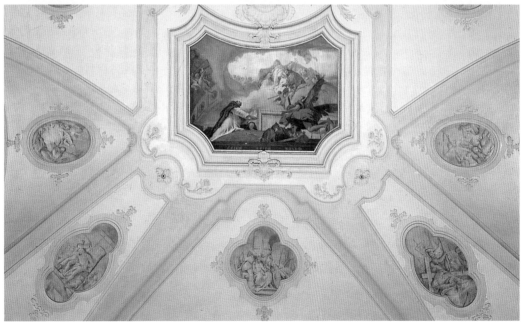

14. THE INSTITUTION OF THE ROSARY

1738–39. Ceiling fresco, 45'11" × 14'9" (14 × 4.5 m)
S. Maria del Rosario, Church of the Gesuati, Venice

This fresco is the largest version of the subject in European art, and it conflates two iconographic traditions, the *Rosenkranzbild*—Mary's giving of the Rosary to mankind—and the dramatization of the Rosary's efficacy on earth, here represented by the expulsion of heresy as St. Dominic passes the Rosary on to mankind.[23] Tiepolo dramatizes Dominic's gesture by pointing to it with a halberd held by an armed soldier, who is accompanied by a muscular figure with a dog. The latter is a reference to the Dominicans, the resident order of the church, from whose name came the wordplay, *Domini cani*, or God's hounds.

Tiepolo articulates a clear devotional message along the central vertical axis of the fresco: Mary, queen of Heaven, has her son, Christ, send the Rosary to earth via St. Dominic, who is supported in his endeavors by armed strength, to expel evil from the world. Across that spiritual line runs an earthly one: Dominic's gift reaches mankind through the head of state, here the *doge* of Venice, behind whom kneels a turbaned heretic (the Turk, Venice's enemy), a nun, and a mother and child, a symbol of Christian charity that appeared often in Venetian devotional art from the Renaissance on. Tiepolo set these crossing axes within a sophisticated zigzagging composition running up to or down from Mary and Christ. This is a fundamental device of eighteenth-century Venetian art and was invented early in the century by Sebastiano Ricci. Giambattista Piazzetta fully exploited the idea in his cloud-filled altarpieces, and Tiepolo expanded the idea in the present ceiling, linking the three individual scenes to create unity through the entire length of the nave vault. In *The Virgin Appearing to St. Dominic* (at the bottom of plate 13), the saint prays to Mary along an oblique line extending up to the right; the zigzagging movement in the *Institution* begins directly above Mary and resolves at the angel high in the heavens whose great wings turn to the left and lead our gaze to the saint in the *Glory* above, whose body and arms open upward to the right.

Two oil sketches can be associated with Tiepolo's preparation for the *Institution*. One (formerly Bode Museum, Berlin; destroyed at the end of World War II), was different in several ways from the finished fresco. The final composition was fully adumbrated in what must have been the second sketch (Private Collection). The two show something of how the painter thought and suggest that Tiepolo's sources for the grand fresco were Veronese's, Palma Giovane's, and Tintoretto's allegorical oil paintings for the ceiling of the Hall of the Great Council in the Ducal Palace. The architecture, the figures of heresy, the pointing halberd and dog at the bottom of the composition, and several smaller motifs all originated in these great state paintings. Tiepolo took them over, reordering them from one sketch to another and finally modifying them to create a painting whose primary theme was pious. The three Renaissance oils must have attracted Tiepolo as sources for the *Institution* for several reasons. First, their grand rhetoric offered him ways to express Dominican propaganda; second, like the *Institution*, they narrated events for the purpose of inspiring personal devotion in the onlooker. But whereas the images of state hold up governmental achievements sanctioned by God to encourage patriotism, the Gesuati fresco displays a special Dominican devotion sent to the order by Mary and Christ to fulfill God's will.

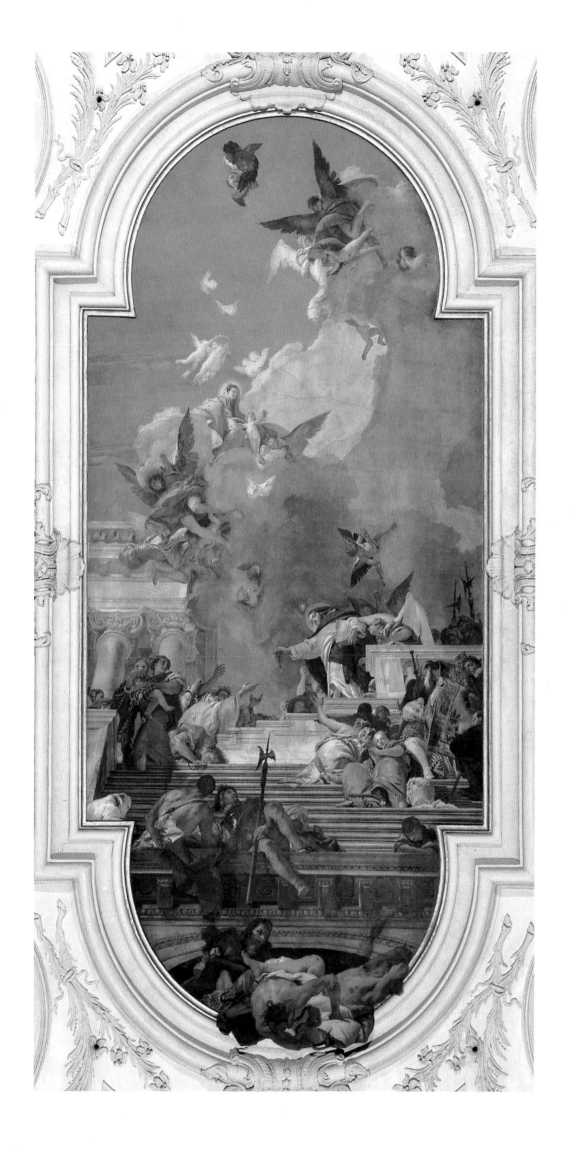

15. THE WAY TO CALVARY

c. 1739. Oil on canvas, 14'9" × 16'11" (4.5 × 5.17 m)
S. Alvise, Venice

Far from the center of Venice stands the conventual church of S. Alvise (Venetian dialect for Ludovico), dedicated to St. Louis of Toulouse, for which Tiepolo painted the large *Way to Calvary* with two related but smaller scenes, *The Crowning of Thorns* and *The Flagellation* (fig. 12). The latter two canvases were first mentioned in print in 1740, and it has generally been assumed that *The Way to Calvary* is contemporary with them.[24] The trio's style and conception appear to confirm this. All of identical height and linked in subject matter, they would appear to have formed a triptych, although no eighteenth-century guidebook locates the two narrower paintings in the church close to *The Way to Calvary*.

The Way to Calvary is a forceful image, especially now that centuries of dirt have been cleaned away. Christ falls to the ground wearing a brilliant red robe, and many of the other robes match his in intensity. His unbearably large cross cuts diagonally upward and projects in space; other figures continue the pull upward but move into the distance, toward Golgotha and the Crucifixion. A horse whinnies, a trumpet sounds, and martial arms and Roman banners and insignia pierce the skyline. Contrasting with the noise and movement are Christ, who is in momentary repose; the two thieves who, although they have not had to drag their crosses, are exhausted; the quiet onlookers in the rear (Mary among them), and the silent, mournful Veronica, who holds the veil with which she has just wiped Christ's face. The boy carrying the superscription behind her mirrors her position.

Tiepolo's oil sketch (Staatlichegemäldegalerie, Berlin) differs in several respects from the painting. Veronica is missing, for example. The most important changes were made in Christ's figure, and in the position of his cross and the placement of the hill of Golgotha. Christ's fall is less artful in the sketch than in the painting, where he is definitely more tragic. His outstretched arm and hand in the painting express dramatic pathos. His cross in the sketch has already been lifted from his back, whereas in the painting it still weighs on him partially. Golgotha is in the left distance in the sketch; in the painting, it rises up monumentally just behind the fallen Christ.

Tiepolo's changes may or may not please today's viewer. Were they totally his own decisions? One must remember that part of the function of an oil sketch was to elicit approval from a patron, who in this case was Alvise Cornaro. Cornaro might have requested the very alterations that render the scene more theatrical and that are today blamed on the painter. An equally melodramatic tone is struck by Rubens's *The Way to Calvary*, an altarpiece executed in the 1630s for the Benedictine abbey of Afflighem and for which the Flemish master made several related sketches. One of them was in a private collection in Venice during the early eighteenth century and was engraved by Pietro Monaco in 1763.[25] Tiepolo must have seen and considered it in the light of Venetian tradition, for example, Tintoretto's sensational *Crucifixion* in the Scuola Grande di S. Rocco. Giambattista's own *Crucifixion* (fig. 4) and his *Beheading of St. John the Baptist* (plate 8) were preparations for this shocking and overwrought image in S. Alvise, whose commission came from one of Venice's most refined families, one with a history of remarkable art patronage. The sophistication of Tiepolo's mature *Way to Calvary* may be judged by comparing it with his youthful *Crucifixion* on Burano.

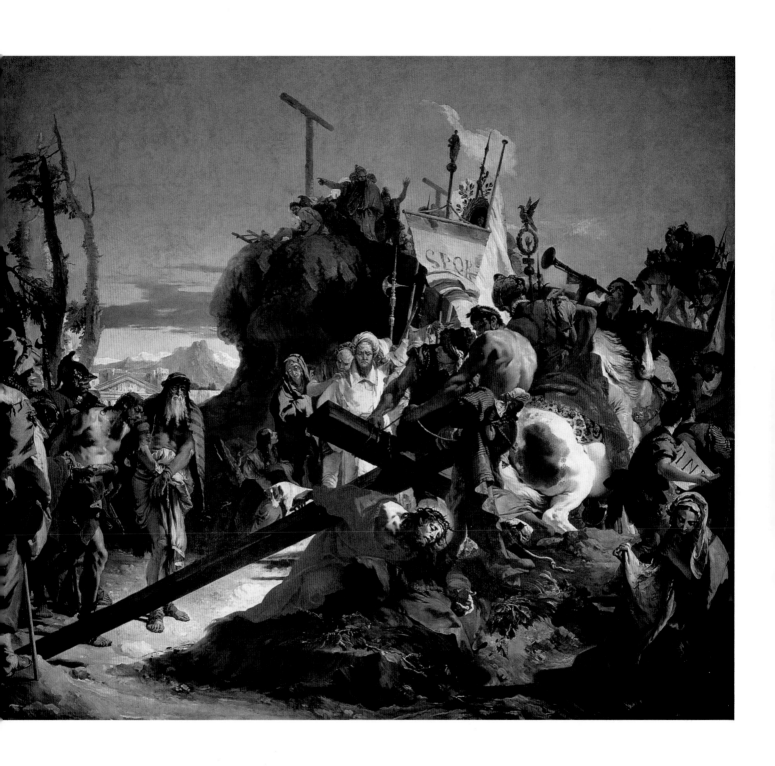

16. THE COURSE OF THE CHARIOT OF THE SUN (detail)

1740. Ceiling fresco, 72'2" × 17'9" (22 × 5.4 m)
Salon, Palazzo Clerici, Milan

The Clerici ceiling (fig. 13) is a turning point in Tiepolo's long career, both an end and a beginning. It was the last of his several commissions in Milan. Defining his first maturity, they had begun with the Archinto and Casati frescoes in 1731–32; they were followed by those in S. Ambrogio in 1737 and his work for Antonio Clerici in 1740. This last commission also opened a new phase. The fresco was his first mature, extensive, secular fresco decoration for a noble's home, the type of project for which he is best remembered today. Palazzo Labia in Venice would follow in the mid-forties, then the Archbishop's Palace in Würzburg and Villa Valmarana in the fifties, and, finally, the Royal Palace in Madrid at the end of his life. His success in Palazzo Clerici must have determined to a great extent how he would approach the later commissions.

Tiepolo's solution for the Clerici ceiling was based on the much smaller and earlier Sandi ceiling in Venice (plate 2), where he had used the room's cornice as a stage above which to open the heavens; Venus and Apollo control the Clerici skies whereas Minerva and Mercury determine events in Palazzo Sandi. (The basic scheme was invented by Luca Giordano in the 1680s for the ceiling in the salon of Palazzo Medici-Riccardi, Florence.) But the differences between the Sandi and Clerici compositions are as important as their similarities. Whether it was because the Milanese hall is larger than the Venetian one or because he was more accomplished in 1740 than in the mid-1720s, here Tiepolo created more open, more irregular, and seemingly more erratically organized figural groupings against a sky so dense with shifting and multicolored cloud formations that the viewer below is forced to promenade, to change direction in the room, and to turn his or her head constantly to understand the painting. The salon's pictorial decoration thus comes alive, as the painted ceiling appears animated rather than static. In the detail here, Venus's shifting draperies, Time's outspread, angular wings and scythe, the chariot's great wheel, and the outstretched limbs of the putti are the ingredients we see of this amazing pictorial concoction.

One of the many distinctions we can make between Tiepolo's mature religious art and his secular subject matter is his interpretive emphasis on physiognomy for his pious figures and on physicality for his gods and goddesses. Although something of an oversimplification, this point is illustrated by Venus and Time on the Clerici ceiling. The painter concentrates on the goddess's voluptuous, passive, and curving form and on Time's solid, muscular body, which is turned so that his strong back, bold wings, and scythe all penetrate space. Tiepolo devotes little attention to their facial expressions, which is the very antithesis of his almost contemporary treatment of God the Father and St. Clement in the Munich altarpiece (plate 12) and of Christ, Mary, and Veronica in *The Way to Calvary* (plate 15).

An anonymous Milanese writer celebrated Tiepolo's Clerici fresco by composing *Poesie dedicate al merito singolarissimo del Sig. Gio. Battista Tiepolo celebre pittore veneto immitatore di Paolo Veronese* . . . (Poems Dedicated to the Most Singular Merit of Sig. Gio. Battista Tiepolo, Celebrated Painter from the Veneto and Imitator of Paolo Veronese).[26] Today, it is an implicit criticism of Tiepolo's art, as well as a commonplace, to write that he was merely a copier of Veronese. But his contemporaries saw such a comparison as the highest of compliments. However, the epithet was not used by Tiepolo's Venetian compatriots until somewhat later, after he had decorated several palaces in the city in the 1740s. Apart from the Milanese reference, the only other early mention of Tiepolo in terms of Veronese was Count Tessin's in 1736.[27] One suspects that foreigners understood Tiepolo's modern art and placed it in the scheme of things earlier than Venetians did.

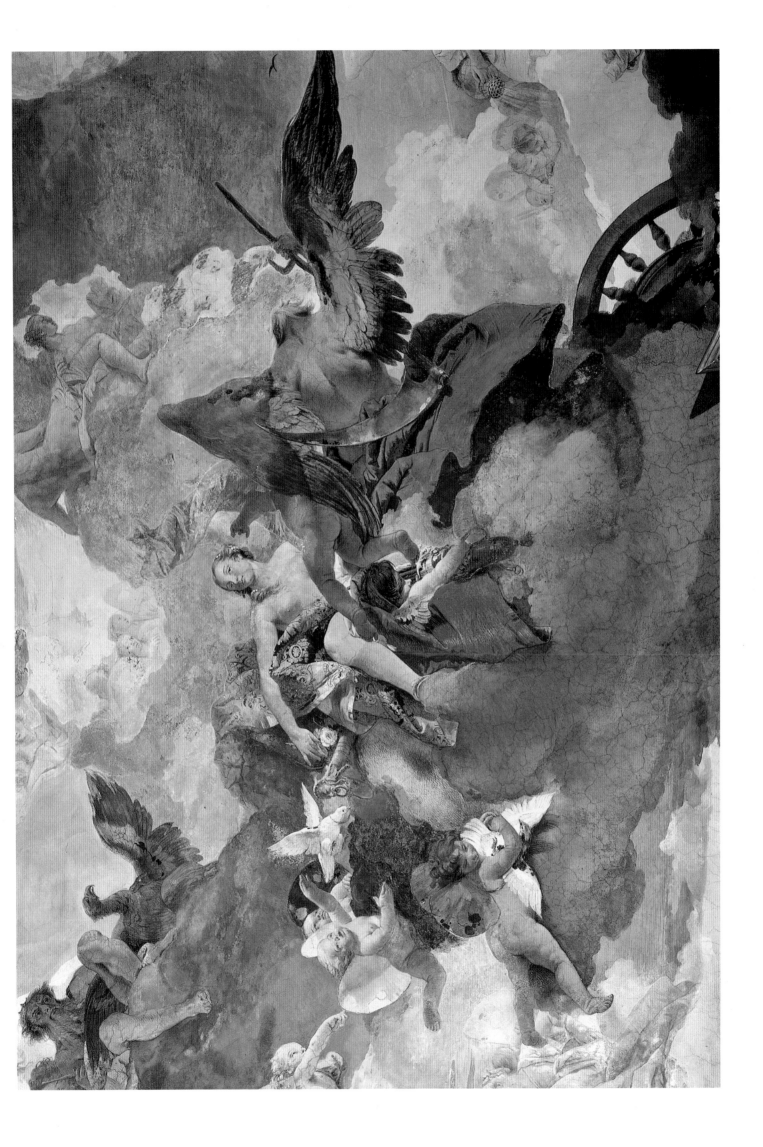

17. THE FALL OF MANNA

c. 1740–43. Oil on canvas, 32'10" × 17'3" (10 × 5.25 m)
S. Lorenzo, Verolanuova (province of Brescia)

This imposingly tall painting and its pendant, *The Sacrifice of Melchizedek* (fig. 27), decorate the two side walls of the Chapel of the Most Holy Sacrament, situated on the left side of the nave in the large parish church of Verolanuova. Over the chapel's altar sits Francesco Maffei's *The Last Supper*; Tiepolo's two canvases were clearly commissioned to provide Old Testament prefigurations of one of Christianity's sacred mysteries. The faithful entering and walking down the nave of S. Lorenzo see the *Fall* directed toward them (on the right wall as one stops to face the chapel; also see the detail in fig. 26); it recounts events from Exodus 16, the Lord's discharge of his promise to rain bread from heaven on the hungry and grumbling Hebrews in the desert. After Mass in S. Lorenzo, the worshipers returning down the nave and passing the chapel once more see *The Sacrifice of Melchizedek*; Genesis 14:18–20 narrates Melchizedek's holding aloft of bread and wine, which foreshadows, according to Christian interpretation, the Eucharist, which would have just been celebrated at the church's high altar. Thus the subjects of Tiepolo's paintings were chosen not only to support the chapel's dedication to the Holy Sacrament, but they were also meant to function thematically in relation to the worshipers' larger experience in S. Lorenzo.

Tiepolo accepted the commission at Verolanuova in a letter dated January 11, 1740.[28] Although he approved the choice of the *Sacrifice* as apposite to the chapel, he wondered whether something more fitting than the second choice, *The Fall of Manna*, could be found; he would let the commissioning deputies know if his "fantasy" suggested anything else. It clearly did not. In late September 1742, the deputies still had not heard from the painter regarding the completion of the two canvases. It is generally assumed from stylistic evidence that they were finished shortly thereafter.

Tiepolo's *The Fall of Manna* followed many earlier versions of the subject in Italian art; the most famous Venetian examples were Tintoretto's of 1592–94 for S. Giorgio Maggiore and Sebastiano Ricci's of about 1718 for Ss. Cosma e Damiano (see plate 6). Both of these canvases are horizontal in format. Because his painting was tall rather than wide, Tiepolo was forced to rethink the subject's usual interpretation; like other painters before him, he depicted many Israelites, all varied in type, position, and placement, but he emphasized the story's celestial aspect. In changing the pictorial tradition, he deviated from the biblical text, as had Nicolas Poussin in his painting (Musée du Louvre, Paris) of 1637–39 for Fréart de Chantelou. For the Bible does not recount that the Jews gathered the manna as it fell; rather, they found it every morning with the dew. Tiepolo has created not only a narrative image but also one that, like that in the adjacent altarpiece, is devotional in intent. Marvelous trees reach up to the heavens and to the manna pouring from an angel's vase down to a platter held aloft by a figure on earth; Tiepolo reinforced this compositional axis with mountains, a tent, a vase-bearing woman in the distance, and by placing the standing Moses, his arms upraised, on a promontory.

The Fall of Manna works beautifully with its pendant, and not only in terms of their subject matter. Its composition opens to the left, past the mounted soldier (also not in the text) to Moses, Aaron, and their tent, thus directing our gaze in toward the chapel's tabernacle. The composition of the *Sacrifice* also draws our attention to the left, past the shadowed soldier holding a red banner, the kneeling Abraham, and Melchizedek, and to the two males standing on the far left with the ox, but this movement is counteracted by the gleaming white tree whose thick, weighty trunk causes us to look down and to the right, that is, toward the painted altar in the center of Tiepolo's picture, which corresponds to Christ's table in Maffei's *Last Supper*.

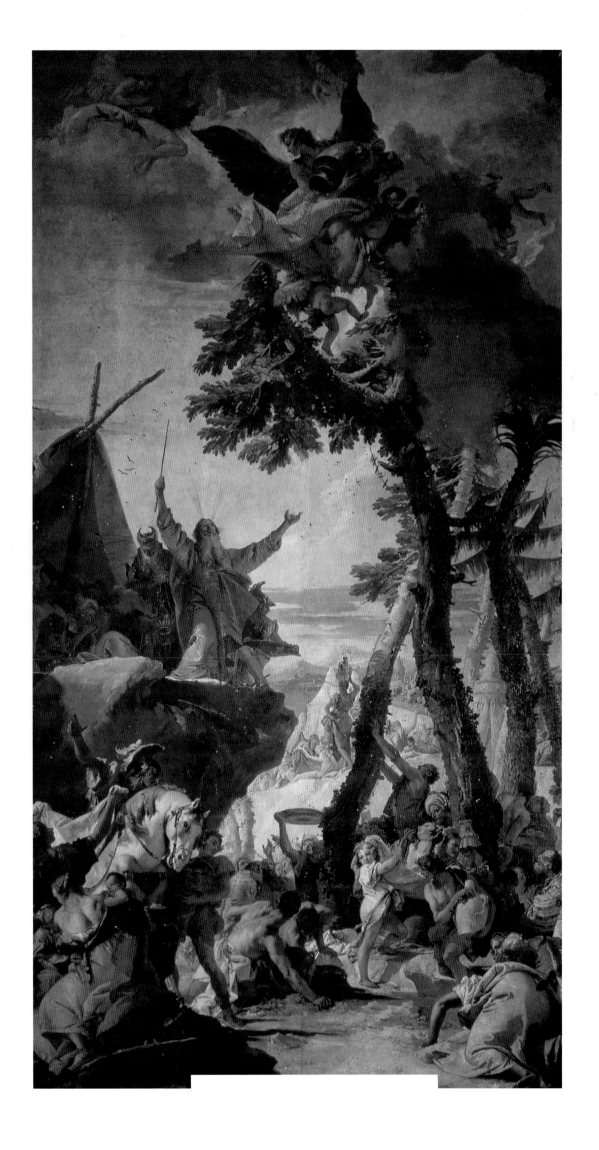

18. RINALDO ENCHANTED BY ARMIDA

c. 1742–45. Oil on canvas, 6' 1⅝" × 7' 5⅝" (1.87 × 2.15 m)
The Art Institute of Chicago. Bequest of James Deering, 1925.700

This painting is one of a group of eight canvases, four in the Art Institute and four in the National Gallery, London, that Tiepolo executed as a pictorial ensemble for a room in a Venetian palace.[29] The four London paintings, all quite narrow and vertical in format, were most likely paired, two by two, around the two larger Chicago paintings. The entire series narrates episodes from Torquato Tasso's *Gerusalemme liberata*, concentrating on the story of Armida and Rinaldo; the sequence began, most likely, with the canvas reproduced here.

Tasso's epic poem relates the Christian forces' heroic struggles to free Jerusalem from the Saracens during the First Crusade, and its many stories had interested painters since its publication in the late sixteenth century. The love story of Rinaldo and Armida in particular fascinated, among others, Annibale Carracci, Poussin, and Guercino, who represented different episodes involving the two, and Lully, Handel, Vivaldi, Scarlatti, Gluck, Rossini, and Donizetti, who set the story to music. The poem enjoyed special popularity in Venice in the mid-eighteenth century. Giambattista Piazzetta designed a series of illustrations for a splendid new edition of the poem published in 1745; and around 1750 Giannantonio Guardi, elder brother of the more famous painter Francesco, executed eight canvases with scenes from the poem to form an ensemble like Tiepolo's. If Tiepolo's cycle indeed dates from the early 1740s, it would be the earliest of these three important and impressive Venetian manifestations of what must have been a *Gerusalemme* fashion in Venice just before midcentury.

Tiepolo's own involvement with Rinaldo and Armida ranged across the 1740s and 1750s. Apart from the Chicago-London cycle, there are the contemporary *Realm of Flora* (plate 19), which allegorizes Armida's garden; the frescoed "Tasso room" in Villa Valmarana (plate 35) of 1757; and the two canvases executed during the Würzburg years, each with its own related oil sketch (Staatlichegemäldegalerie, Berlin, and Cailleux Collection, Paris). Several other paintings on the subject have also been attributed to Tiepolo.[30] In each commission the artist created a different pictorial magic, capturing Armida's love for Rinaldo and his infatuation with her in her enchanted garden.

The Chicago paintings are remarkable for their open spaces and pastel coloring. Density and weight of any kind are avoided, gravity seems overcome, and air appears luminous. Architecture has been reduced to a minimum, and saturated colors are found on only a few draperies. In this manner Tiepolo evokes the story's fairy-tale nature, its magical elements, and the poetry of Tasso's epic.

In the painting here, Armida catches sight of the beautiful sleeping Rinaldo for the first time (Book XIV). She had been sent by her uncle, the wicked commander of the pagan forces, to seduce the Christian general and thus weaken the Western enemy. Although intent upon her treacherous plan, she yields to human emotion and falls unexpectedly and deeply in love with him. Tiepolo depicted Armida as a bewitching sight, only partially covered with a skirt of the palest greens and resting on a brilliant, yellow gold mantle. Both it and a piece of the pale green drapery waft upward. A cloud partially hides her magical chariot, the circular shape of one of its wheels repeated in Rinaldo's shield on the other side of the compositional grouping.

82

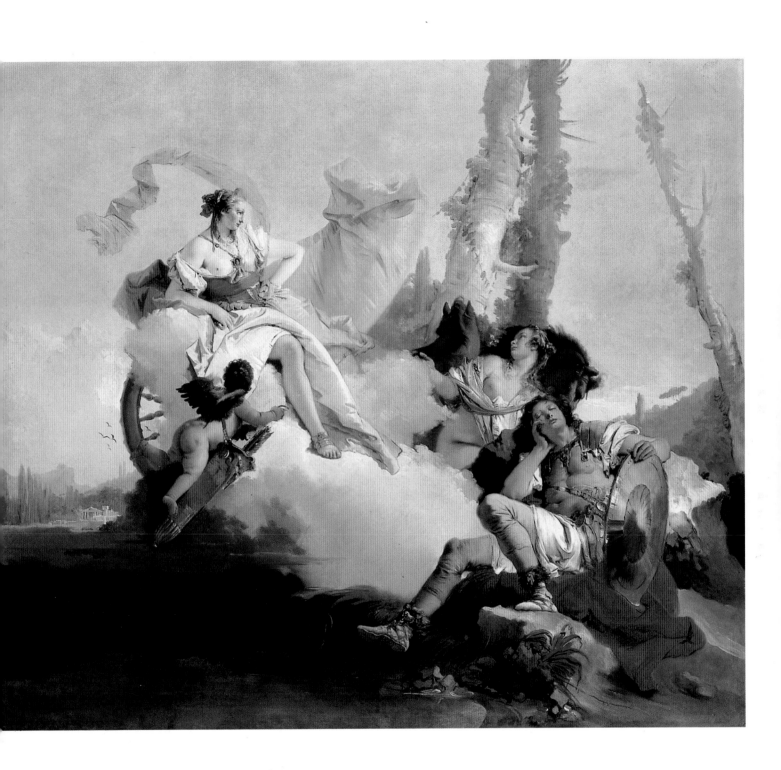

19. THE REALM OF FLORA

1743–44. Oil on canvas, 28½ × 35" (71 × 89 cm)
The Fine Arts Museums of San Francisco. M. H. De Young Memorial Museum.
Gift of Samuel H. Kress Foundation

Commissioned by Francesco Algarotti for Count Heinrich Brühl, minister to King Augustus III of Poland, *The Realm of Flora* and its pendant, *Maecenas Presenting the Arts to Augustus* (The Hermitage, Leningrad), were completed and shipped to Brühl's palace in Dresden in March 1744. The pair refer to the German minister and his eminent position at the court; with them, Algarotti hoped to flatter Brühl in order to receive the crowning position of his career, the Saxon post of superintendent of the king's royal collections and buildings.[31] The two paintings function visually in counterpoint with one another. Whereas the first depicts female protagonists in a pastoral scene, the second presents male figures in an urban setting; Flora's world was mythological but Maecenas's was historical. And while three actual ancient sculptures—the *Faun with a Kid*, *Egeria*, and *Flora*—decorate the garden scene, Minerva and Apollo were copied from Raphael's *The School of Athens* to ennoble Augustus's court.[32] Finally, the fountain in the garden of Brühl's country villa appears in the distance in *Flora*, and his Dresden palace stands along the far embankment in *Maecenas*.

The pendants harmonize thematically as well. In *Maecenas*, Tiepolo depicted the famous Roman patron of the arts presenting three female personifications of Painting, Sculpture, and Architecture to Emperor Augustus; the nearby youth holding a horn is Music, and the blind Homer represents Poetry. The painting is an allegory of the patron's public role in society, of his power to enlighten both ruler and state. In contrast, *Flora* is an intimate parable about the power of art, beauty, and love to affect a patron.

It has always been assumed that the voluptuous nude on the chariot is Flora, but this is incorrect. The dancing figure on the right repeats almost exactly Poussin's Flora from his *The Realm of Flora*, which had entered the Dresden royal collections in 1722 and was known personally to Algarotti.[33] Hiding on the far left of Tiepolo's scene are two soldiers whose rod and shield identify them as Carlo and Ubaldo, Rinaldo's two faithful companions in Torquato Tasso's great epic, the *Gerusalemme liberata*, which was Algarotti's favorite modern poem.[34] The two soldiers are spying on the enchanting Armida, the scheming witch who had charmed Rinaldo in her magic garden to deprive the Christian forces of their heroic general during their struggles against the Saracens.

The Realm of Flora does not recount any one moment of Tasso's *Gerusalemme liberata*. Just as *Maecenas* does not depict history but allegorizes it, so this painting does not "recite" poetry but pictorializes it. Tiepolo—and Algarotti—sought here to recapture Tasso's famous description of Armida's garden (Book XVI: 9–10), in which the poet linked art to nature but distinguished between artifice and reality. During the seventeenth and eighteenth centuries, Tasso's verses became part of a theoretical discussion on painting and poetry and on their relationship to nature; it is a discourse referred to as *ut pictura poesis* (as is poetry, so is painting), whose foundations lie in Aristotle's *Poetics* and Horace's *Art of Poetry*. *The Realm of Flora* continues that artistic debate in pictorial terms. It is a pastorale about art and its power to enchant within an eternal springtime of love and poetry. Algarotti's pair of works for Brühl is unique in the history of Western art, and Tiepolo composed them to contrast the majestic domain of state with the splendid world of poetic love.

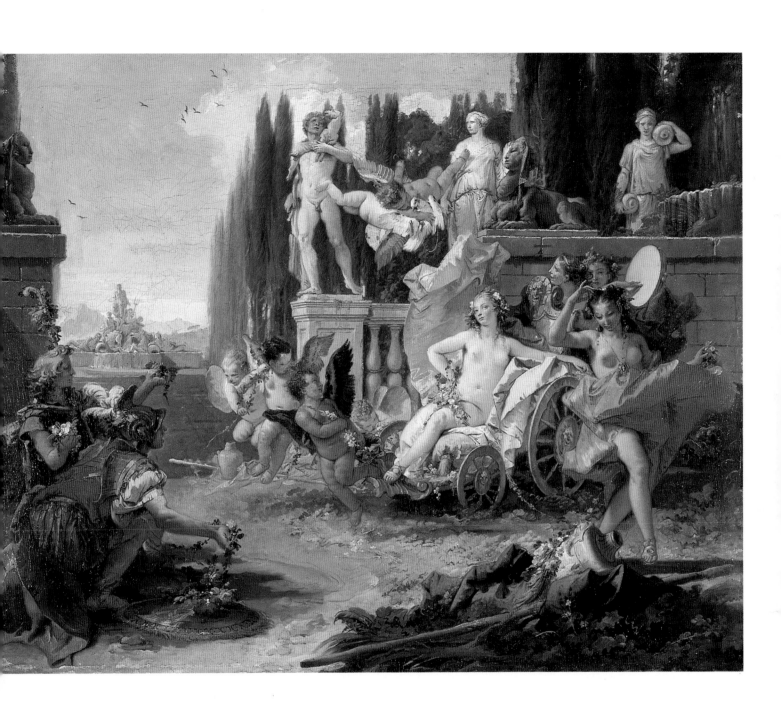

20. THE BANQUET OF ANTHONY AND CLEOPATRA

1743–44. Oil on canvas, 8'2" × 11'4¼" (2.49 × 3.46 m)
The National Gallery of Victoria, Melbourne. Felton Bequest, 1933

In 1743, Francesco Algarotti returned to his native Venice as emissary of Count Heinrich Brühl of Dresden to buy paintings for the royal gallery of Augustus III, king of Poland and elector of Saxony (see plate 19). Tiepolo was among the "moderns" Algarotti intended to buy works from and he lost no time in beginning his dealings with the famous painter.[35] He first ordered a scene of Timotheus Playing the Lyre for Alexander the Great. Nothing appears to have come of that plan, and, for unknown reasons, Algarotti changed the subject to Caesar Contemplating the Head of Pompey, a gory narrative in which the Roman Consul arrives in Alexandria and is confronted with his enemy's decapitated head. In late January 1744, Algarotti wrote to Brühl that he had also ordered a Banquet of Anthony and Cleopatra for the king, a work Tiepolo had already begun for another patron.[36] The pair were shipped to Dresden a couple of years later.

Caesar Contemplating the Head of Pompey has unfortunately disappeared, although a drawing for it surfaced on the New York art market several years ago and its oil sketch survived until recently.[37] From that evidence, it would appear that on the left, before an open sky, bystanders calmly watched the first consul's horror at seeing the ghastly trophy, and Caesar's shudder was dramatically mirrored in his horse's rebellious turn on the far right. Algarotti had written to Brühl about *Caesar* months before mentioning the *Banquet*, but the former painting appears to have been conceived and composed in terms of the latter, which was already begun. Both scenes take place in Egypt, and the two male protagonists—Caesar and Anthony—were the most famous Romans to have visited that country; each hero, moreover, reacts with astonishment. Whereas *Caesar* is set against an open sky, the *Banquet* is situated before an architectural background. Tiepolo stirs our imagination with the grim tale of war and death in *Caesar* and delights us with the story of flowering sensuality in the *Banquet*.

Cleopatra's banquet is about a wager: when challenged by her Roman visitor to see which one of them could offer a more expensive feast, the queen dropped one of her priceless pearl earrings into a glass of vinegar. It dissolved; she won her bet, and Anthony, too, but of course she now lacked a matching set of pearl earrings. Tiepolo was not the first Venetian painter to depict this rather foolish tale of wanton spending. Several sixteenth-century frescoists decorated rooms in Veneto villas with it; Gregorio Lazzarini, Tiepolo's teacher, painted a *Cleopatra* and Sebastiano Ricci painted the feast itself. The story appealed to those whose prodigal tastes needed historical legitimization, but it also offered male patrons an image of one of history's most famous *femmes fatales*. Cleopatra's gesture, moreover, harmed no one. The *Banquet* was not a tale of self-harm, such as Cleopatra's own later suicide or Lucretia's, nor was it one in which she threatened anyone else, as did the biblical Judith and Jael.

Tiepolo imagined a brilliant scene around Cleopatra, Anthony, and his joint consul, Lucius Plancus, the story's mediator. The queen of Egypt is poised, about to let the pearl drop, and an arch springing up directly behind her hand calls attention to the imminent act. Anthony pulls back slightly, and figures à la Veronese play secondary roles to what is, in essence, a soprano-tenor-baritone trio. Algarotti, who owned a small version of the painting (Musée Cognac-Jay, Paris), praised the work for its magnificence, its perspective, and above all for what he termed a pictorial erudition worthy of Poussin, his favorite painter. But as the *Banquet* makes clear, Tiepolo was not thinking of historical archaeology when he painted it.

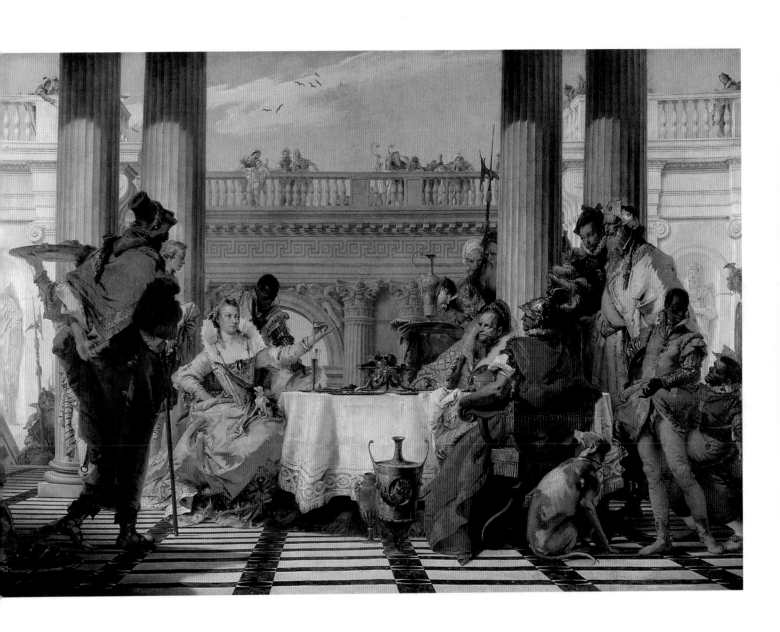

21. OIL SKETCH FOR "THE TRANSLATION OF THE HOLY HOUSE"

c. 1743–45. Oil on canvas, 48⅞ × 33½" (124 × 85 cm)
Gallerie dell'Accademia, Venice

22. OIL SKETCH FOR "THE TRANSLATION OF THE HOLY HOUSE"

c. 1743–45. Oil on canvas, 48 × 30" (121.6 × 76 cm)
British Rail Pension Fund, on loan to the National Gallery, London

Executed in preparation for his great frescoed ceiling in S. Maria di Nazareth in Venice (the church of the Scalzi, or Discalced Carmelites), these two sketches reveal how Tiepolo altered a composition, enlarged on its theme, and even changed his conception of a heavenly image. The church's name derives from a fifteenth-century panel painting brought from the lagoon island of S. Maria di Nazareth; it depicts the Virgin and Child on the Tree of Jesse and carries an inscription dedicated to the Virgin of Nazareth.[38] Tiepolo's fresco (fig. 16), sadly destroyed by bombs in 1915, refers to the church's dedication by depicting the miraculous flight of the Virgin's home from Nazareth to the West. To prevent profanation by infidels invading the Holy Land in 1291, angels are said to have carried the Holy House to Loreto, Italy, where it is still venerated today as a Marian relic.

Tiepolo signed a contract for the Scalzi fresco on September 13, 1743. Documents and the two studies suggest rather conclusively that after he made an initial oil sketch (plate 21), the ceiling was rebuilt to suit a differently proportioned and shaped image; he then made a second sketch (plate 22), for which Girolamo Mengozzi-Colonna created a fictive surround on the new vault; Tiepolo finally worked in the church during the spring, summer, and fall of 1745.

In the Accademia sketch, the Holy House is borne from left to right across the skies by angels; Mary stands on its roof with great equilibrium, and God the Father, Christ the Savior, and the Holy Dove reign in the heavens above. Other angels provide musical accompaniment and a figure of heresy lurches at the bottom left. The second sketch's elongated shape (second because it agrees almost totally with the completed fresco) must reflect Tiepolo's desire to expand the composition and open up the heavens. The second sketch and the fresco were conceived as tripartite compositions; Tiepolo increased the number and force of the heretical figures below and placed greater emphasis on the power of God the Father to transform the small house into a holy object mediating between sin and grace. Like the Virgin Mary atop it, the Holy House casts evil out of the world and assists the faithful in their search for salvation. A zigzagging vertical line connects these motifs, and they cause us to look deep into space, from an area in shadow to a cloud-filled zone above, and finally to the distant empyrean.

Tiepolo altered Christ's position, too, in the second sketch. No longer the Savior in the heavens, he is now a baby in his mother's arm; Tiepolo thus made explicit the link between Mary and the Nazarene building—both are holy vessels. He also shifted St. Joseph; his head and uplifted arms are now on line with God the Father above and the falling figures of heresy below. The artist moved the Holy House to the left and the celestial orchestra to the right. Tiepolo expanded the composition even more fully in the fresco.

Both sketches reveal the mature artist's expressive brushwork, which brilliantly models the figures; it suggests light darting through the skies and the wind swirling through the clouds, causing draperies to flutter and striking against angelic wings.

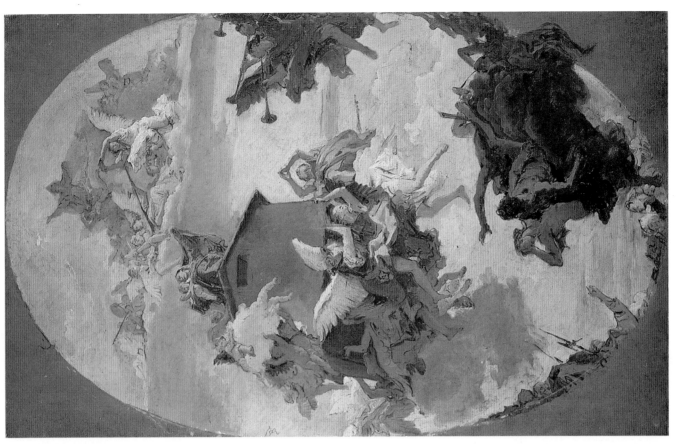

22.

21.

23. THE GENEROSITY OF SCIPIO

1744. Wall fresco, 18' × 16' 1" (5.5 × 4.9 m)
Salon, Villa Cordellina, Montecchio Maggiore (province of Vicenza)

Tiepolo's *The Generosity of Scipio* and *The Family of Darius Before Alexander* (fig. 14) are sublime images, for their monumental spaciousness, certainly, but also for their convincing depiction of deeply felt human emotions. Indeed, they are especially impressive because the protagonists' feelings reach out to visitors in the enormous salon, even overpowering the impressive Roman backdrops, their fluttering draperies, and military insignia.

Tiepolo's patron was Carlo Cordellina, a successful lawyer whose specialization in international jurisprudence may explain his choice of subject matter for the frescoes: both show heads of state offering clemency to foreign prisoners. To renovate his inherited villa, Cordellina had turned to Giorgio Massari; based on Palladian principles, the expanded building is of noble aspect and proportions.[39] The salon is entered from both the front and rear, and it occupies the entire double height of the villa's central body. Tiepolo had completed eight monochromes and half the ceiling fresco, an *Apotheosis of Virtue*, by late October 1743 and hoped to finish the ceiling by mid-November.

This information comes from a letter the artist sent to Francesco Algarotti, the Venetian luminary (see p. 33), in which he added that he would prefer to spend a day discussing painting with Algarotti to the villa's many pleasures. Algarotti's impact on Tiepolo's art is clear from the *Scipio* fresco. Scipio Africanus is enthroned and flanked by two great statues of Minerva and Apollo, motifs that Tiepolo took from Raphael's *The School of Athens*, which was one of Algarotti's favorite paintings. Not only these borrowings reveal the painter's new source of stimulation, however; the archaeological apparatus in both frescoes reflects his new friend's erudite historicism.

In the *Scipio*, visitors see deeply shadowed figures and objects at either edge of the fresco. Scipio himself sits within a veil of transparent darkness. But gleaming in the center of the scene is the most beautifully dressed hostage history has ever known, the Celtiberian princess, who is being returned to her fiancé. She is dressed in a gown of terre verte topped by a robe of cinnabar green and a cloak of pale lilac lined in pale orange. She is, as it were, the sun next to the moon, for Tiepolo dressed Prince Aluccius in deeper yet related shades of dark green and burnt umber. The prince is enamored of his princess and expresses his tenderness for her through glance and gesture.

Tiepolo altered the coloring of his protagonists' robes from his oil sketch (Nationalmuseum, Stockholm); there, the prince wore a blue robe and his fiancée a silver cloak over a yellow gold gown. In the fresco he also pushed the two figures off to the right edge of the archway. Not only did he expand the space but he heightened the drama as well. The inner, receding wall brings our gaze to the reunited pair and — importantly — directs their focus to either side of and just before the pier's vertical molding. The Cordellina frescoes are among Tiepolo's most affecting images, and they signal a new mastery of quiet drama in his art.

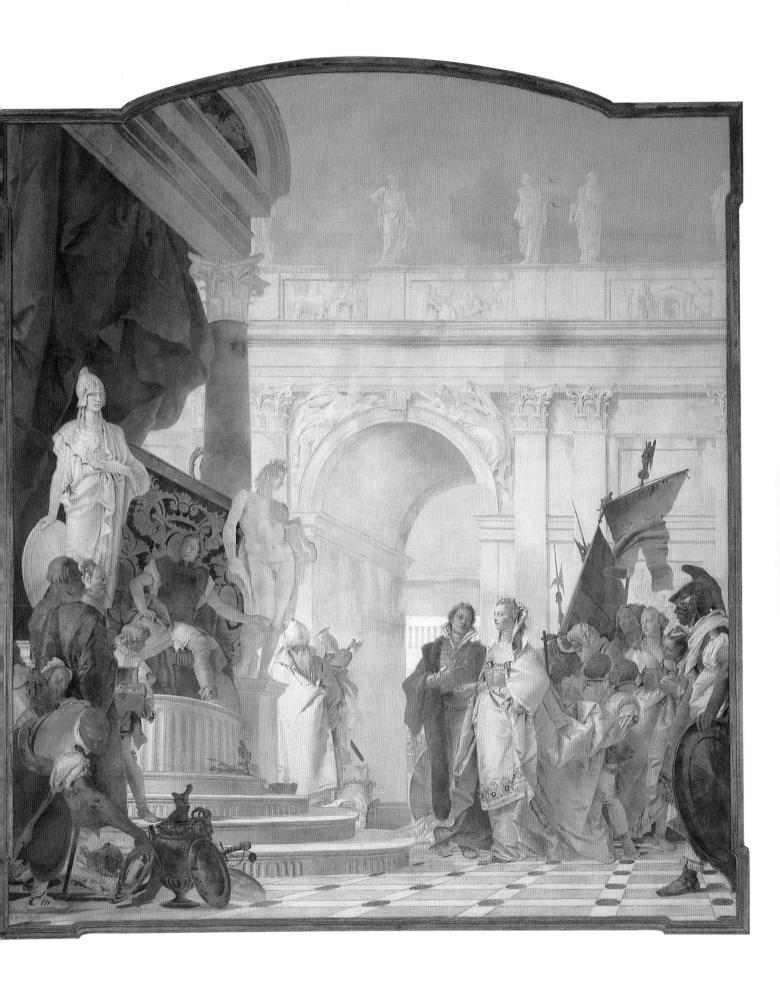

24. WALL FRESCOES WITH "THE BANQUET OF ANTHONY AND CLEOPATRA"

c. 1744–47
Salon, Palazzo Labia, Venice

Tiepolo's Labia paintings are the most concentrated, dramatic interpretations of his several versions of the subjects; at the same time, they are his most elaborate and grandiose presentations of them. Over the *Banquet* is *Time Abducting Beauty* (or *Pluto and Persephone*) and over *The Meeting of Anthony and Cleopatra* (plate 25) is *Aeolus and Two Youthful Winds*. Bellerophon soars overhead in the ceiling painting.

Climbing up the first flight of the grand staircase leads one to the palace's *piano nobile*, or main floor; at the landing, doors open onto the salon, which rises up two stories. The wall opposite the entryway to the salon is mostly windows, but the walls to the right (here and fig. 15) and left (plate 25) contain the Cleopatra scenes. Although splendidly painted and overwhelmingly impressive, they are hardly the room's only decoration. Indeed, there does not appear to be a surface left untouched by Tiepolo and Girolamo Mengozzi-Colonna, his collaborator here and a Bolognese specialist in perspective painting who had begun working with Tiepolo in the 1720s and continued in that capacity throughout the next quarter-century. Real doorways and windows pierce the main walls; each of these openings has a real marble molding. The two painters created vistas that open up behind and around the doors and windows, disclosing new spaces, both exterior and interior. The fictive structural system is massive, heavy pilasters and columns supporting lighter ones above; it is also colorful, changing from deep beige to lighter tawny and white in the distance; and it is diverse in surface decoration, with richly textured marbles around the real doorways, white stone at the illusionistic capitals, and brightly veined dark marbles ornamenting the pedestals and the frieze of the entablature. The fictive architecture ends where the walls meet the ceiling. Each of the doors in the two walls is topped by an illusionistic pediment on which sit personifications of Painting, Music, Architecture, and Geometry. Other figures and scenes decorate the entry and window walls. On the ceiling is *Pegasus Triumphing over Time*; around it Tiepolo painted four Roman scenes in monochrome.[40]

The Labia family from Spain was a recent addition to Venice's patriciate, having been admitted only in 1646, during the Turkish War of Candia when the Venetian State allowed wealthy families into the governing class in exchange for sorely needed monies. Like several other "new dynasties," the Labia made their presence felt in the city by forming a collection of paintings and building a grand palace—this enormous structure stands on the Rio del Cannaregio just before it opens into the Grand Canal at the church of S. Geremia. Their commission to Tiepolo produced frescoes that are his grandest secular decoration in Venice, and they rank among the greatest accomplishments of his sixty-year career.

In 1752, while visiting the salon, Joshua Reynolds made a drawing of the *Meeting*. Jean-Honoré Fragonard made one of the *Banquet* two decades later, and his traveling companion, Bergeret de Grancourt, praised the frescoes for their grandness and nobility. Although contemporary artists with tastes as different as Reynolds's and Fragonard's admired Tiepolo's work, the succeeding decades and centuries saw the great Labia palace slowly turn into a ruin. Today, the frescoes restored and our taste for Tiepolo renewed, we can only begin to imagine how the room came alive during an eighteenth-century ball: the chandeliers sparkled with candlelight and the space was filled with music coming from the balconies above; below, elegantly dressed and bejeweled Venetians wearing powdered wigs stopped for a moment to watch a famous pair of ancient characters meet and fall in love.

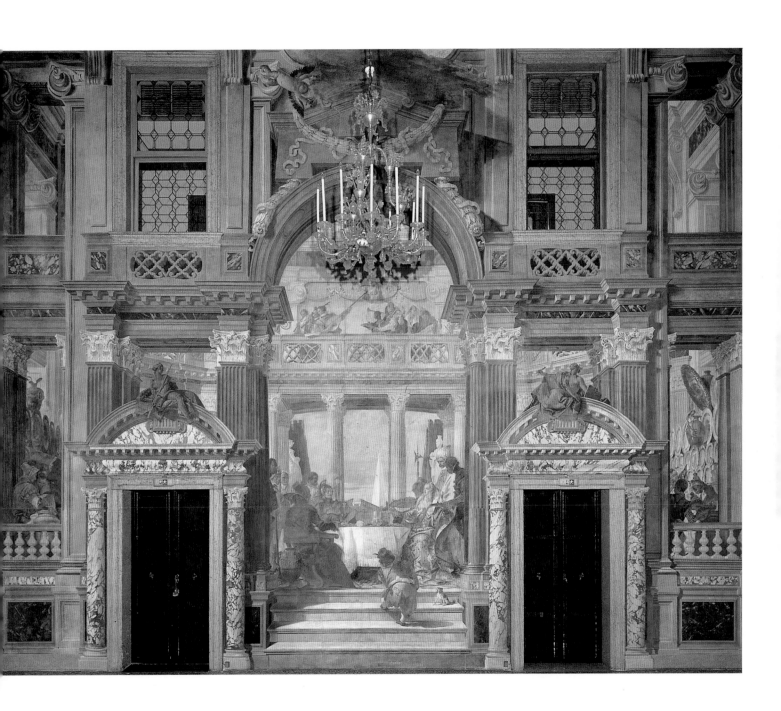

25. THE MEETING OF ANTHONY AND CLEOPATRA

c. 1744–47. Wall fresco, 21'4" × 9'10" (6.5 × 3 m)
Salon, Palazzo Labia, Venice

Tiepolo's "love affair" with Cleopatra took place in the mid-1740s. He painted her banquet (plate 20) in 1743–44; he paired that subject with her meeting with Anthony for two immense paintings now in Russia (Archangel Museum), also in 1743–44; and he repeated those two scenes in the salon of Palazzo Labia in about 1744–47 (plate 24, fig. 15).[41] Each of these paintings can be associated with a sketch or a small copy in oil.

The *Meeting* represents no historically known encounter between the future lovers, and it is a rumble of noise and a tumult of activity, unlike the facing *Banquet*, which portrays action in midstream. In the *Meeting*, Cleopatra's robes bustle and Anthony's armor and sword clink as the two figures descend into our space. Horns sound in the distance, and a small rose-colored sail with a pink tassel flutters in the wind way above an outstretched, muscular arm. The great prow of Anthony's ship breaks against the sky, and in the right foreground a hound is restrained from pouncing on the famous pair. In an oil sketch now in the National Gallery of Scotland, Edinburgh, Tiepolo had for the most part devised the scene as he would fresco it. The only important alteration in the fresco is that Anthony walks toward us, leading Cleopatra to the steps, whereas in the sketch the queen stops while he gallantly stoops to kiss her hand. The change is a major one, for the scene is now connected with our world, and it contrasts with the *Banquet*, in which the table and columns lock the figures in their drama.

The exact dating of the frescoes is uncertain, although part of the ensemble was done by 1746–47, when Franz Martin Kuen, a German artist spending a year in Venice, made a drawing entitled *Time Abducting Beauty* (sometimes called *Pluto and Persephone*), after the group painted at the top of the *Banquet* wall. One can assume that the ceiling, too, must have already been finished. The Labia family had been admitted into the Venetian patriciate in 1646 (see p. 92); perhaps the ensemble was completed in order to celebrate the centenary of that date.

The Labia scenes and their sketches are painted in a vertical format. For the paintings in the Archangel Museum, which are approximately contemporary in date, Tiepolo arrayed the narratives in broad, horizontal formats. Their dimensions almost equal those of the frescoes, but in reverse. Tiepolo envisioned scenes filled with many secondary actors who bring our attention to the protagonists in the center. The *Banquet* (and its sketch in the National Gallery, London) unfolds atop a grand porticoed walkway; two broad balustrades and a flight of steps lead our gaze upward. Both the architectural surround and the many flanking figures recall Veronese's several paintings for refectories; indeed, Tiepolo made at least two drawings for the Cleopatra theme that suggest he began with Veronese, and Raphael's *The School of Athens*, in mind.[42] The Russian *Meeting* (and its sketch in a private collection, New York) likewise expands outward. A large ship is on the left; on the right, Cleopatra walks ceremoniously toward Anthony, and pages hold out her brilliantly colored gown.

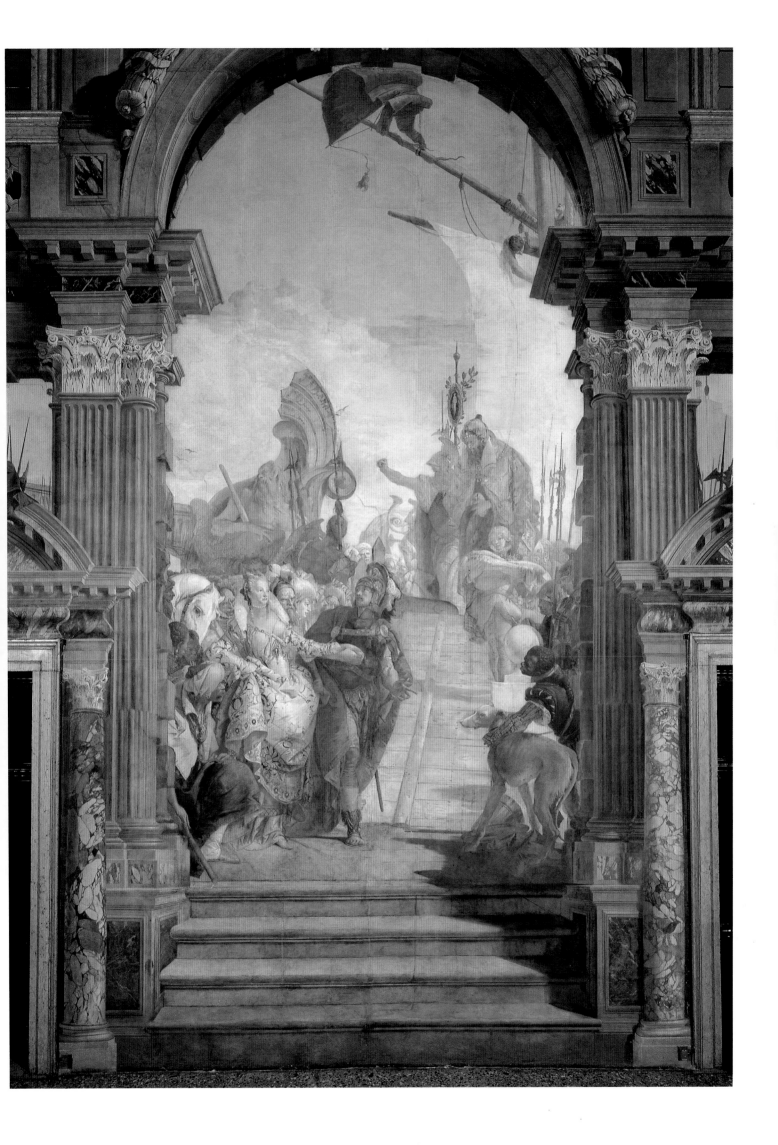

26. THE MARTYRDOM OF ST. JOHN, BISHOP OF BERGAMO

1745. Oil on canvas, 19′8″ × 8′2″ (6 × 2.5 m)
Cathedral, Bergamo

The *Martyrdom* was commissioned in late July of 1743 but was not delivered and put in place until the late summer of 1745; it is exactly contemporary with the Scalzi project (plates 21, 22, fig. 16) and with the paintings for Augustus III of Poland and his minister, Count Brühl (plates 19, 20).[43] Tiepolo had worked in Bergamo before, frescoing a number of scenes in the Colleoni Chapel (plate 8) in 1732–33; now that he was famous, his contacts in the city may have wanted an oil painting from him for their impressive series of twelve monumental paintings for the cathedral, almost all of them executed in the eighteenth century. Seven of them, including Tiepolo's, are just under twenty feet high and depict the martyrdoms of local saints. These seven were placed in elaborate, decorative stuccoed frames on the curved, rear wall of the choir, directly over the choir stall. The wealth required for this extensive pictorial decoration, and for the city's other contemporary ecclesiastical commissions, indicates Bergamo's prosperity during the eighteenth century.[44]

Tiepolo's *Martyrdom*, the second from the left in the ensemble, depicts the martyrdom of Bergamo's thirteenth bishop, a vehement antiheretic, who may have died violently but who more likely died a peaceful death in about 685. His relics were moved to beneath the cathedral's high altar in 1704.

The *Martyrdom* represented a new step in Tiepolo's art. He had, of course, painted several scenes of martyrdom in the past: St. John the Baptist's in the Colleoni Chapel in 1733 (plate 8); St. Agatha's, for the Franciscans in S. Antonio in Padua, in 1736–37; St. Sebastian's, for an Augustinian monastery in Diessen, Bavaria, in 1739; and Christ's, in S. Alvise, in about 1739 (plate 15).[45] The Bergamo commission was different from all of these in that it was neither an altarpiece, as in Padua and Diessen, nor was it primarily a narrative. Rather, it had to fulfill both functions; that is, it recounts the terrible drama of St. John's death, but the faithful in church also had to understand the purpose and significance of his Christian martyrdom. In this way, the *Martyrdom* follows closely on one of the artist's very early works, *The Martyrdom of St. Bartholomew* (plate 1), which was also conceived as part of a much larger cycle to which Tiepolo contributed but one painting. And, like that early scene, this one combines the horror of a violent death with the certainty of heavenly salvation.

The differences between Tiepolo's methods of the early 1720s and 1745 show, of course, the different instructions that were given to the painters in the two separate commissions, but they also illuminate how this specific artist had matured during that twenty-year period. The *St. Bartholomew*, like all the works in that series, focuses single-mindedly on the apostle; he fills up the canvas, there is no architecture, and bystanders are few. How heroic Tiepolo's art became by the 1740s, and how dramatic are its figures! In the *Martyrdom*, the distant archway repeats the arc of the saint's reaching gesture; the loggia's engaged column marks the vertical axis of the saint's pose and the downward driving force of the knife; and the monumental freestanding columns on the right link the heavenly messenger carrying God's crown and palm frond with the martyr below.

We also find in the *Martyrdom* an example of Giovanni Domenico Tiepolo's precocious intervention in his father's work, painted when the son was eighteen years old. The oil sketch (plate 26a) is pure Giambattista. Drama and visionary ecstasy characterize the Christian victory over death. In the completed painting, however, several figures in the right middleground add another note. A mother, turning her child from the martyrdom, is minutely described in costume, and the expressive faces of two men, younger to the left and older to the right, pull our attention away from the protagonist himself. These two extremes—too prosaic and overdramatic—characterize the very young Domenico's art.

26a. Giambattista Tiepolo. *Oil Sketch for "The Martyrdom of St. John, Bishop of Bergamo."* c. 1743–45. Oil on canvas, 15¾ × 8⅝″ (40 × 22 cm). Accademia Carrara, Bergamo

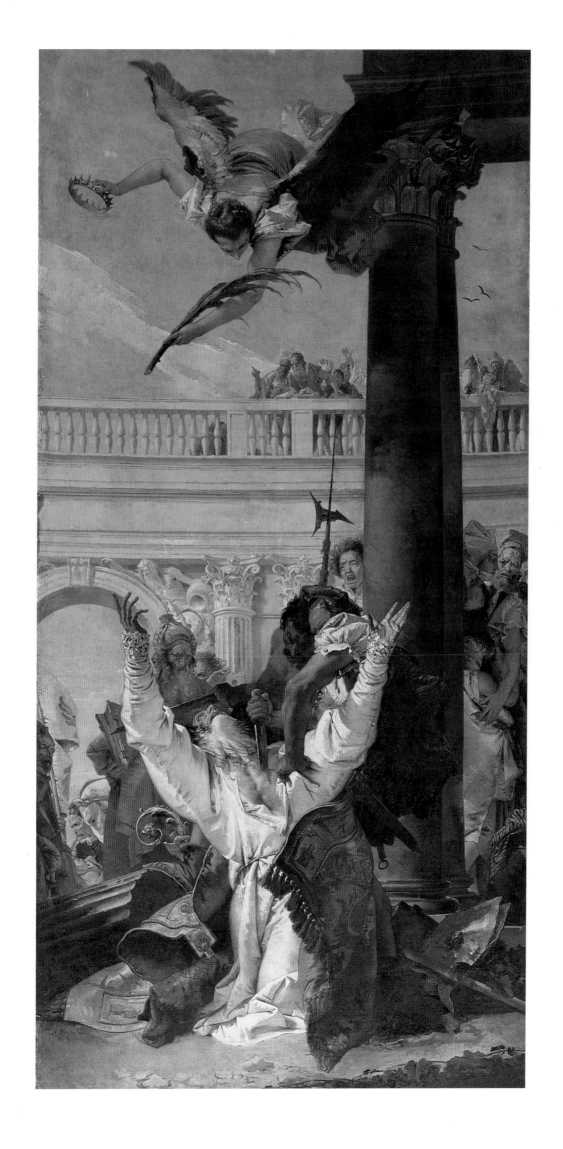

27. THE AGONY IN THE GARDEN

c. 1748–50. Oil on canvas, 31 × 35⅜" (79 × 90 cm)
Kunsthalle, Hamburg

Situating this work chronologically in Tiepolo's oeuvre is difficult because of the questions concerning the painting's attribution. The *Agony* is one of six canvases, all of almost identical size, that depict episodes from Christ's Passion: *The Last Supper* (Musée du Louvre, Paris); the *Agony*; *The Crowning with Thorns* (Kunsthalle, Hamburg); *The Crucifixion* (St. Louis Art Museum); *The Deposition from the Cross* (National Gallery, London); and *The Ascension* (Virginia Museum of Fine Arts, Richmond). Seen together, they would form an imposing and impressive group. Christ's earthly ordeal is dramatically depicted, the colors are often hot and raging, and the six compositions work beautifully together, strong verticals emphasized in the columns of the "opening" *Last Supper* and in the ascending Christ in the "closing" *Ascension*. Bold diagonals characterize the four intermediary paintings, and one's attention is thus carried from image to image. The diagonal in the *Agony*, moving from upper left to lower right, is picked up in *The Crowning with Thorns*, the subsequent episode, where one's focus is pulled up to the central figure of Christ and the ruined but monumental column on the right. In the left and right foregrounds of the two paintings, shadowy figures, their backs to us, complement each other's positions.

The group's sophisticated conception and the motifs in the paintings certainly declare "Tiepolo authorship." The bold compositional sweep, the falling Christ, the watching soldiers and "Turks," and the choppy topography in the *Agony* agree with corresponding elements in *The Way to Calvary* (plate 15). Some of the painterly handling in the *Agony* also appears to be by Giambattista himself. There can be no question, however, that the entire series was a collaborative effort of father and son. Giovanni Domenico Tiepolo, born in 1727, debuted as an independent artist with his fourteen *Stations of the Cross*, done for the Oratory of the Crucifix at S. Polo in 1747 (see p. 38). Although these works are modest, the ensemble is impressive, particularly having come from a twenty-year-old. And its rich narrative orchestration within the context of quotidian reality differs totally from Giambattista's dramatic mode.

The *Agony* and its five related canvases differ radically from the 1747 *Stations* in their heroic interpretation of Christ's sufferings. But their insistence on what is already a self-evident drama distinguishes the intervening hand of a junior, inexperienced partner. For instance: the torches and the soft illumination in the distance nicely direct our attention to the main event; but the fir trees rising behind Christ and the angel are all too obvious devices meant to reinforce the figures' poses, and they trivialize and distract from the mystical scene in front. For further discussion of collaborations between father and son, see page 96.

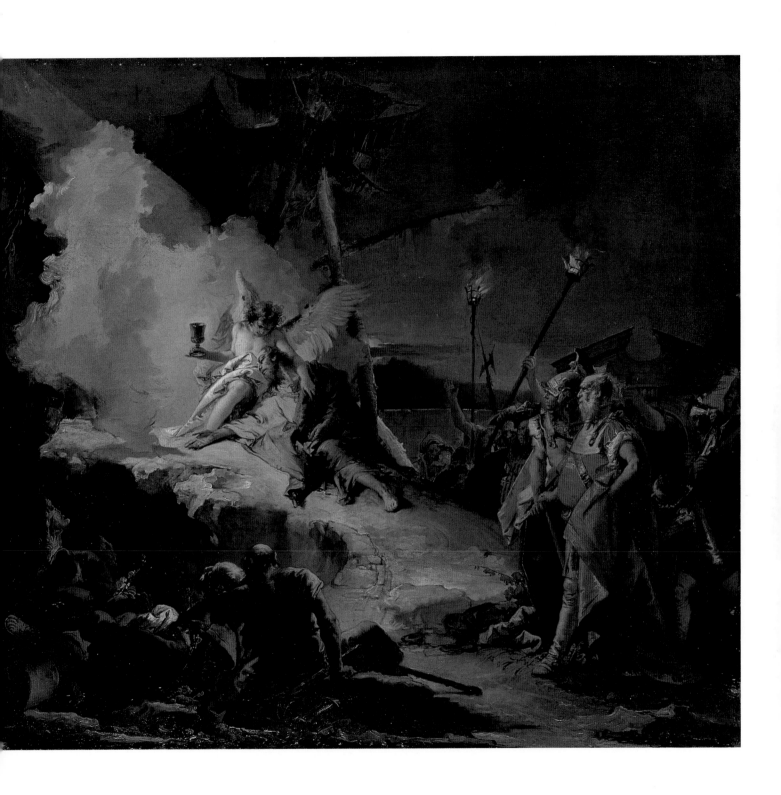

28. THE LAST COMMUNION OF ST. LUCY

c. 1748–50. Oil on canvas, 7'3" × 3'1" (2.22 × 1 m)
Ss. Apostoli, Venice

Tiepolo painted this moving, and surprisingly minute, work for a site very near his new home in the parish of S. Fosca, to which he moved in 1747. The painting is still in its original position over the altar of the exquisite Cornaro Chapel in Ss. Apostoli, and it must have been commissioned by members of that illustrious patrician family, for whom Tiepolo had worked during every decade of his career. He had painted for the last Cornaro *doge* beginning in 1716; in the thirties, he frescoed in a Cornaro palace near Treviso, he completed an important altarpiece for a family altar in S. Salvador, and he executed the triptych in S. Alvise for Alvise Cornaro (plate 15); in 1749, his son Giandomenico Tiepolo published his prints of the *Stations of the Cross* and dedicated them to the same Alvise Cornaro (see p. 38). In the *Last Communion*, Tiepolo inserted a tiny reference to the Cornaro: their coat-of-arms — blue and yellow fields with a lion and a cross — is visible midway down the painting on the far right, next to a youth and between the dark columns.

The Cornaro Chapel had been added to the right flank of Ss. Apostoli in the fifteenth century.[46] Caterina Cornaro, queen of Cyprus, was buried there, and so were her father and brother. Around 1510, Benedetto Diana painted a *Last Communion of St. Lucy* for the chapel's altar, and it remained there into the eighteenth century. St. Lucy was an apt choice for devotion in Ss. Apostoli: she was one of its patron saints. And her last communion was certainly relevant to a funerary chapel.

Lucy was from Syracuse in Sicily and lived sometime during the Church's first centuries; she venerated St. Agatha, of nearby Catania. Agatha's saintly intervention helped cure the hemorrhaging of Lucy's mother, Eutichia. Paintings often show Lucy being blinded, but she was in fact martyred by stabbing because of her Christian beliefs. Blinding does not in any case necessarily kill, and the act seems to have been popular in images of the saint in order to identify her (Lucia/*luce*/light) rather than to re-create history. Tiepolo, however, refers to her martyrdom and her legend by inserting both a knife and a platter with eyes in the painting's foreground, and a tiny red wound in Lucy's neck is visible. Like Diana's original altarpiece for the chapel, Tiepolo concentrated on Lucy's last moments on earth. She is attended by a priest wearing richly embroidered vestments, such as are usually donned during Mass, and by a bearded figure who has removed his hat as if in church. These and several other elements do not figure in Tiepolo's oil sketch (Museo Civico di Castello Sforzesco, Milan). The painting thus reenacts the Communion that would take place during a real Mass for the dead in the Cornaro Chapel.

Comparisons with Veronese's *The Martyrdom and Last Communion of St. Lucy* of about 1580 (The National Gallery of Art, Washington, D.C.) and Sebastiano Ricci's *The Last Communion of St. Lucy* (plate 28a), 1730, reveal Tiepolo's debt to both earlier paintings. His own canvas must be contemporary with renovations that took place in Ss. Apostoli between 1748 and 1752/53. And because the artist left for Würzburg late in 1750, not returning until Christmas 1753, the altarpiece can be situated with fair accuracy between 1748 and 1750.

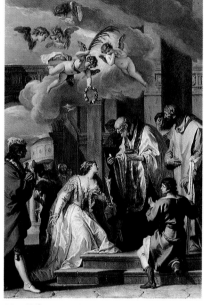

28a. Sebastiano Ricci. *The Last Communion of St. Lucy*. c. 1730. Oil on canvas, 14'1¼" × 7'10¼" (4.3 × 2.4 m). S. Lucia, Parma

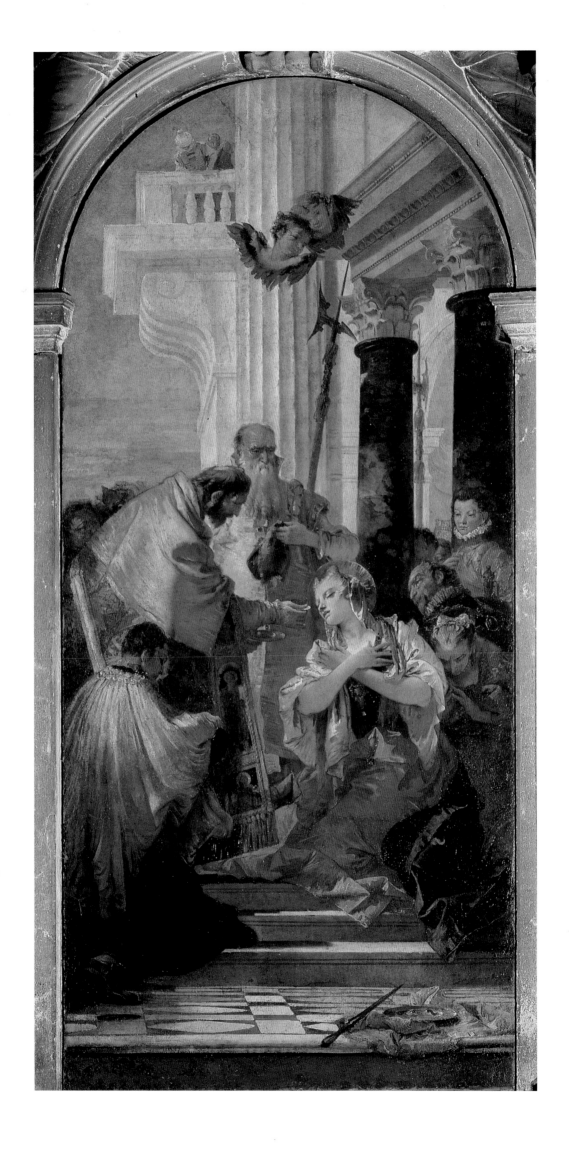

29. THE VIRGIN AND CHILD WITH SIMON STOCK

1749. Oil on canvas, 17'6" × 11'3" (5.33 × 3.42 m)
Chapter Room, Scuola Grande dei Carmini, Venice

Tiepolo painted four great Marian ceilings in Venice: in the Gesuati, 1738–39 (plates 13, 14); the Scalzi, 1745 (fig. 16); the Scuola dei Carmini; and the Pietà (S. Maria della Visitazione), 1754.[47] Of the four, the *The Virgin and Child with Simon Stock* is his most immediate image of Christ's mother. Unlike the other three, it was not painted on a large ceiling, vaulting high above the parishioner, but on a flat ceiling of moderate size close to the confraternal members who would have been gathered in dedication to the Virgin of Carmel. Unlike the other three ceilings, too, it is an oil painting, richly and deeply colored, in which bright cloud formations do not figure. It was conceived, therefore, not as a spectacular vision of the heavens but as a personal apparition.

The painting depicts the Virgin's gift of the scapular to Stock, a thirteenth-century Englishman who created the Third Order of the Carmelites and founded convents in Cambridge, Oxford, Paris, and Bologna. According to tradition, the Marian scapular offers those wearing it a reduced punishment in Purgatory, where souls are supposedly cleansed of their sins by terrible fires. The cult of the scapular sprang up after Pope John XXII's "scapular bull" of 1322. Its popularity increased further after the Counter Reformation. Tiepolo had painted a scapular image two decades earlier (fig. 6), showing souls yearning for their release from Purgatory. The motif reappears here in the canvas's bottom right corner, but unlike the earlier work, the Carmini ceiling focuses on Stock, a result no doubt of the many Carmelite publications of the 1720s and 1730s which retold the Englishman's Marian vision and explained its significance for the Carmelite order.

Tiepolo's 1740 contract with the lay confraternity at the Carmini called for Mary to be accompanied by the prophets Elijah and Elisha, who would have provided Old Testament background for the Marian painting, as similar imagery did in the Gesuati and Scalzi ceilings. But he did not include them, perhaps because the canvas was just not large enough; however, he referred to their presence with the homespun fabric held by the angel above Simon Stock. According to 2 Kings:14–15, after Elijah ascended to heaven on a chariot of fire, Elisha took his earthly mantle; their followers called out, "The spirit of Elijah rests on Elisha." Carmelites interpreted this as a metaphor for their own scapular, which had thus descended to them from Elijah, legendary founder of the order on Mt. Carmel.

Tiepolo surrounded *The Virgin and Child with Simon Stock* with eight smaller canvases of two different shapes. Four are on the sides of the central painting and feature cherubs with objects relevant to the scapular, and four are in the ceiling's corners and show personifications of Virtues and Beatitudes. All these figures face the confraternity's members as they arrive in the chapter room. But the most forceful facial expression is that of the Virgin. In the oil sketch (Musée du Louvre, Paris), she looks at Simon Stock; on the ceiling Tiepolo altered her position so that she turns to the lay brothers, who can thus participate in Stock's miraculous vision. The painter himself, who we know lived in devotion to the Virgin of Carmel, joined in that experience; when the ceiling was completed, the Scuola elected him one of its members.

Tiepolo's nine canvases are framed by white and gold moldings; the entire complex is set into a fancifully designed stucco surround decorated with elegant floral motifs, palm fronds, roses, shells, and cherubs. The ensemble is painted gold, light green, bright ocher, and white.

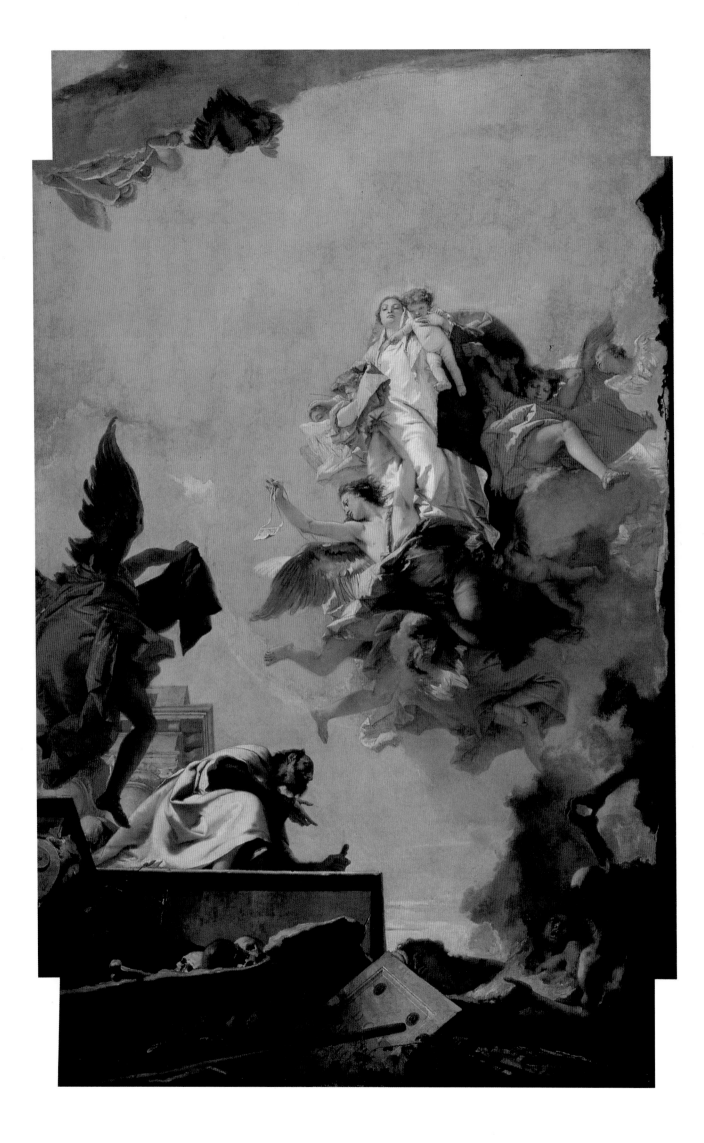

30. APOLLO BRINGING BEATRICE OF BURGUNDY TO THE SEAT OF THE GERMAN EMPIRE

1751. Ceiling fresco, 29'6" × 59' (9 × 18 m)
Kaisersaal, Archbishop's Palace, Würzburg

Of the three frescoes Tiepolo painted in the Kaisersaal, or Imperial Hall (fig. 30), the ceiling was the first. The allegorical painting transforms Frederick Barbarossa and Beatrice of Burgundy into eternal, quasi-mythological figures, raising history to a realm beyond time. Like Rubens before him in his cycle of paintings for Marie de'Medici, Tiepolo accomplished this in spite of his subject matter and because of his great talent.

In 1152, Frederick, duke of Swabia, was elected king of Germany. Three years later, after having refused a Byzantine wife who would have tied him politically to Constantinople, he was crowned emperor of Germany by Pope Hadrian IV in Rome. In 1156, Frederick I Barbarossa ("Redbeard") married Beatrice of Burgundy, daughter of Count Raynald III, who had won a decisive victory over the German Lothair III a generation earlier. Raynald enlarged his territory from the small town of Mâcon in Burgundy into what is known today as the Franche-Comté. By marrying Beatrice—that ceremony was re-created by Tiepolo on one of the Kaisersaal walls (see fig. 30)—Frederick took possession of the whole of northern Burgundy, hoping with it to strengthen his influence in nearby Germany on his way to greater power throughout Europe. Tiepolo's Kaisersaal ceiling was meant to poeticize the emperor's expansionist goals, showing how the Sun itself (Apollo on the chariot) participates in and contributes to Frederick's plan.

Tiepolo designed the ceiling so that it is oriented to those entering the Kaisersaal. The imperial podium on the left sits high over the palace itself, and Apollo and his quadriga have entered from the skies over the extensive gardens, which are beyond the great windows opposite the entry wall. The enormous horses drawing the chariot gallop toward the enthroned figure of *Genius imperii* and rear to a halt just before it, over the center of the illusionistic opening. Their rushing and prancing forms are at the heart of a centripetal force that breaks over the fresco's gilt molding, which is itself not regular in outline but appears to ebb and flow around the ceiling. Frescoed figures seem to hover above our space or just about to tumble into it. Cupids and doves swarm through the air, darting in and out of sight; several gods accompany Beatrice in her celestial journey; and Fame awaits her at its culmination. Brightly lit and darkly shadowed multicolored clouds swirl across the scene. Tiepolo had fully conceived this thrilling pictorial experience in the oil sketch (Staatsgalerie, Stuttgart); he then expanded it compositionally and deepened it illustionistically into space.

The chariot streaking through the heavens in a ceiling painting was not a new image in Italian art, although it had not been depicted by a Venetian painter. Both Guido Reni and Guercino, to name only the two most well known artists, had painted such motifs in Rome, in the Casinò Rospigliosi, 1614, and in the Casinò Ludovisi, 1621, respectively. Guercino's more illusionistically conceived fresco, in particular, must have been useful to Tiepolo. But apart from the obvious differences in both scale and distance from the viewer, Guercino's and Tiepolo's paintings are also dissimilar in that Tiepolo's light and wind seem accidental and arbitrary, not regulated like Guercino's. Tiepolo's hierarchically ordered empyrean appears to exist, paradoxically, within a natural realm that is akin to ours.

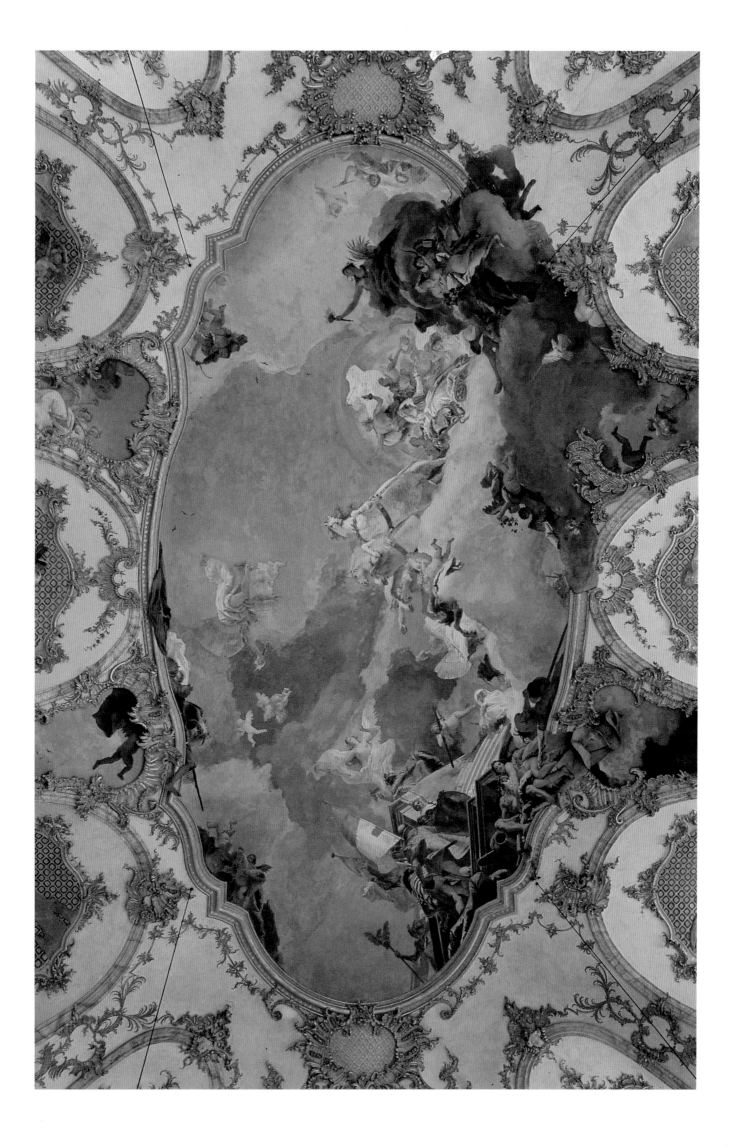

31. THE ALLEGORY OF THE FOUR CONTINENTS (detail)

1752–53. Ceiling fresco, 62'4" × 100' (19 × 30.5 m)
Stairwell, Archbishop's Palace, Würzburg

The visual culmination of one's climb up the grand staircase in the Archbishop's Palace in Würzburg is Europe. Both ramps bring visitors directly beneath it; all roads, as it were, lead to it. The stairwell's principal doorways, furthermore, direct visitors into the Weisser Saal (White Hall) and thence into the Kaisersaal (Imperial Hall), from under the section of the ceiling depicting Europe. An axis that moves from semidarkness at the palace entrance (fig. 32), to Europe, and on to the Kaisersaal, is as obvious an exaltation of Western Europe's sense of geopolitical centricity as one can imagine.

The figure of Europa sits off the central axis of the north wall, as do the magnificent female personifications of Africa, Asia, and America on their respective walls. This is one way in which Tiepolo avoided rigid schematization in the ceiling's design. Europa sits on a bull, which is certainly not to be read as Jupiter but as an identifying emblem, functioning like the camel, elephant, and crocodile that accompanying the other enthroned Continents. Also included with Europa is a mass of figures and objects all meant to differentiate her from the other three parts of the world. That is, Europe is thriving and culturally rich, whereas America is inhabited by savages, and Africa by merchants and primitives; Asia once saw a great civilization, but it has declined.[48] Europe is home to the Church (the patron of the ceiling, Bishop Karl Philip von Greiffenklau was, after all, part of its hierarchy); the visual and musical arts thrive there (America can offer only tambourines to Europe's sophisticated instruments); great architecture is still being built (Asia's is in ruin, and Africa offers but a tent); and instruments of modern warfare have been devised (America still uses the bow and arrow, and Africa the spear).

Most significant, Europe knows virtue and human achievement. Directly at the center of the wall, a crozier points up to the "ascension" of the portrait of Bishop von Greiffenklau. He is wrapped in an imperial mantle, and the golden frame is a simulated wreath of laurel steadied by a griffon's claws (*Greifenklauen*). The bishop's noble profile is made majestic by the great crown held above him by Truth, who is crowned with laurel. Fame trumpets the patron's accomplishments and his ascent. Mercury, the messenger god, carries word of Greiffenklau's arrival to the Sun God reigning in the heavens. Various figures are scattered about: Saturn and Time with his scythe, on the left, and Diana, the goddess of the Night, on the right, her back toward us. Barely visible on a nearby cloudbank, behind Fame's trumpet, sits Jupiter holding his thunderbolt, and his cupbearer Ganymede stands next to him.

Tiepolo approached painting Greiffenklau much as he did the patron of his very early *Crucifixion* (fig. 4), treating the portrait bust as a discrete entity, not in the same world as the figures surrounding it. In the Würzburg fresco, Tiepolo transformed an outmoded pictorial device into a magnificent form of cultural propaganda. Furthermore, this portrait medallion is at the apex of a pyramidal grouping of several portraits: the figure standing under the pediment has been identified as Antonio Bossi, the great stuccoist for the Archbishop's Palace, and the individual reclining comfortably over the cannon in the center is usually identified as Balthasar Neumann, the palace's architect and a former artillery officer. Other figures are surely officials and members of Greiffenklau's court. At the far left Giambattista and his son Giandomenico, also a painter (see pp. 96, 98) look on from a separate sphere, citizens of Europe but outsiders to Würzburg. Like Chardin in his self-portraits of only two decades later, Tiepolo portrays himself as a simple worker intent on observing the world. This eighteenth-century rationalist view of a painter almost seems a throwback to the early Renaissance conception of the artist as artisan, not genius. Understated as Tiepolo's portrait is, however, it sits over the most important corner of the stairwell, that leading directly to the Kaisersaal.

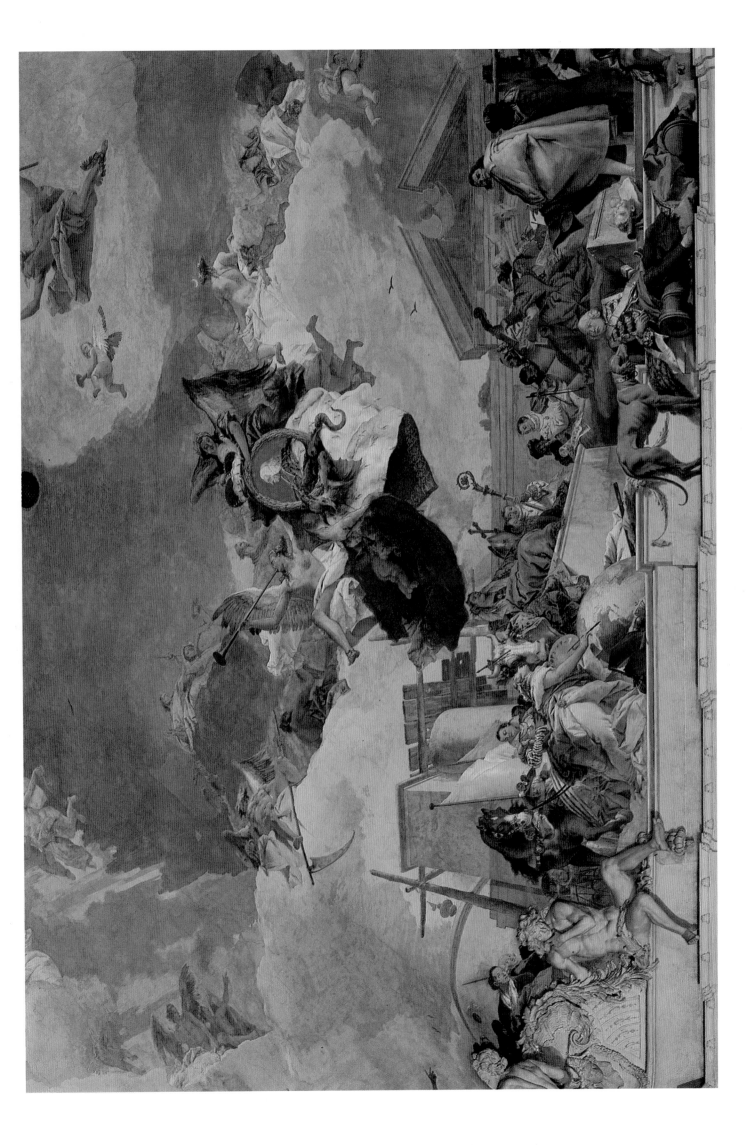

32. THE ALLEGORY OF THE FOUR CONTINENTS (detail)

1752–53. Ceiling fresco, 62'4" × 100' (19 × 30.5 m)
Stairwell, Archbishop's Palace, Würzburg

> "Miraculous volumes of
> colour billowed, gleamed,
> vibrated, above us."[49]

So Anthony Powell described through one of his characters a fictitious ceiling by Tiepolo in Venice. No better chararacterization of the stairwell fresco could be expressed. Reigning at the very height of the ceiling's heavens, his magnificent body taut and springing with energy, is Apollo, who holds aloft a statuette of the *Hercules Farnese* in his left hand. Hercules's twelve labors made him famous for his courage and strength; his superhuman accomplishments transformed him for many into a demigod. Tiepolo's immensely deep and broad space glorified Bishop von Greiffenklau's ascent toward the greatest human example of virtue ever known, which is recognized and exalted by divine light before the entire world. The cloud banks both envelop and expand outward from this mythical apotheosis, and Apollo's swelling form (his stance a vigorous restatement of the famous *Apollo Belvedere* in Rome) is reinforced by the immense zodiacal band arching across the sky between America and Africa, the entablature of the foreshortened Temple of Truth below him, and the brilliant nimbus encompassing him. Throughout the composition, zigzagging movements open and push up toward Apollo, and ultimately resolve into perfectly circular rhythms at the ceiling's apex. The total impact of the fresco is produced by both the multiplicity of images and the unified composition.

Tiepolo's ceiling is traditional yet unexpectedly innovative. Many of his figures are purely Venetian in type, inconceivable without his study of Tintoretto and Veronese. But the boldness of the overall design of the vault is unexpected. Indeed, it had not been thought possible before Tiepolo's arrival in Würzburg that one composition could encompass the entire area above the stairwell. For not only is the surface itself enormous, but the many viewpoints available as one approaches it and walks under it posed terrific problems for any painter (see pp. 40–41). In doing away illusionistically with the ceiling itself, Tiepolo followed an Emilian and central-Italian Baroque tradition of decorating church vaults and domes of pretending that the ceiling simply did not exist. In secular ceiling imagery in Florence and Rome, illusionistic architectonic structure in one form or another was almost always depicted. There was one exception to this trend, however, in Luca Giordano's fresco in Palazzo Medici-Riccardi, Florence, of 1682. Tiepolo had to have based his own ideas on it, although there is no proof that he ever saw it firsthand. Tiepolo's originality in the stairwell fresco lay in conceiving an allegorical ceiling fresco in terms of a Christian heaven, but filling it with the real light of day mixed with the blaze of divine luminescence.

Tiepolo's ability to cover the immense span with such a rich and varied group of figures and motifs was a result of his great capabilities as a draftsman. The surviving evidence appears to indicate that his preliminary sketches consisted mainly of chalk drawings. Thus, while the young Tiepolo had done his planning with pen and wash drawings, the mature artist skipped the first phase—so it would seem—and turned directly to chalk. We can hypothesize that the painter developed this system to speed up his work. Europe and America consumed about ten days' labor each, Africa and Asia about fifteen, and the center of the vault about another fifty. The conclusion is that the stairwell fresco took, amazingly, only about one hundred days to execute.[50]

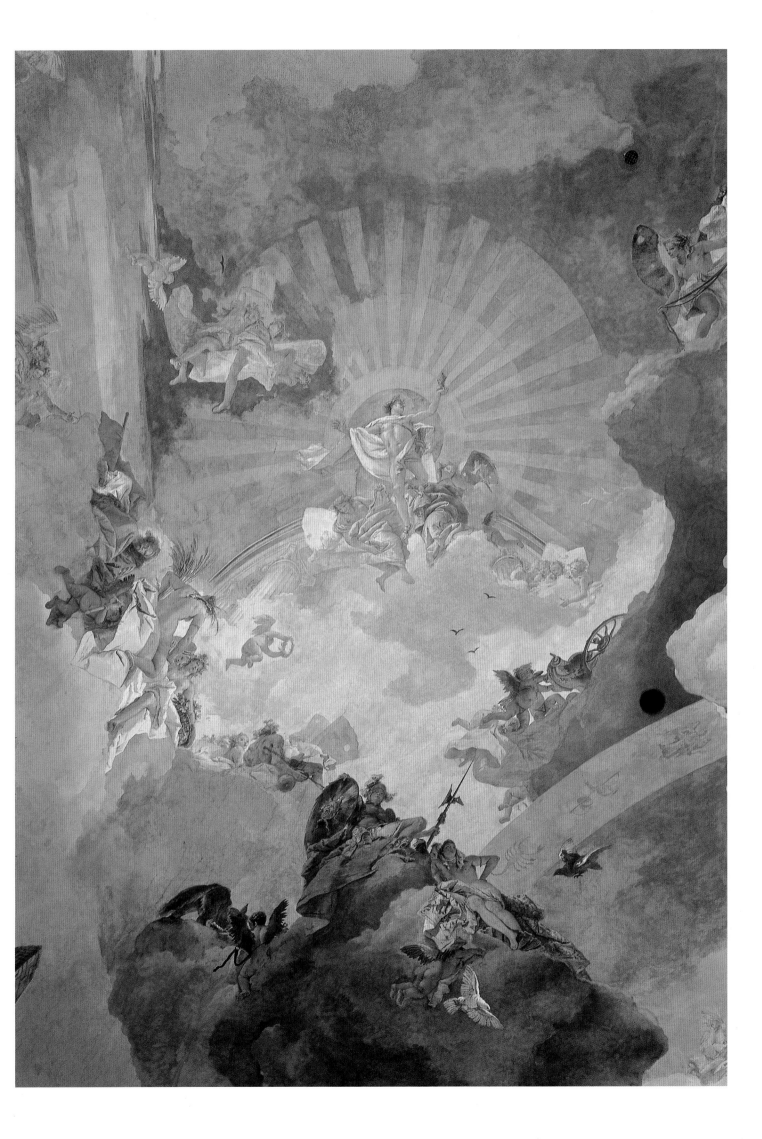

33. THE DEATH OF HYACINTH

c. 1752–53. Oil on canvas, 9'5" × 7'8½" (2.87 × 2.35 m)
Thyssen-Bornemisza Collection, Lugano

Painted for an unknown patron and a somewhat puzzling image because of its combination of tragic and comic elements, *The Death of Hyacinth* is nevertheless an affecting and impressive work. The subject of Apollo lamenting the death of his lover occurs infrequently in the history of art, although Cellini had sculpted a marble version of it in about 1550, Rubens had prepared a sketch of the subject for the decoration of King Philip IV's Torre de la Parada outside Madrid, and Poussin made a drawing of Apollo carrying Hyacinth after his death. The story comes from several ancient sources, among them Ovid's *Metamorphoses* (Book X), where the lovers Apollo and Hyacinth compete in a discus-throwing contest. The god forcefully hurled his discus; the young and beautiful Spartan prince heedlessly went to retrieve it before it fell to earth. He was hit in the head and killed. The god's grief over his dead lover is a moving lament, and his prediction that a new flower will germinate to mark his sorrow produces the hyacinth.

Tiepolo's painting is very large—really monumental—and his treatment of the story is apparently serious, in marked contrast with the irony of the smaller *Jupiter and Danaë* (plate 11) of two decades earlier and with the overstated drama of *Apollo and Daphne* (Musée du Louvre, Paris) of about 1745. Bystanders watch quietly and sympathetically, a concerned Cupid supports the magnificent head of Hyacinth, funereal cypresses mourn in the distance, and Apollo's suffering, even if expressed rhetorically, is convincing. The god raises his left hand in shock while bringing the right hand to his brow as if to imply his own guilty part in the act.

And yet comedy is not far off. Tiepolo has turned the discus contest into a tennis match that, given the tiny racket nearby, hardly required heroic effort. A slack net is visible in the distance, and three tennis balls lie in the foreground. The sport seems just too delicate for the two heroic figures, especially since we know that one of those balls has just knocked out and murdered the prince. And as if to mock the game itself, the very seriousness of the event, Tiepolo painted a ball in the opening of the pediment behind them, directly on line with the keystone of the arch and with poor Hyacinth below, next to whom varieties of his flower bloom. Giandomenico Tiepolo certainly understood his father's comic intention; in a fresco he painted in his own home, Villa Tiepolo at Zianigo, late in the century (the work is now in Ca' Rezzonico, Venice), he reused the figure of the dead Hyacinth for a Pulcinella, or clownlike character, positioning him in reverse and showing him drunk and exhausted after a badminton game.

But there is something more in *Hyacinth* beyond Apollo's grief and Tiepolo's subtle mocking. The satyr grinning lewdly from his position as a caryatid, his private parts hidden by Apollo's raised hand, suggests lasciviousness. Here Tiepolo relies on an almost identical grouping in Veronese's *Venus and Mars Tied by Love* of about 1580 (The Metropolitan Museum of Art, New York). In it, a satyr-caryatid reigns over Venus and Mars, the latter recumbent in the goddess's lap. We can thus surmise that Tiepolo is commenting on the illicitness of Apollo and Hyacinth's relationship.[51] Whether it is because of their homosexuality or because the Sun God had too many lovers we do not know. However, the parrot overhead—a symbol of licentiousness in so many Western paintings—certainly adds another sardonic note to what is, at first glance, a scene of tragic lament.

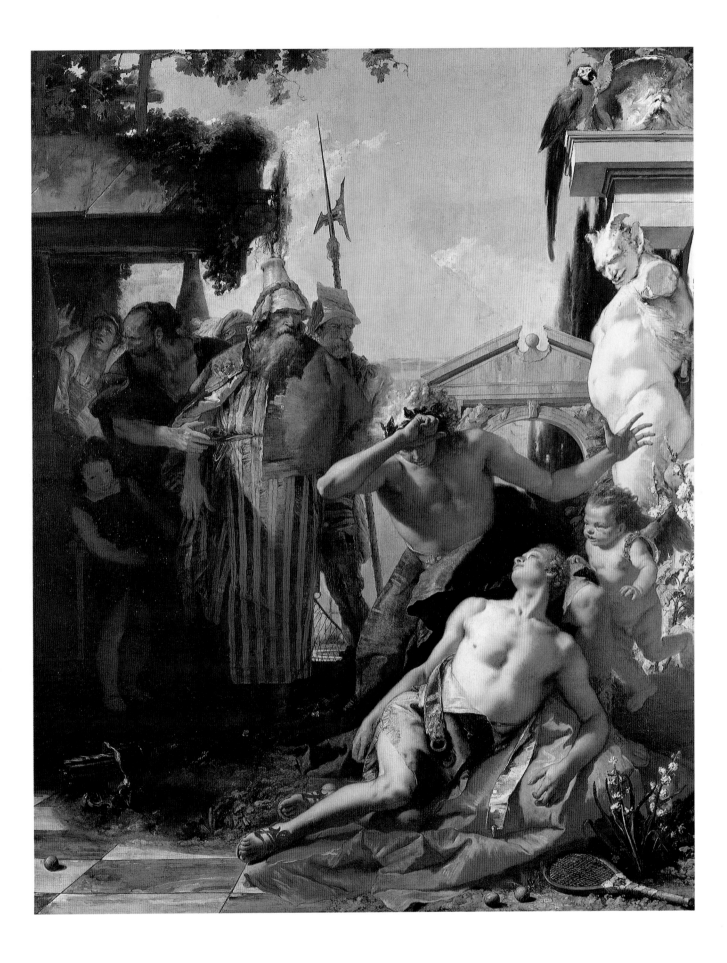

34. THE VIRGIN AND CHILD APPEARING TO ST. JOHN NEPOMUK

1754. Oil on canvas, 11'4" × 4'9" (3.46 × 1.45 m)
S. Polo, Venice

On May 8, 1754, Tiepolo unveiled this painting over the second altar on the left in S. Polo.[52] Because the main entrance to the church is on its right flank and directly opposite that altar, the Nepomuk altarpiece sits in a distinguished position in this Byzantine-Gothic structure. Mary wears a luminous ruby gown covered by a rich blue mantle; supported by a cloud, she approaches St. John and presents the Christ Child to both him and the faithful at prayer. A radiant aura emanates from the saint, and he seems overwhelmed by the Marian apparition as he momentarily turns away from his crucifix.

A relic of John Nepomuk, a fourteenth-century Czech canonized in 1729, had been donated to the altar below this painting in 1740 by Augustus III, king of Poland and elector of Saxony, thereby initiating a special devotion to the saint that was celebrated annually at the church on his feast day, April 29, by handing out to worshipers holy cards carrying an inscription. This generous Augustus is the same one who would soon buy Tiepolo's *Caesar Contemplating the Head of Pompey* and *The Banquet of Anthony and Cleopatra* (plate 20), painted in 1743–44, and who commissioned paintings from other Venetian artists, such as Giambattista Piazzetta, Antonio Canaletto, Bernardo Bellotto, and Rosalba Carriera. Was he Tiepolo's patron here at S. Polo?

Certain evidence implies that he might have been. Tiepolo's Mary and Christ are close to Raphael's Virgin and Child in his *Sistine Madonna* (Gemäldegalerie, Dresden), painted for the church of S. Sisto in Piacenza in about 1513. Furthermore, the little cherub on the left in Tiepolo's painting holds his hand to his mouth very much like one of his predecessors in the Piacenza work. Although it is surprising that the eighteenth-century Venetian would have turned to the High Renaissance Umbrian for ideas (one thinks of Raphael's impact on eighteenth-century art more in terms of Neoclassicism than in relation to the last High Baroque master), it is quite possible that he did. In 1754, the same year Tiepolo painted the Nepomuk altarpiece, the *Sistine Madonna* was carried away from Piacenza to Dresden, where it joined the collection of Augustus III. The figural similarities between Raphael's and Tiepolo's altarpieces signal the latter's homage to the earlier painter, but they may also reveal Tiepolo's clever way of identifying his patron, Augustus III, who had endowed the S. Polo altar in 1740 and who was the new owner of the *Sistine Madonna*. The clever idea may also have come from Francesco Algarotti, an official in Augustus's court and one of Tiepolo's friends, who arrived in Venice from Dresden in 1753 and remained until 1756.

The S. Polo painting shows a new aspect in Tiepolo's altarpieces. Before his German trip, he had used architecture to stabilize his compositions (see plates 7, 9, 12, 28); here, instead, sacred events transpire in a realm with very few tangible points of reference and in which the figures seem weightless. No doubt a result of his Würzburg frescoes, in which space overwhelms figures, this change must also be seen in the light of Piazzetta's recent death on April 29, 1754. Comparing the Nepomuk altarpiece with any one of Piazzetta's can only suggest that Tiepolo's thick and dark cloud-filled glory in S. Polo was as much an homage to Piazzetta, who died on the feast day of St. John Nepomuk, as the miraculous vision emerging out of it was to Raphael, whose famous altarpiece in Piacenza was leaving Italy forever.

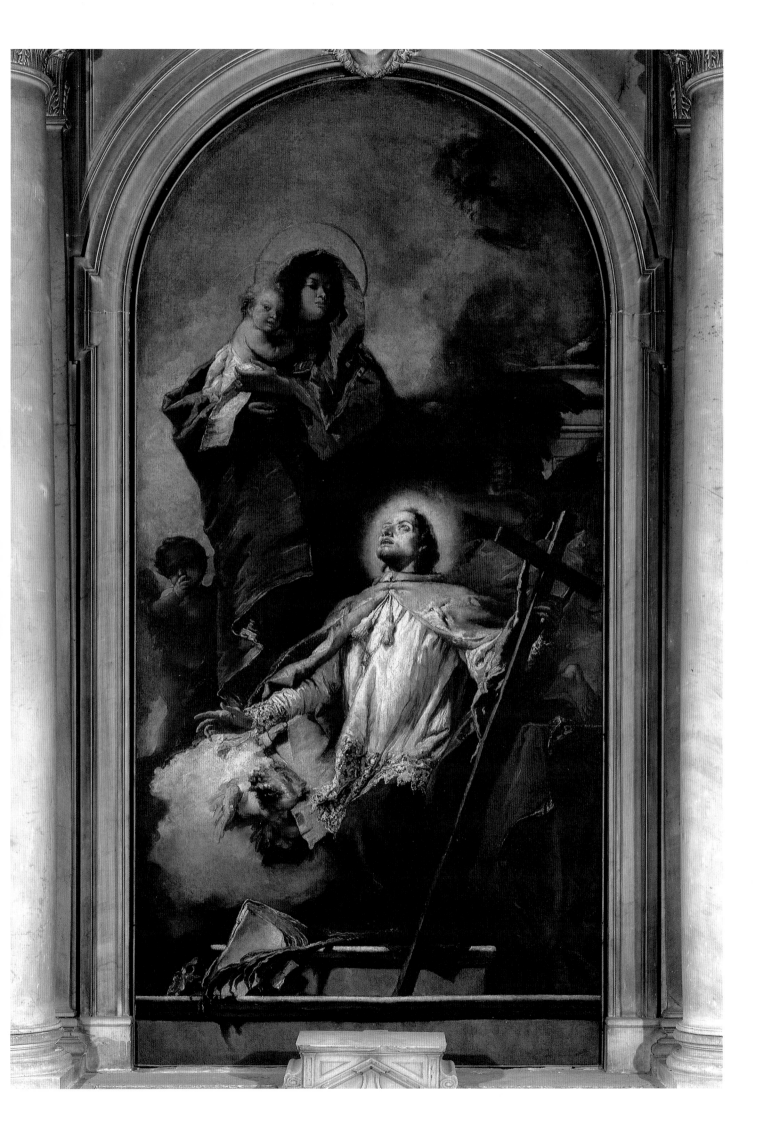

35. RINALDO ABANDONING ARMIDA

1757. Wall fresco, 7'3" × 10'2" (2.2 × 3.1 m)
Villa Valmarana, Vicenza

Visitors walking through Villa Valmarana pass scenes from Homer's *Iliad*, Ariosto's *Orlando furioso*, and Virgil's *Aeneid* before arriving at the love story of Rinaldo and Armida, from Torquato Tasso's *Gerusalemme liberta* (see pp. 42–45). They view the episodes on the walls as they occur in Tasso's narrative: Armida's initial sighting of Rinaldo; a love scene; Rinaldo ashamed of his image as it is reflected in the magic shield held up to him by Carlo and Ubaldo. Finally, one sees his abandonment of the beautiful witch (Book XVI), a scene Tiepolo had painted several times before but never as movingly as here. Looking at this final painting in the villa's decorative program, at Rinaldo's sacrifice of love for duty, one wonders whether the Valmarana themselves did not feel some of the same melancholy each time they left their country idyll for urban responsibilities in nearby Vicenza.

Untying the tight compositional "knot" that he had created in the garden scene, where Rinaldo reclines, infatuated, in Armida's embrace, Tiepolo here breaks the pair in two, separating them both physically and emotionally. The leave-taking is anything but painless for Rinaldo. Massive and dressed in military garb, he pulls away from Armida and yet seems to halt momentarily as if unable to act without the wise urging of Carlo and Ubaldo. Rinaldo's arms appear prisoners of his own indecision, his left hand awkwardly holding onto his right forearm but neither pulling it back nor pushing it onward.

Armida sings a tragic lament, and the gesture of her ample figure is echoed in the bending tree behind her and in the distant umbrella pine. A tight pearl choker emphasizes the full roundness of her neck and its straining as she pleads her case. Her mirror, on the right, is abandoned like her, exercising its spell no longer. Ignoring the mirror, Rinaldo will bend to pick up his shield in a moment. The two objects help present the narrative, Tiepolo like Tasso placing them in key positions in order to further his story. In the adjacent garden scene, the same mirror and shield also define the compositional grouping but to opposite effect, for Rinaldo turns to the magic mirror and away from his shield.

In contrast to the Valmarana's Homeric episodes, which are enacted within *trompe l'oeil* architectural settings (figs. 33, 34), and the Virgilian scenes, which are framed by simple moldings, the two "modern" epics — Ariosto's *Orlando* and Tasso's *Gerusalemme* — are surrounded by highly ornate, painted scrollwork. Rich, thick, gold borders set off Ariosto's stories from their wall surfaces. Tiepolo's designs for the frames around Tasso's scenes are the villa's most elegant; white, continuously undulating on all four sides, *rocaille* in the extreme, they add to the perfumed bouquet of Armida's garden and the silver lilac coloring of the frescoes. Tiepolo's brushwork squiggles across surfaces, brilliantly modeling moving forms with short strokes and creating cast shadows and bright light with zigzagging, serpentine daubs. His loose and rapid handling is more akin to the technique he used in oil sketches than to that of traditional fresco painting.

114

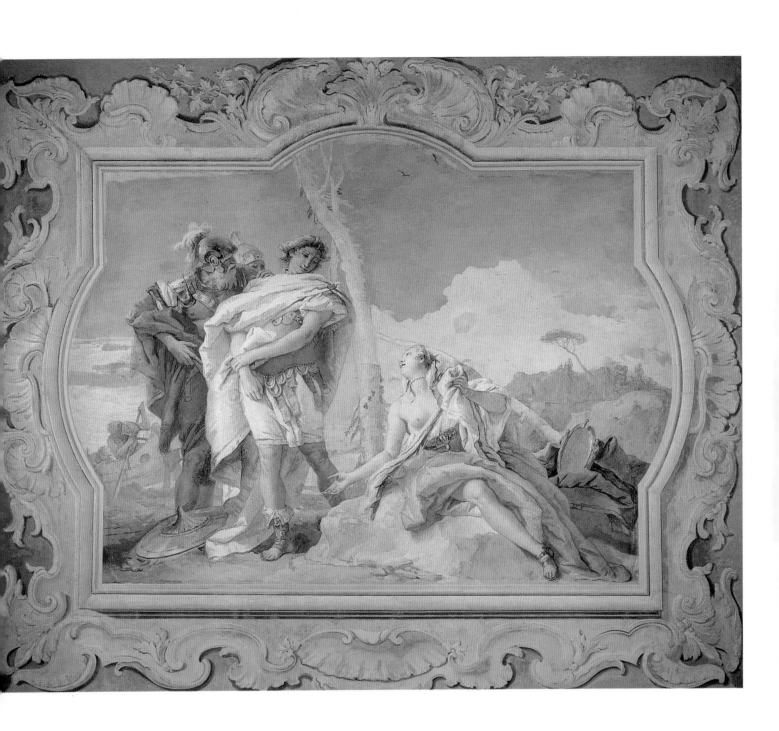

36. ST. THECLA LIBERATING ESTE FROM THE PLAGUE

1759. Oil on canvas, 22'2" × 12'10" (6.75 × 3.9 m)
S. Tecla, Este (province of Padua)

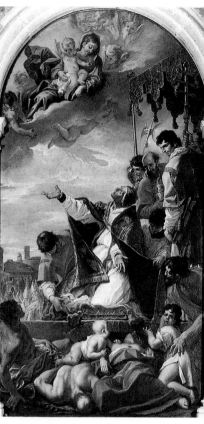

36a. Sebastiano Ricci. *St. Gregory the Great Interceding with the Virgin and Child Against the Plague*. 1700. Oil on canvas, 11'9" × 6'2 (3.58 × 1.88 m). S. Giustina, Padua

This is the last great altarpiece Tiepolo painted in Italy before he went to Spain in 1762. Commissioned in 1758, the completed work was placed in the presbytery behind the high altar at the Cathedral of S. Tecla on Christmas Eve, 1759; Tiepolo himself attended the unveiling of the painting. In 1748, the Venetian Carlo Rezzonico, bishop of nearby Padua, had consecrated the newly renovated S. Tecla. A decade later, Tiepolo painted frescoes in his palazzo in Venice celebrating the marriage of the bishop's nephew. The contemporaneity of the S. Tecla and Rezzonico projects, both of them involving Tiepolo, the bishop's family ties to Venice and his pastoral-administrative links to Este all suggest that the altarpiece may have originated as a commission from within his family, perhaps even from the bishop himself, who ascended the throne of St. Peter as Clement XIII in 1759.

The painting recalls the 1630 scourge of the black plague in the Veneto. Este was particularly hard hit, and devastation there was followed by economic depression. A century later, the town was on the mend; farming had recovered, the collapsing cathedral was renovated, and new paintings and sculpture were commissioned to decorate it.[53] At the 1748 consecration of S. Tecla, Antonio Zanchi's *The Canonization of Lorenzo Giustinian* was removed from the presbytery, possibly with the thought of replacing it with an image more suitable to the town's regeneration. Indeed, Tiepolo's canvas of a decade later shows the church's titular saint, a first-century inhabitant of Asia Minor who had survived more attempted martyrdoms than one can possibly believe. She seeks relief for beseiged Este, and with a powerful gesture, God the Father banishes a darkened figure symbolic of the plague. The sun's brilliant rays shine on Este and its bell tower below.

European plague imagery disappeared soon after Tiepolo's painting was completed; but the tradition of plague prints that preceded it was strong. It included Marco Raimondi's engraving *The Plague in Phrygia*, after drawings by Raphael, Pietro Testa's *Saints Interceding with the Virgin for the Victims of the Plague*, and copies after Poussin's *The Plague of Ashdod*. Tiepolo must also have known Sebastiano Ricci's *St. Gregory Interceding with the Virgin* in Padua's S. Giustina (plate 36a), from which he took the idea of a platform built over a sewer. This body of images furnished Tiepolo with such particulars as the child seeking its dead mother's breast, the figure covering its nose from the stench of death, the distraught man (is he the father?) covering his head, and the men in the middle distance carrying a corpse. (The last two motifs are not in the oil sketch, plate 36b.)

Part of the power of the altarpiece comes from its remarkable color. As in the oil sketch, Tiepolo used beiges, ochers, and earth tones for much of the landscape, the clouds, and the stone platform in the foreground. Deviating from the sketch, however, he inserted two areas of bright color, perhaps so that his tragic image would not just decorate the church's immense interior but would dominate it. The robe of God the Father is a rich cobalt blue modeled in deep shadow, and behind him flies an angel in golden drapery. It was St. Thecla's passionate plea for help that interested the painter most of all, though, for he draped her in layers of bright gold, rose, vermilion, and radiant white. In the oil sketch, she calls to God and raises her arms, but in the painting, it is the feverish intensity of her colorful garments that resounds throughout the interior of Este's cathedral.

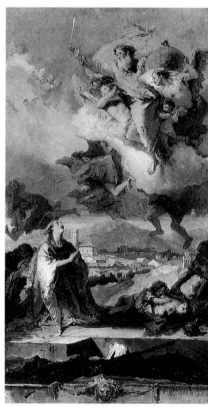

36b. Giambattista Tiepolo. *Oil Sketch for "St. Thecla Liberating Este from the Plague."* 1759. Oil on canvas, 32 × 17⅝" (81.3 × 44.8 cm). The Metropolitan Museum of Art, New York. Rogers Fund, 1937 (37.165.2)

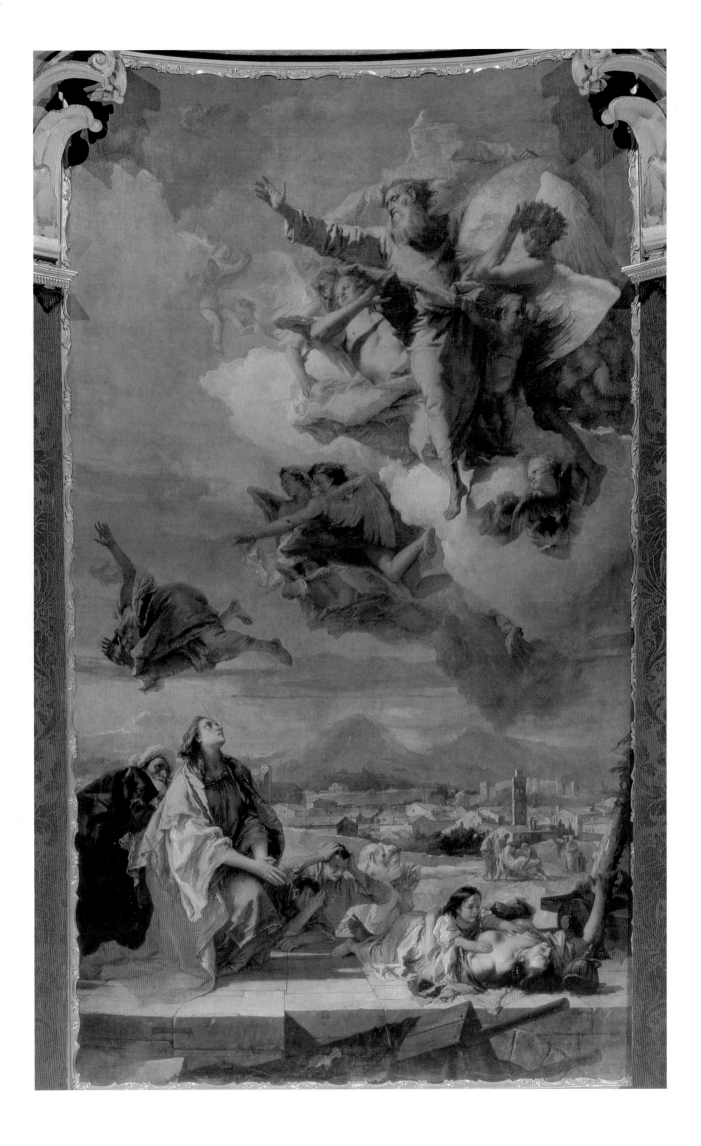

37. A YOUNG WOMAN IN DOMINO AND THREE-CORNERED HAT

c. 1760. Oil on canvas, 24⅜ × 19½" (62 × 49 cm)
The National Gallery of Art, Washington, D.C. Samuel H. Kress Collection

Giambattista and his two painter-sons, Domenico and Lorenzo, produced a number of portraits. Among them are likenesses of real people as well as the fascinating *têtes de caractère*, a series of orientalizing male portraits apparently inspired by prints by Rembrandt. Domenico produced two sets of prints of this kind of portrait after his return to Venice from Madrid in 1770.[54] Lorenzo, who spent his remaining years in the Spanish capital, became a portrait specialist and painted a number of realistic representations of *Madrileños* ranging from peasants to vendors to uniformed soldiers. One exceptional "Tiepolo" portrait, left unfinished and attributed to either Domenico or Lorenzo (British Rail Pension Fund, London), shows members of the Tiepolo family: Lorenzo painting a small portrait of his mother, Cecilia Guardi, beautifully robed and comfortably seated; her son Giuseppe Maria, a priest in the Somaschi order, standing behind her; and three Tiepolo daughters seated on the right.

Giambattista did not begin painting portraits until relatively late in his career. His *Antonio Riccobono* (Accademia dei Concordi, Rovigo) probably dates from the mid-1740s, although it is not a study from life, but rather a portrait of a famous, sixteenth-century humanist. Giambattista's very impressive *Portrait of a Procurator* (Galleria Querini-Stampalia, Venice) may date from midcentury; its subject has never been convincingly identified, but the forcefully depicted official dressed in brilliant red robes, viewed from below and standing before a monumental structure, contrasts strikingly with the earlier Venetian tradition of portraiture.

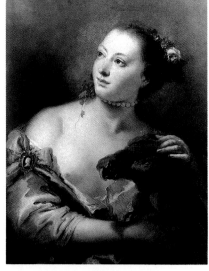

37a. Giambattista Tiepolo. *A Woman with a Parrot.* c. 1760. Oil on canvas, 27½ × 20⅜" (70 × 52 cm). Ashmolean Museum, Oxford

The present work is one of a group of female portraits that must have been done shortly before the three Tiepolos went to Spain. A letter sent from Venice to Count Carrara of Bergamo and dated December 15, 1760, notes that Tiepolo "is now doing some half-length female portraits *a capriccio* for the Empress of Moscow."[55] This series must include the *Woman with a Parrot* (plate 37a), the *Woman with a Mandolin* (Institute of Arts, Detroit), *Woman with a Fur* (whereabouts unknown), and the *Young Woman in Domino*. Very similar in size, the four might have formed a group; the parrot and mandolin portraits carry associations with love, and our work and the *Woman with a Fur* would have contrasted in showing a woman covered except for her face, and a woman nude except for a drapery over her shoulder. But why such subjects should have interested Empress Elizabeth is puzzling.

The black domino, a floor-length cloak, and the three-cornered hat were (and are) worn during Carnival in Venice, the period of seven to ten days preceding Lent during which merrymaking and festivities rule the city's life. In the eighteenth century, Carnival and mask-wearing could extend for months, beginning sometime in the winter. Pietro Longhi painted a number of works showing Venetian aristocrats garbed in their *domini* and engaged in flirtatious behavior or attending public amusements. Francesco Guardi's *Ridotto* (Ca' Rezzonico, Venice) depicts Venetian society at play in a public gambling house before the beginning of Lent. The haunting image here, whether by Giambattista or by Domenico, as the painterly handling might suggest, hints at something other than the fun of Carnival. Serious rather than playful, private and not public, still instead of boisterous, the portrait implies that there is a different side to Carnival, the quiet before the street activities or—more interesting yet!—the intimacy that can develop afterwards, when masks are removed.

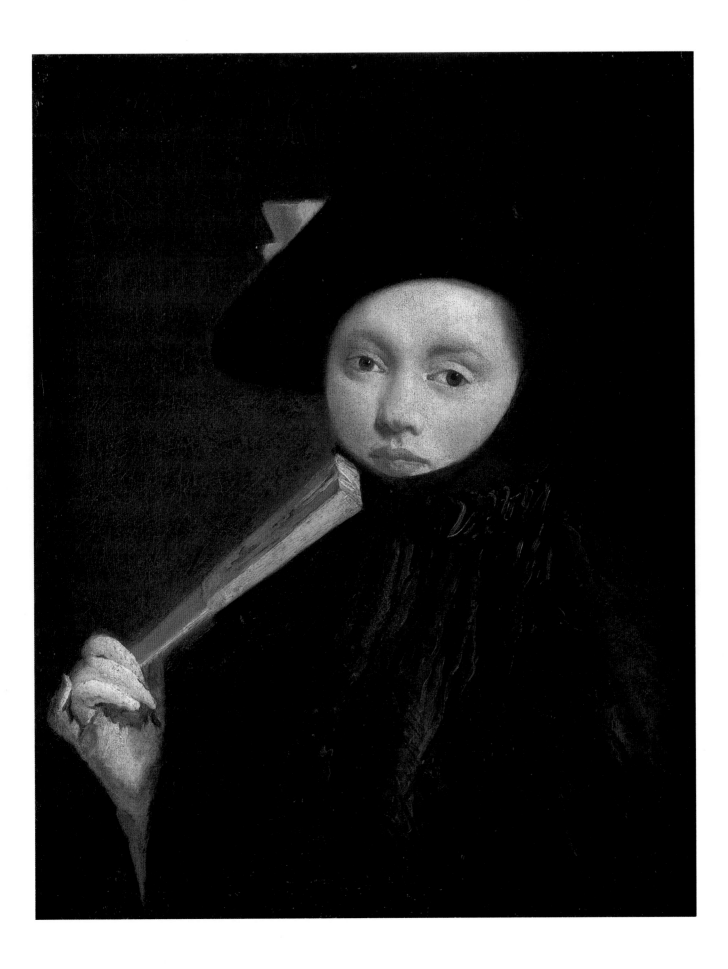

38. THE APOTHEOSIS OF AENEAS

1765–66. Ceiling fresco, 75'6" × 52'6" (23 × 16 m)
Guard Room, Royal Palace, Madrid

In 1762, Tiepolo left Venice to paint the ceiling of the Throne Room in the Royal Palace, Madrid (see pp. 45–46). After its successful completion in 1764, he was asked to stay on to paint two more ceilings in the palace, in the Saleta (a small hall) and the Guard Room. A large oil painting by Corrado Giaquinto, first painter to Charles III, which depicts Venus's gift of arms to her son, Aeneas, may have been executed with the Guard Room ceiling in mind. Giaquinto returned to Naples in 1762, however, and the project was left unfinished.[56] In his fresco for the Guard Room, Tiepolo changed the theme but retained Giaquinto's protagonists, Venus and Aeneas. The latter was certainly a hero worthy of decorating the Guard Room. Furthermore, in the *Aeneid*, Virgil had sent the Trojan prince to Hesperia, the West, to found Rome. Several Latin poets associated Hesperia with Spain, Europe's westernmost land mass, and Bishop Isidorus of Seville (d. 636) identified Hesperia as Spain in his *Etymologiae* (or *Origines*, Bk. XIV).[57] (He was made a doctor of the Church in the eighteenth century.) The ceiling must imply, therefore, that the Spanish monarchy descended from Aeneas and his divine mother.

Tiepolo shows Aeneas entering the heavens on an ascending glory of clouds, his outstretched arm raised to his left toward Venus, who is awaiting him on a brighter cloud bank, seated and holding a plumed helmet in her hands as a gift. Vulcan, the artisan of the helmet, and his forge are below, and midway between him and the Trojan prince sits Time, whose angular and shadowed figure Aeneas has bypassed in his ascent to Eternity. Above Aeneas, almost hidden in the clouds, is the Temple of Immortality, and around him are Merit, Strength, and Justice.[58] (Giambattista painted a related but not identical ceiling for a palace in St. Petersburg; this image was made into a print by his son Lorenzo.)

Two oil sketches (Fogg Art Museum, Cambridge, Massachusetts, and Museum of Fine Arts, Boston) can be associated with the ceiling. The one in Cambridge is clearly the final study because of its closeness to the fresco. Differences between the sketches include a wolf that dominates the lower left corner of the Boston painting; Aeneas stands with his back to us there rather than facing us as in the Fogg sketch and in the fresco, and his mother stands in an exaggerated contrapposto position. Both sketches show the same protagonists, however, and their compositions are alike, organized along a zigzagging line that moves up toward Aeneas on the left and then darts back to the right, to Venus and the flying Mercury above.

The significance of the changes, particularly as they appear on the finished ceiling, is that Tiepolo was modifying the illusionism he had evolved over decades. The *Aeneas* ceiling is not his usual heavenly *tour de force* in which figures speed through space, parts of them disappearing into the thick atmosphere. Here, everyone is still, and although "sandwiched" among clouds, not one god, goddess, or Virtue is lost sight of. Was the old Tiepolo fundamentally changing his style? Hardly; and we must recall that even at their most extreme, Tiepolo's heavens are not difficult to read, like those of Correggio, Pietro da Cortona, or Giovanni Lanfranco. But there can be no doubt that this fresco, like some other monumental imagery of Tiepolo's maturity, was his response to the Neoclassicism that he saw in Madrid and had already experienced in Venice.[59] Nor can there be any doubt that the "corrected" viewpoint here, which makes the heavenly scene easily comprehensible, is more akin to Carlo Maratta's *The Triumph of Clemency* (Palazzo Altieri, Rome), of the 1670s, and to Sebastiano Conca's *The Crowning of St. Cecilia* (S. Cecilia, Rome), 1725—both hallmarks of the classical tendencies in Italian Baroque ceiling painting—than to Tiepolo's own *Apollo Bringing Beatrice of Burgundy to the Seat of the German Empire* (plate 30), in which figures are severely twisted and radically foreshortened.

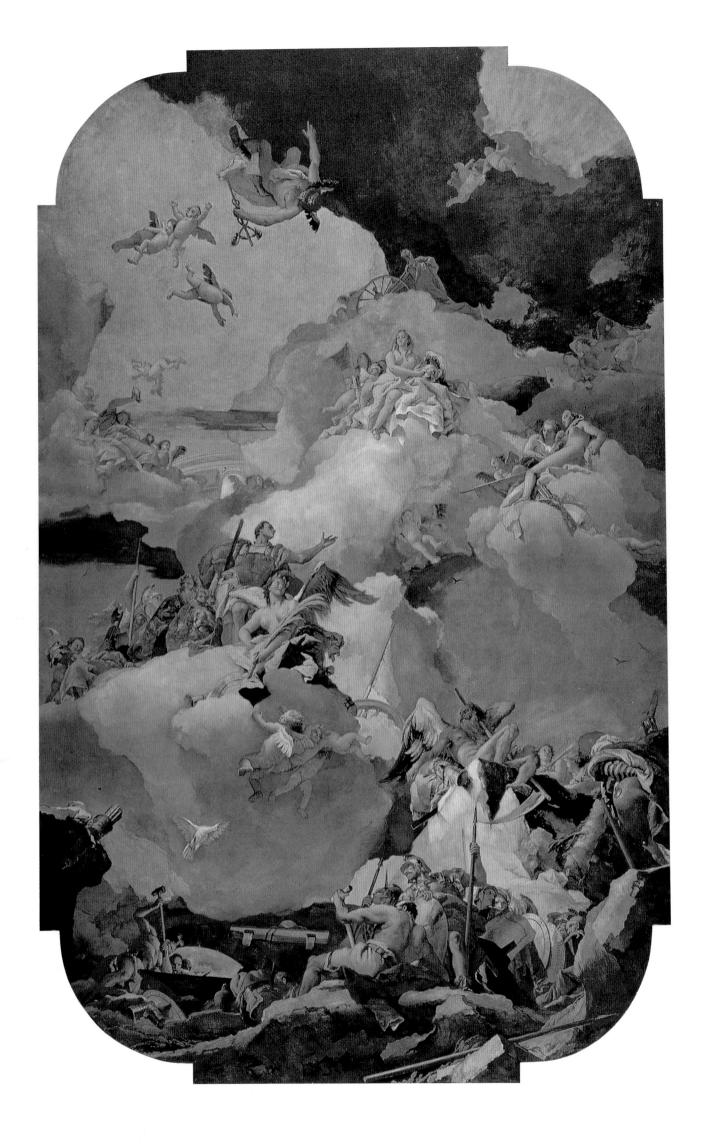

39. OIL SKETCH FOR "ST. CHARLES BORROMEO ADORING THE CRUCIFIX"

1767. Oil on canvas, 24⅞ × 15" (63 × 38 cm)
Courtauld Institute Gallery, London. Princes Gate Collection, Seilern Bequest, 1978

Construction of the little church of S. Pascual Babylon in Aranjuez, outside Madrid, was begun in 1765 (see p. 46) as a commission from Charles III for a group of Franciscans dedicated to poverty and devoted to St. Peter of Alcantara.[60] The project was under the direction of Padre Joaquín de Eleta, the king's confessor and himself an Alcantrine Franciscan. Royal wealth and Franciscan devotions distinguish the church and its decoration.

The interior was designed to hold seven altars; all were to be adorned with altarpieces (some no longer exist). Tiepolo received the commission to paint the entire series in March 1767; his sketches were ready for inspection by August 5 of that year, and the altarpieces themselves were completed by August 29, 1769. The Franciscan order was devoted to the cult of the Immaculate Conception. In addition, its congregation in this church was dedicated to St. Pascual Babylon, living under the rule of St. Peter of Alcantara, in the province of St. Joseph, and under the patronage of St. Charles Borromeo, cardinal-protector of the Franciscan order. Thus, six of the seven paintings depicted those saints and the Immaculate Virgin. The seventh shows St. Anthony's Vision of the Christ Child.

The altarpieces were removed from S. Pascual in 1775. Four of the seven canvases remain intact as a group in the Museo del Prado, Madrid, and fragments of the other three are there, in the Institute of Art, Detroit, and the Cincinnati Art Museum. The five surviving oil sketches belong to the Courtauld Institute Galleries, London. A comparison of the sketch for the *Immaculate Conception* (fig. 35) with the completed painting (fig. 36), which stood over the altar in the left transept, illuminates Tiepolo's translation of a first idea into a large-scale image. In the sketch, angels and cherubs hover in space, dark shadows frame the silvery Virgin who stands against a golden light, and tremulous brushwork delineates forms. In the altarpiece, Tiepolo simplified poses (note the cherub holding the lily on the lower right, and the Holy Dove above); he corrected shapes (note the change from an oval mirror to a square one); fewer curving forms and shadows encumber the Virgin; and his brushwork is more regular.

St. Charles Borromeo Adoring the Crucifix was the only one of the seven altarpieces that never adorned its altar. But its oil sketch is an extraordinary work because of the artist's decision to picture the fervent St. Charles in a large architectural surround. It is the only one of the altarpieces so conceived. The diagonal of the large crucifix holding the taut body of Christ is counterbalanced by the orientation of the cherub's head at the bottom left, St. Charles's robes and mitre to the right, and the tilting angel above. Against these diagonal forms, Tiepolo set the rigid geometry of the church interior and altar, and he composed the saint's own pose as a transitional one, somewhere between the verticality of the columns behind and the bold diagonal of the crucifix. Charles is thus in the act of physically yielding to Christ when we see him.

The colors of the sketch are equally dramatic. Charles is dressed in white and pink that moves to red. The white in the angel's wings and in the column below, the large, falling mass of gold drapery, the light blue of the two openings in the window and arch, and the olive green architecture create a chromatic vibrancy meant to express the saint's mystical experience.

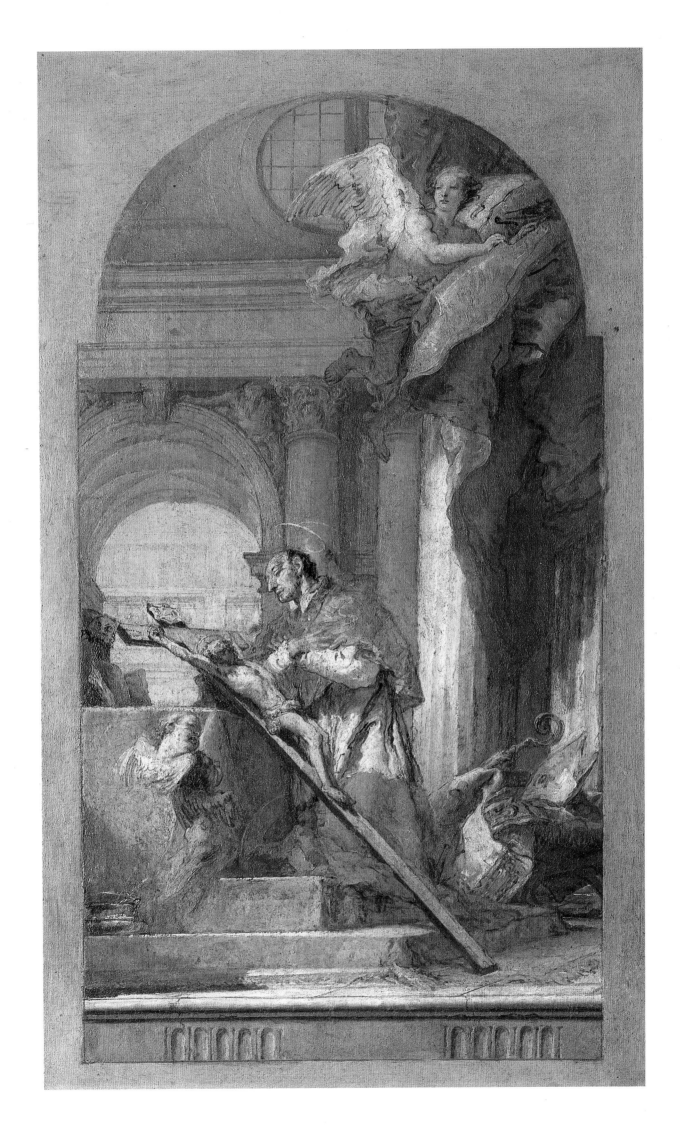

40. THE REST ON THE FLIGHT INTO EGYPT

c. 1767–70. Oil on canvas, 21⅞ × 16⅜" (55.4 × 41.4 cm)
Staatsgalerie, Stuttgart

During the last years of his life in Spain, Tiepolo painted a number of small devotional works, most likely for members of the royal court. The themes were not new, either to Tiepolo or to Catholic art. But the late Spanish religious works are new, nonetheless, because their imagery reaches a depth of feeling and an economy of gesture unprecedented in the painter's oeuvre. The *Rest on the Flight* is, perhaps, the most remarkable of this group of paintings.

The work is notable, too, because it resembles none of the many renderings of this theme that either Giambattista or his son Giandomenico had produced until then.[61] Very early in his career, in about 1720, Giambattista had painted a small *Rest on the Flight* (Fine Arts Gallery, San Diego, California) that is dark and murky and shows the Holy Family being startled by an angelic apparition. For S. Massimo in Padua, he had also painted a *Rest on the Flight*, in about 1745, and it focuses on Mary holding the Christ Child on her lap. Several drawings reveal Giambattista's continuing interest in the theme of the Flight. And between 1750 and 1753, Giandomenico produced a series of twenty-seven engravings entitled *Idee pittoresche sulla fuga in Egitto* (Picturesque Ideas on the Flight into Egypt) dedicated to Prince-Bishop Karl Philip von Greiffenklau of Würzburg. Depicting the Holy Family's travels, from the time they leave their home through their journey into the wilderness accompanied by angels and their stops at strange cities, these intimate scenes bring us close to a family forced to wander. One can only think of Giandomenico himself, who had left his mother and most of his siblings in Venice to cross the Alps into Germany.

Giambattista's Spanish *Rest on the Flight* is like Giandomenico's series in that it can be associated with an artist far from home. And, yet, it is totally different from anything the son had imagined or the father had painted or drawn. For the members of the Holy Family are really not the protagonists. Landscape overwhelms them, and it is the terrain neither of the Holy Land nor of Egypt. The mountains are pre-Alpine in character and so is the lone tree; the river, which does figure often in the theme of the Flight, reinforces the sense of the dangerousness and intractability of the lands the Holy Family must travel to reach safety. How arduous the journey has already been is suggested by the mountains behind them; just how difficult the voyage will be once they cross the river can also be envisioned.

But how indeed will they cross that river? Mary and Joseph look at each other, no doubt to resolve that very question. She turns to him and leans against the fir, just as the tree pushes against the mountain. The baby Christ, almost incidental in the scene, lies helpless in his mother's lap. A landing juts into the water, but no boat is in sight; nor are there any ripples to suggest that one has just left or that one will soon arrive. Two birds cross the river, one small and white flying low toward the distant bank, the other large and dark flying toward the Holy Family. But Mary and Joseph cannot fly like the birds, and there seems to be no possibility that they will ever get to the other side.

Exhausted and faced with the overwhelming immensity of God's world, Mary and Joseph need divine aid to overcome their frailty and to meet the challenges placed before them. The work implies that only faith in miracles can help at times, but it also professes something more. For it is difficult to imagine a quieter and humbler profession of Christian trust than this tiny painting; Tiepolo, far from home, tired, and unable to imagine his way back across the immense distances that separated him from his beloved Venice and family, appears to say here that he leaves his fate in God's hands. If it should be willed that he go home, no doubt the Lord will so provide.

NOTES

Essay

1. V. Da Canal, *Vita di Gregorio Lazzarini* (Venice, 1809).

2. Da Canal, p. xxxii; and see E. Martini, "I ritratti di Ca' Cornaro di G. B. Tiepolo giovane," *Notizie da Palazzo Albani*, 3 (1974), pp. 30–35.

3. For contrasting opinions on how many and which figures in the Ospedaletto commission are Tiepolo's, see B. Aikema, "Early Tiepolo Studies, 1. The Ospedaletto Problem," *Mitteilungen des Kunsthistorischen Institutes in Florenz*, 26 (1982), pp. 339–82, and G. M. Pilo, *La Chiesa dello 'Spedaletto' in Venezia* (Venice [1988]), passim. For *The Crossing of the Red Sea*, see W. L. Barcham, *The Religious Paintings of Giambattista Tiepolo: Piety and Tradition in Eighteenth-century Venice* (Oxford, 1989), pp. 14–27.

4. See A. Mariuz and G. Pavanello, "I primi affreschi di Giambattista Tiepolo," *Arte veneta*, 39 (1985), pp. 101–13, and Aikema, "Quattro note su Giovanni Battista Tiepolo Giovane," *Mitteilungen des Kunsthistorischen Institutes in Florenz*, 31 (1987), pp. 441–54.

5. For the *Assumption*, see Mariuz and Pavanello, pp. 101–13; and for the *St. Lucy*, L. Moretti, "Notizie e appunti su G. B. Piazzetta: Alcuni piazzetteschi e G. B. Tiepolo," *Atti dell'Istituto Veneto di Scienze, Lettere ed Arti*, 143 (1984–85), pp. 379–80; and then Aikema, "Quattro note," pp. 441–44.

6. For Tiepolo's homes, see P. L. Sohm, "A New Document on Giambattista Tiepolo's Santa Fosca Residence," *Arte veneta*, 40 (1986), p. 239.

7. See Mariuz and Pavanello, pp. 103–12.

8. The work was begun in 1722 and completed only in 1727; see Moretti, p. 379. For further discussion of the painting, see Barcham, *Religious Paintings*, pp. 34–39, 146.

9. Lilian Zirpolo has written an article, soon to be published, that reidentifies this subject.

10. See M. Muraro, "Ricerche su Tiepolo giovane," *Atti dell'Accademia di Scienze, Lettere ed Arti di Udine*, 9 (1970–72), pp. 5–64; Barcham, "Patriarchy and Politics: Tiepolo's 'Galleria Patriarcale' in Udine Revisited," in *Studi di storia dell'arte in onore di Michelangelo Muraro*, ed. D. Rosand (Venice, 1984), pp. 427–38, and Barcham, *Religious Paintings*, pp. 55–75.

11. For his Vicentine patrons, see R. Menegozzo, *Nobili e Tiepolo a Vicenza: L'artista e i committenti* (Vicenza, 1990).

12. See especially G. Knox, "Some Notes on Large Paintings Depicting Scenes from Antique History by Ricci, Piazzetta, Bambini and Tiepolo," *Atti del Congresso Internazionale su Sebastiano Ricci e del suo tempo*

(Venice, 1976), pp. 96–104; Knox, "Pagani, Piazzetta and Pellegrini: from Ca' Corner to 'The Elms,'" *Apollo*, 110, 1979, pp. 428–37; and Knox, "Roman and Less Roman Elements in Venetian History Painting, 1650–1750," *RACAR*, 12, 1985, pp. 175–78.

13. See the essays in *Il Settecento*, vol. 5, pts. 1, 2, of *Storia della cultura veneta*, eds. G. Arnaldi and M. Pastore Stocchi (Vicenza, 1985–86).

14. S. Maffei, *Epistolario* (1732), vol. 3, cols. 106, 217–26. Tiepolo would also have known Madrisio in Udine.

15. Maffei, *Verona illustrata*, pt. 3, vol. 4 (Milan, 1826), p. 327.

16. Da Canal, p. xxxii.

17. Sohm, p. 239.

18. Our understanding of Tiepolo's drawings and his working technique rests on the studies that George Knox has produced over the last thirty years; see the relevant bibliography in his *Giambattista and Domenico Tiepolo: A Study and Catalogue Raisonné of the Chalk Drawings* (Oxford, 1980), vol. 1, pp. 358–59. For technical information on Tiepolo's drawings, see M. B. Cohn, "A Note on Media and Methods," in Knox, *Tiepolo: A Bicentenary Exhibition, 1770–1970*, exh. cat., Fogg Art Museum (Meriden, Connecticut, 1970), pp. 211–21.

19. Tiepolo's statement was made in a letter of November 17, 1734; see G. Fogolari, "Lettere inedite del Tiepolo," *Nuova antologia* (1942).

20. I am grateful to Philip Sohm for offering me much of the information regarding the Clerici family and its palace fresco that he found in the State Archives, Milan. See, too, entry on Giorgio Clerici in P. Cabrini, *Dizionario biografico degli italiani*, vol. 26 (Rome, 1982), pp. 396–400.

21. For Palazzo Archinto, see Sohm, "Giambattista Tiepolo at the Palazzo Archinto in Milan," *Arte lombarda*, 68–69 (1984), pp. 70–78; and for Palazzo Canossa, see Sohm, "Unknown Epithalamia as Sources for G. B. Tiepolo's Iconography and Style," *Arte veneta*, 37 (1983), pp. 138–50.

22. Knox disagrees in his "Anthony and Cleopatra in Russia: A Problem in the Editing of Tiepolo Drawings," in *Editing Illustrated Books*, ed. W. Blissett (New York and London, 1980), pp. 35–55.

23. G. M. Urbani De Gheltof, *Tiepolo e la sua famiglia* (Venice, 1879), p. 106.

24. See C. D. Lewis, *The Late Baroque Churches of Venice* (New York and London, 1979), pp. 149ff.

25. Ibid., p. 234.

26. For the contracts dating the armature's construction, Mengozzi-Colonna's painting on the vault, and the payments to Tiepolo for his fresco, see Barcham, "Giambattista Tiepolo's Ceiling for S.

Maria di Nazareth in Venice: Legend, Traditions, and Devotions," *Art Bulletin*, 61 (1979), p. 430, n. 1.

27. The Carmini inauguration was in June 1744. For discussions on the Tasso and Russian commissions and their dating, see Knox, "The Tasso Cycles of Giambattista Tiepolo and Giannantonio Guardi," *Museum Studies*, 9 (1978), pp. 49–95, and Knox, "Anthony and Cleopatra in Russia," pp. 35–55.

28. See Barcham, "The Cappella Sagredo in San Francesco della Vigna," *artibus et historiae*, 7 (1983), pp. 101–24.

29. See Knox, *Catalogue of the Tiepolo Drawings in the Victoria and Albert Museum* (London, 1975), pp. 14–15.

30. For the 1743 date of the Capricci's publication, see M. Santifaller, "Carl Heinrich von Heinecken e le acqueforti di Giambattista Tiepolo a Dresda," *Arte veneta*, 26 (1972), pp. 145–53.

31. For these and Tiepolo's other endeavors in the print medium, see D. Succi, *Da Carlevarijs ai Tiepolo: Incisori veneti e friulani del settecento*, exh. cat., Museo Correr (Venice, 1983), and Succi, *Giambattista Tiepolo: Il segno e l'enigma*, exh. cat., Castello di Gorizia (Treviso, 1985).

32. See Knox, "G. B. Tiepolo: The Dating of the 'Scherzi di Fantasia' and the 'Capricci,'" *Burlington Magazine*, 114 (1972), pp. 837–42. Knox now dates the execution of all the plates to 1743. Opinion is divided among three camps: those who believe Tiepolo began making the *Scherzi* in the late 1730s and continued with the *Capricci* in the forties; those who date all the etchings to the forties; and those who believe he began the *Capricci* and the *Scherzi* in the forties but continued producing the latter group in the fifties.

33. Although many of the motifs appear throughout Tiepolo's oeuvre, their combined preponderance in the prints and in the Verolanuova canvases cannot be denied.

34. Knox, *Etchings by the Tiepolos*, exh. cat., National Gallery of Canada (Ottawa, 1976), p. 14.

35. C. Dempsey, "Tiepolo Etchings in Washington," *Burlington Magazine*, 114 (1972), pp. 503–7.

36. See Barcham, *Religious Paintings*, pp. 169ff.

37. Station IX is inscribed with the date 1747, and Station XIII bears testimony that it was painted when the artist was twenty; see Mariuz, *Giandomenico Tiepolo* (Venice, 1971), p. 144.

38. Tiepolo's "Wagnerian" curtain predates by more than a century the German composer's innovations for his operatic proscenium in nearby Bayreuth.

39. P. A. Orlandi, *Abecedario pittorico* (Venice, 1753), p. 282.

40. D. Howard, "Giambattista Tiepolo's

Frescos for the Church of the Pietà in Venice," *Oxford Art Journal*, 9 (1986), p. 13.

41. See L. Jones, "Peace, Prosperity and Politics in Tiepolo's 'Glory of the Spanish Monarchy,'" *Apollo*, 114 (1981), pp. 220–27.

42. For the Aranjuez commission, see C. Whistler, "Tiepolo, Charles III, and the Church of S. Pascual Babylon at Aranjuez," *Apollo*, 121 (1985), pp. 321–27, and Whistler, "G. B. Tiepolo at the Court of Charles III," *Burlington Magazine*, 128 (1986), pp. 199–203; and see M. Levey, *Giambattista Tiepolo: His Life and Art* (New Haven and London, 1986), pp. 271–82.

43. H. Taine, *Voyage en Italie* [1864] (Paris, 1902), p. 291, on Tiepolo's ceiling in S. Maria del Rosario (plates 13, 14).

Colorplates

1. Moretti, "La data degli Apostoli della chiesa di San Stae," *Arte veneta*, 27 (1973), pp. 318ff.

2. See S. J. Barnes, *Anthony van Dyck*, exh. cat., National Gallery of Art (Washington, D.C., 1990–91), pp. 130–134.

3. Mariuz, *L'opera completa del Piazzetta* (Milan, 1982), pp. 112–13.

4. Aikema, "Nicolò Bambini e Giambattista Tiepolo nel salone di Palazzo Sandi a Venezia," *Arte veneta*, 40 (1986), pp.167–71; he attributes the frieze to Bambini.

5. A. Szilagyi, "Amphion Playing the Lyre," *Renaissance Studies in Honor of Craig Hugh Smyth* (Florence, 1985), vol. 2, pp. 477–87.

6. Aikema, "Quattro note," pp. 441–54.

7. Moretti, "Notizie e appunti," pp. 359–95.

8. But see Levey's dating, p. 41.

9. Muraro, "Ricerche su Tiepolo giovane," pp. 5–64, and Barcham, "Patriarchy and Politics," pp. 427–38.

10. S. J. Jordan, "The Iconography of the Sala Rossa Frescoes by Tiepolo," *Arte veneta*, 29 (1985), pp. 170–73, for the identification of Jeremiah as Jonah.

11. Barcham, *Religious Paintings*, pp. 91–99.

12. A. M. Zanetti, *Descrizione di tutte le pubbliche pitture della città di Venezia* (Venice, 1733), p. 190; Lewis, p. 330.

13. V. Coronelli, *Guida de' forestieri . . . per la città di Venezia* (Venice, 1724), p. 202.

14. The two drawings are in a private collection, New York, and in the Graphische Sammlung, Staatsgalerie, Stuttgart.

15. P. Molmenti, *Tiepolo: La Vie et l'oeuvre du peintre* (Paris, 1911), pp. 105–6.

16. Mariuz, *L'opera completa del Piazzetta*, p. 87.

17. Its altar was completed in 1733; *I Tiepolo e il settecento vicentino*, exh. cat. (Vicenza, 1990), p. 35.

18. Barcham, *Religious Paintings*, pp. 158–59.

19. O. Sirèn, *Dessins et tableaux de la Renaissance italienne dans les collections de la Suède* (Stock-

holm, 1902), pp. 103–13.

20. Levey, "The Modello for Tiepolo's Altarpiece at Nymphenburg," *Burlington Magazine*, 99 (1957), pp. 256–61, and *The Seventeenth and Eighteenth Century Italian Schools (National Gallery Catalogues)* (London, 1971), pp. 223–25.

21. H. Braham, *The Princes Gate Collection* (London, 1981), p. 74; the Bergamo version is looser in handling and slightly larger.

22. A. Massari, *Giorgio Massari* (Vicenza, 1971), pp. 42ff.; A. Niero, *Tre artisti per un tempio: S. Maria del Rosario-Gesuati, Venezia* (Padua, 1979); and Barcham, *Religious Paintings*, pp. 109–29.

23. Barcham, *Religious Paintings*, pp. 109–29.

24. G. Albrizzi, *Il forestiere illuminato* (Venice, 1740), p. 171.

25. *Le Siècle de Rubens*, exh. cat. (Brussels, 1965), pp. 176–79; F. Vivian, *Il Console Smith, mercante e collezionista* (Vicenza, 1971), pp. 223–24; and Levey, *Giambattista Tiepolo*, pp. 90–91.

26. Biblioteca Nazionale Marciana, Venice, Misc. 118.

27. Sirèn, pp. 107–8; Sohm, "The Critical Reception of Paolo Veronese in Eighteenth-Century Italy: The Example of Giambattista Tiepolo as Veronese Redivivus," *Paolo Veronese, Fortuna Critica und künstlerisches Nachleben* (Sigmaringen, 1990), pp. 87–107.

28. S. Pangiaro, *Il Tiepolo a Verolanuova* (Brescia, 1983), p. 27.

29. Knox, "Tasso Cycles," pp. 49–95.

30. Ibid., pp. 84–88.

31. Levey, "Tiepolo's 'Empire of Flora,'" *Burlington Magazine*, 99 (1957), pp. 89–91. Algarotti owned sketches of Tiepolo's two paintings; see G. Selva, *Catalogo dei quadri dei disegni e dei libri . . . del fu Sig. Conte Algarotti in Venezia*, p. 59.

32. The statue thought to represent Flora during the Renaissance and Baroque eras is no longer so considered; for reproductions of all three, see *Raccolta di statue antiche e moderne . . . da Domenico de Rossi, illustrata . . . di Paulo Alessandro Maffei . . .* (Rome, 1704; reprinted 1742), plates 51, 86, and 122.

33. Barcham, "Giambattista Tiepolo's *Triumph of Flora*: A Springtime for Dresden," forthcoming in *Arte veneta*.

34. F. Algarotti, "Lettere varie al signor Giuseppe Santarelli a Venezia," *Opere* (Leghorn, 1764), p. 310 (letter of March 9, 1747).

35. For Algarotti's correspondence with Dresden, see H. Posse, "Die Briefe des Grafen Francesco Algarotti an den sächsischen Hof und seine Bilderkäufe für die Dresdner Gemäldegalerie 1743–1747," *Jahrbuch der Preuszischen Kunstsammlungen*, 52 (1931), pp. 1–73.

36. Levey, "Tiepolo's 'Banquet of Cleopatra' at Melbourne," *Arte veneta*, 8 (1954), pp. 199–203; and Haskell, "Algarotti and Tiepolo's 'Banquet of Cleopatra,'" *Burlington Magazine*, 100 (1958), pp. 212–13.

37. The drawing, measuring 209 × 295 mm, was sold as Lot 147 at Sotheby-Parke Bernet on Jan. 16, 1986, and the sketch is reproduced in M. Precerutti Garberi, "Di alcuni dipinti perduti del Tiepolo," *Commentari*, 9 (1959), pp. 110–23.

38. Barcham, "Giambattista Tiepolo's Ceiling for S. Maria di Nazareth in Venice," *Art Bulletin*, 61 (1979), pp. 430–47.

39. R. Schiavo, *Giovambattista Tiepolo alla Villa Cordellina di Montecchio Maggiore* (Tavernelle, 1989); Menegozzo, *Nobili e Tiepolo*, pp. 43–60; M. E. Avagnina, F. Rigon, and Schiavo, *Tiepolo: Le ville vicentine* (Milan, 1990), pp. 36–58; D. Battilotti, "'Lusso plausibile' e senza 'frivolità.' Un celebre avvocato, una villa, due palazzi,'" and B. Mazza, "Il trionfo della Ragione: Giambattista Tiepolo per Carlo Cordellina," in *I Tiepolo e il Settecento vicentino*, pp. 297–305 and 306–15, respectively.

40. B. Molajoli, A. Scattolin, and P. Rotondi, *Palazzo Labia, oggi* (Turin, 1970); T. Pignatti, F. Pedrocco, E. Martinelli Pedrocco, *Palazzo Labia a Venezia* (Turin, 1982).

41. Knox, "Giambattista Tiepolo: Variations on the Theme of Anthony and Cleopatra," *Master Drawings*, 12 (1974), pp. 378–90, and "Anthony and Cleopatra in Russia," pp. 35–55.

42. Levey, *Giambattista Tiepolo*, figs. 142, 143.

43. F. Zava Boccazzi, "La documentazione archivistica delle tele settecentesche nel coro del Duomo di Bergamo," *Arte veneta*, 30 (1976), pp. 233–39.

44. B. Belotti, *Storia di Bergamo e dei bergamaschi* (Bergamo, 1959).

45. For the works in Padua and Diessen, see A. Pallucchini, *L'opera completa di Giambattista Tiepolo* (Milan, 1968), nos. 110 and 125.

46. Barcham, *Religious Paintings*, pp. 202–8.

47. For all four, see ibid., chap. 2, passim.

48. M. H. Freeden and C. Lamb, *Die Fresken der Würzburger Residenz* (Munich, 1956); M. Ashton, "Allegory, Fact, and Meaning in Giambattista Tiepolo's Four Continents at Würzburg," *Art Bulletin*, 68 (1978), pp. 109–25; F. Büttner, "Die Sonne Frankens: Ikonographie des Freskos im Treppenhaus der Würzburger Residenz," *Münchner Jahrbuch der bildenden Kunst*, 3 (1979), pp. 159–86.

49. A. Powell, *Temporory Kings (A Dance to the Music of Time)* (London, 1973), p. 76.

50. Knox, *Giambattista and Domenico Tiepolo*, vol. 1, pp. 39–50.

51. Veronese's *Venus and Mars Tied by Love* was in the Orléans Collection, Paris, in the eighteenth century, but Tiepolo could have known it through a print. An identical satyr-caryatid in the reverse position appears in Veronese's *The Allegory of Music* on the ceiling of the Library of St. Mark's, Venice.

52. Barcham, *Religious Paintings*, pp. 222–24.

53. Ibid., pp. 224–29.

54. Knox, *Domenico Tiepolo: Raccolta di teste* (Udine, 1970), and "'Philosopher Portraits' by Giambattista, Domenico, and Lorenzo Tiepolo," *Burlington Magazine*, 117 (1975), pp. 147–55.

55. F. M. Tassis, *Vite de' pittori, scultori, e architetti bergamaschi* (Milan, 1970), vol. 1, p. 135.

56. E. Young, *Catalogue of the Spanish and Italian Paintings (The Bowes Museum, Barnard Castle, County Durham)* (Washington, County Durham, 1970), pp. 98–100.

57. See entry on Hispania in *A Dictionary of Greek and Roman Geography*, ed. W. Smith (London, 1873), vol. 1, p. 1074.

58. S. De Vito Battaglia, *Il bozzetto di Giambattista Tiepolo per il soffitto della Sala di Guardia nel Palazzo Reale di Madrid* (Rome, 1931), p. 7.

59. Whistler, "G. B. Tiepolo at the Court of Charles III," p. 202; and Barcham, "Cappella Sagredo," p. 123.

60. Whistler, "Tiepolo, Charles III, and the Church of S. Pascual Babylon at Aranjuez," pp. 321–27.

61. Knox, *Catalogue of the Tiepolo Drawings*, p. 82.

ACKNOWLEDGMENTS

I am grateful to George Knox, without whose work on Tiepolo my own efforts would be lesser than they are. I want to thank, too, Diane De Grazia, Charles Miers, Justin O'Connor, and Erich Schleier for their advice and help. Charles Scribner III was especially kind, and I am indebted to his generosity. Catherine Puglisi was, as always, watching and listening. Lauren Boucher, Barbara Lyons, Diana Murphy, Ellen Nygaard Ford, and Shun Yamamoto at Harry N. Abrams, Inc., have contributed immensely to the production of this book.

PHOTOGRAPHIC CREDITS